STILL LIFE and
SPECIAL EFFECTS
PHOTOGRAPHY

a guide to professional lighting techniques

STILL LIFE and
SPECIAL EFFECTS
PHOTOGRAPHY

a guide to professional lighting techniques

MAR 5 2003

RotoVision

Published and distributed by ROTOVISION SA
Route Suisse 9
CH-1295 - Mies
Switzerland

Sales, Production and Editorial Office:
RotoVision SA,
Sheridan House, 112-116a Western Rd,
Hove, East Sussex BN3 1DD, UK
Tel: +44 (0) 1273 727268
Fax: +44 (0) 1273 727269
Email: sales@rotovision.com
Website: www.rotovision.com

ISBN 2-88046-660-1

This book was designed and produced by
Design Revolution, Brighton UK

Production and separations in Singapore by ProVision Pte. Ltd.
Tel: +65 6334 7720
Fax: +65 6334 7721

CONTENTS

HOW TO USE THIS BOOK

▼

THE LIGHTING DRAWINGS IN THIS BOOK ARE INTENDED AS A GUIDE TO THE LIGHTING SET-UP RATHER THAN AS ABSOLUTELY ACCURATE DIAGRAMS. PART OF THIS IS DUE TO THE VARIATION IN THE PHOTOGRAPHERS' OWN DRAWINGS, SOME OF WHICH WERE MORE COMPLETE (AND MORE COMPREHENSIBLE) THAN OTHERS, BUT PART OF IT IS ALSO DUE TO THE NEED TO REPRESENT COMPLEX SET-UPS IN A WAY WHICH WOULD NOT BE NEEDLESSLY CONFUSING.

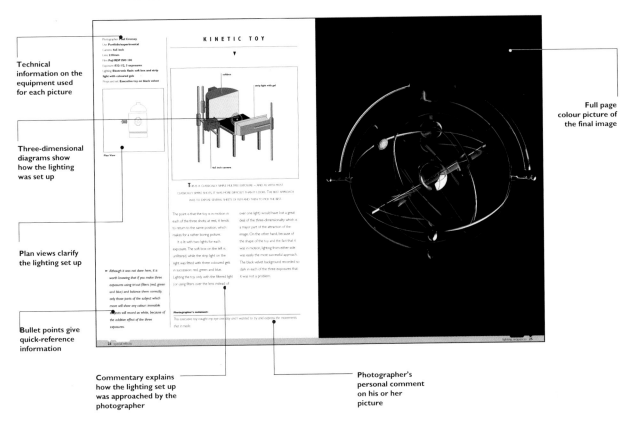

Technical information on the equipment used for each picture

Three-dimensional diagrams show how the lighting was set up

Plan views clarify the lighting set up

Bullet points give quick-reference information

Commentary explains how the lighting set up was approached by the photographer

Photographer's personal comment on his or her picture

Full page colour picture of the final image

Distances and even sizes have been compressed and expanded: and because of the vast variety of sizes of soft boxes, reflectors, bounces and the like, we have settled on a limited range of conventionalized symbols. Sometimes, too, we have reduced the size of big bounces, just to simplify the drawing.

None of this should really matter, however. After all, no photographer works strictly according to rules and preconceptions: there is always room to move this light a little to the left or right,

to move that light closer or further away, and so forth, according to the needs of the shot. Likewise, the precise power of the individual lighting heads or (more important) the lighting ratios are not always given; but again, this is something which can be "fine tuned" by any photographer wishing to reproduce the lighting set-ups in here.

We are however confident that there is more than enough information given about every single shot to merit its inclusion in the book: as well as purely

lighting techniques, there are also all kinds of hints and tips about commercial realities, photographic practicalities, and the way of the world in general.

The book can therefore be used in a number of ways. The most basic, and perhaps the most useful for the beginner, is to study all the technical information concerning a picture which he or she particularly admires, together with the lighting diagrams, and to try to duplicate that shot as far as possible with the equipment available.

A more advanced use for the book is as a problem solver for difficulties you have already encountered: a particular technique of back lighting, say, or of creating a feeling of light and space. And, of course, it can always be used simply as a source of inspiration.

The information for each picture follows the same plan, though some individual headings may be omitted if they were irrelevant or unavailable. The photographer is credited first, then the client, together with the use for which the picture was taken. Next come the other members of the team who worked on the picture: stylists, models, art directors, whoever. Camera and lens come next, followed by film. With film, we have named brands and types, because different films have very different ways of rendering colours and tonal values. Exposure comes next: where the lighting is electronic flash, only the aperture is given, as illumination is of course independent of shutter speed. Next, the lighting equipment is briefly summarized — whether tungsten or flash, and what sort of heads — and finally there is a brief note on props and backgrounds. Often, this last will be obvious from the picture, but in other cases you may be surprised at what has been pressed into service, and how different it looks from its normal role.

The most important part of the book is however the pictures themselves. By studying these, and referring to the lighting diagrams and the text as necessary, you can work out how they were done; and showing how things are done is the brief to which the *Pro Lighting* series was created.

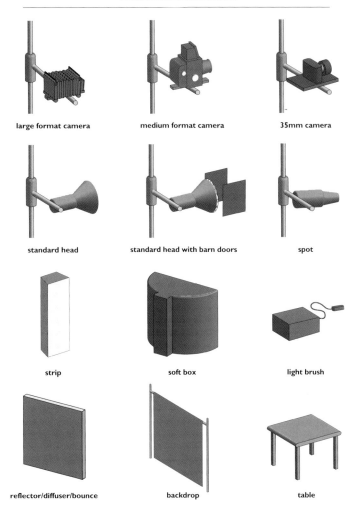

DIAGRAM KEY

The following is a key to the symbols used in the three-dimensional and plan view diagrams. All commonly used elements such as standard heads, reflectors etc., are listed. Any special or unusual elements involved will be shown on the relevant diagrams themselves.

THREE-DIMENSIONAL DIAGRAMS

large format camera

medium format camera

35mm camera

standard head

standard head with barn doors

spot

strip

soft box

light brush

reflector/diffuser/bounce

backdrop

table

PLAN VIEW DIAGRAMS

large format camera

medium format camera

35mm camera

bounce

standard head

standard head with barn doors

spot

gobo

diffuser

reflector

strip

soft box

light brush

backdrop

table

GLOSSARY OF LIGHTING TERMS

▼

Lighting, like any other craft, has its own jargon and slang. Unfortunately, the different terms are not very well standardized, and often the same thing may be described in two or more ways or the same word may be used to mean two or more different things. For example, a sheet of black card, wood, metal or other material which is used to control reflections or shadows may be called a flag, a French flag, a donkey or a gobo — though some people would reserve the term "gobo" for a flag with holes in it, which is also known as a cookie. In this book, we have tried to standardize terms as far as possible. For clarity, a glossary is given below, and the preferred terms used in this book are asterisked.

Acetate
see Gel

Acrylic sheeting
Hard, shiny plastic sheeting, usually methyl methacrylate, used as a diffuser ("opal") or in a range of colours as a background.

***Barn doors**
Adjustable flaps affixed to a lighting head which allow the light to be shaded from a particular part of the subject.

Barn doors

Boom
Extension arm allowing a light to be cantilevered out over a subject.

***Bounce**
A passive reflector, typically white but also, (for example) silver or gold, from which light is bounced back onto the subject. Also used in the compound term "Black Bounce", meaning a flag used to absorb light rather than to cast a shadow.

Continuous lighting
What its name suggests: light which shines continuously instead of being a brief flash.

Contrast
see Lighting ratio

Cookie
see Gobo

***Diffuser**
Translucent material used to diffuse light. Includes tracing paper, scrim, umbrellas, translucent plastics such as Perspex and Plexiglas, and more.

Electronic flash: standard head with parallel snoot (Strobex)

Donkey
see Gobo

Effects light
Neither key nor fill; a small light, usually a spot, used to light a particular part of the subject. A hair light on a model is an example of an effects (or "FX") light.

***Fill**
Extra lights, either from a separate head or from a reflector, which "fills" the shadows and lowers the lighting ratio.

Fish fryer
A small Soft Box.

***Flag**
A rigid sheet of metal, board, foam-core or other material which is used to absorb light or to create a shadow. Many flags are painted black on one side and white (or brushed silver) on the other, so that they can be used either as flags or as reflectors.

***Flat**
A large Bounce, often made of a thick sheet of expanded polystyrene or foam-core (for lightness).

Foil
see Gel

French flag
see Flag

Frost
see Diffuser

***Gel**
Transparent or (more rarely) translucent coloured material used to modify the colour of a light. It is an abbreviation of "gelatine (filter)", though most modern "gels" for lighting use are actually of acetate.

***Gobo**
As used in this book, synonymous with "cookie": a flag with cut-outs in it, to cast interestingly-shaped shadows. Also used in projection spots.

"Cookies" or "gobos" for projection spotlight (Photon Beard)

***Head**
Light source, whether continuous or flash. A "standard head" is fitted with a plain reflector.

***HMI**
Rapidly-pulsed and

effectively continuous light source approximating to daylight and running far cooler than tungsten. Relatively new at the time of writing, and still very expensive.

***Honeycomb**

Grid of open-ended hexagonal cells, closely resembling a honeycomb. Increases directionality of

Honeycomb (Hensel)

light from any head.

Incandescent lighting

see Tungsten

Inky dinky

Small tungsten spot.

***Key or key light**

The dominant or principal light, the light which casts the shadows.

Kill Spill

Large flat used to block spill.

***Light brush**

Light source "piped" through fibre-optic lead. Can be used to add highlights, delete shadows and modify lighting, literally by "painting with light".

Electronic Flash: light brush "pencil" (Hensel)

Electronic Flash: light brush "hose" (Hensel)

Lighting ratio

The ratio of the key to the fill, as measured with an incident light meter. A high lighting ratio (8:1 or above) is very contrasty, especially in colour, a low lighting ratio (4:1 or less) is flatter or softer. A 1:1 lighting ratio is completely even, all over the subject.

***Mirror**

Exactly what its name suggests. The only reason for mentioning it here is that reflectors are rarely mirrors, because mirrors create "hot spots" while reflectors diffuse light. Mirrors (especially small shaving mirrors) are however widely used, almost in the same way as effects lights.

Northlight

see Soft Box

Perspex

Brand name for acrylic sheeting.

Plexiglas

Brand name for acrylic sheeting.

***Projection spot**

Flash or tungsten head with projection optics for casting a clear image of a gobo or cookie. Used to create textured lighting effects and shadows.

***Reflector**

Either a dish-shaped

surround to a light, or a bounce.

***Scrim**

Heat-resistant fabric

Electronic Flash: projection spotlight (Strobex)

Tungsten Projection spotlight (Photon Beard)

diffuser, used to soften lighting.

***Snoot**

Conical restrictor, fitting over a lighting head. The light can only escape from the small hole in the end, and is

therefore very directional.

***Soft box**

Large, diffuse light source made by shining a light

Tungsten spot with conical snoot (Photon Beard)

Electronic Flash: standard head with parallel snoot (Strobex)

through one or two layers of diffuser. Soft boxes come in all kinds of shapes

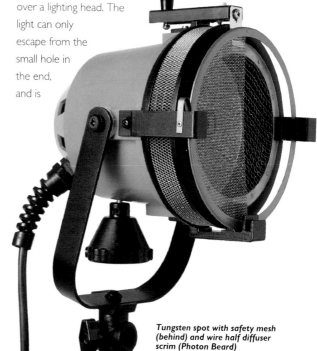

Tungsten spot with safety mesh (behind) and wire half diffuser scrim (Photon Beard)

Electronic flash: standard head with large reflector and diffuser (Strobex)

and sizes, from about 30x30cm to 120x180cm and larger. Some soft boxes are rigid; others are made of fabric stiffened with poles resembling fibreglass fishing rods. Also known as a northlight or a windowlight, though these can also be created by shining standard heads through large (120x180cm or larger) diffusers.

***Spill**

Light from any source which ends up other than on the subject at which it is pointed. Spill may be used to provide fill, or to light backgrounds, or it may be controlled with flags, barn doors, gobos etc.

***Spot**
Directional light source. Normally refers to a light using a focusing system

with reflectors or lenses or both, a "focusing spot", but also loosely used as a reflector head rendered more directional with a honeycomb.

***Strip or strip light**
Lighting head, usually flash, which is much longer than it is wide.

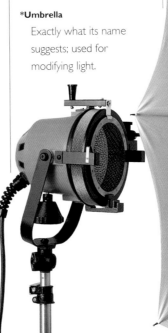

Electronic flash: strip light with removable barn doors (Strobex)

Strobe
Electronic flash. Strictly, a "strobe" is a stroboscope or rapidly repeating light source, though it is also the name of a leading manufacturer.

Tungsten spot with removable Fresnel lens. The knob at the bottom varies the width of the beam (Photon Beard)

Strobex, formerly Strobe Equipment.

Swimming pool
A very large Soft Box.

***Tungsten**
Incandescent lighting. Photographic tungsten

Electronic flash: standard head with standard reflector (Strobex)

lighting runs at 3200°K or 3400°K, as compared with domestic lamps which run at 2400°K to 2800°K or thereabouts.

***Umbrella**
Exactly what its name suggests; used for modifying light.

Umbrellas may be used as reflectors (light shining into the umbrella) or diffusers (light shining through the umbrella). The cheapest way of creating a large, soft light source.

Windowlight
Apart from the obvious meaning of light through a window, or of light shone through a diffuser to look as if it is coming through a window, this is another name for a soft box.

Tungsten spot with shoot-through umbrella (Photon Beard)

SECTION ONE:
STILL LIFE

▼

STILL LIFE IS ONE OF THE HARDEST OF PHOTOGRAPHIC GENRES TO DEFINE. PORTRAITS, NUDES, ARCHITECTURE, LINGERIE, FOOD, EVEN SPECIAL EFFECTS ALL RAISE CERTAIN EXPECTATIONS; BUT STILL LIFE IS ANOTHER MATTER. IT RANGES FROM ADVERTISING SHOTS TO THE MOST PERSONAL OF WORK; FROM PICTURES WHICH CAN TAKE DAYS TO ASSEMBLE IN THE STUDIO, TO THOSE WHICH ARE "FOUND" COMPOSITIONS AND ARE PHOTOGRAPHED BY AVAILABLE LIGHT IN A FEW MOMENTS; FROM SUBJECTS NO BIGGER THAN THE PALM OF YOUR HAND, TO THOSE WHICH FILL A ROOM.

When researching the photographs for this book we endeavoured to provide a mix of images which display as wide a range of lighting techniques as possible, while still remaining worthwhile and attractive pictures in their own right. Inevitably, you'll find some of the images more exciting than others – but if you take the time to look at some of the less immediately arresting pictures instead of flipping past them, you will find, first, that there is more to them aesthetically than meets the eye; and, second, that the lighting techniques are often very cleverly deployed. Conversely, other shots, which are real visual show-stoppers, may on some occasions turn out to be quite unexpectedly simple: proof, if any were needed, that it is the photographer's eye which is the truly creative force, and that technique is only a handmaiden.

In the words of the photographer Jeff Procopowicz, "a great picture which is technically great is a great picture, and a great picture which is technically flawed is still a great picture, too."

You will not find technical flaws in here – at least, you should not – but you will find pictures which deliberately use "flaws" or "limitations" in the photographic process to create memorable and highly attractive pictures. You will also find pictures which are as close to technical perfection as can be imagined – but this, of course, is taken for granted.

Another thing you will not find in this book is the kind of still life which was so popular in the late 18th century and most of the 19th: the grand set piece, typically centred on a dead pheasant and characterized by dramatic chiaroscuro lighting. Nor are there very many bowls of fruit or other food-based pictures.

This rather surprised us as we eagerly opened each new batch of submissions. We had expected to see such pictures, and indeed we would very much like to have seen more; but they simply did not come in. It seems that there has been a shift away from this sort of still life image, to – well, to what you can see for yourself in these pages.

WHY STILL LIFE?

We believe – though we can never be sure – that this book will offer equal (though different) attractions for both professionals and amateurs. Professionals may buy the book for ideas, and to see what their fellow professionals are doing. It is no exaggeration to say that everyone who reads this book will learn something from it – and, for a professional, a single new idea may be well worth the purchase price of the book. It is not that professionals are so short of new ideas that they need to buy books like this: it is that new ideas have to be sparked by something, and looking at other photographers' work is a good way to spark them into life.

If there are technical details as well, so much the better: often, it will be a matter of applying a technique from these pages to an idea which may well have been fermenting quietly in the back of the mind for a long time, so that seeing someone else's picture finally gives you the impetus to try to realize your own idea.

In many ways, though, the amateur has more to gain because he (or she) can learn more; and this is particularly true of still life. As a genre, it is far less popular than it used to be among amateurs, and yet it is no less rewarding than ever it was. Admittedly, many people in this busy modern world may feel that they do not have the time to work in the slow, reflective way which characterizes many still life photographers; but what they may not realize is that there can be an almost meditative aspect to still life photography which is very calming and relaxing; and, better still, if you get it right you have a permanent reminder in the form of a picture.

Meditative it may be, but this is not necessarily the same as easy or even relaxed. Getting the right props, in the right position, with the right lighting is time-consuming and can on occasion be frustrating; but equally, "giving it a good coat of think" brings the satisfaction of overcoming difficulties and proving (to yourself if to no-one else) that you can master your subject. Also, it does not all have to be done at once: you can leave a still life for hours, or even days, and come back to it when you have a better idea.

STUDIOS AND SETTINGS

A basic problem for the amateur – and indeed for the professional, if other work demands the same space – is the opportunity to leave a still life substantially set up, whether overnight or for longer. On the bright side, though, many still lifes require very little space for themselves: even a dining room table may be big enough. The lights and the camera can be removed and replaced, if need be, without disturbing the essential integrity of the composition, though a Polaroid reference shot of the set-up can be a useful *aide-mémoire* when it comes to re-creating the lighting and the camera angle. So, for that matter, can Polaroid taken before the composition, lighting, etc., are finalized.

It can also be a useful exercise to go looking for "found" still lifes; that is, for compositions which present themselves in everyday life. One photographer might find inspiration in the garden, with rusty watering-cans and weathered planters. Another might see pictures in the kitchen, whether in well-worn utensils or in the sleek lines of something new.

CAMERAS, LENSES AND FILM

Surprisingly many (12 per cent) of the still lifes in this book were shot with 35mm, and exactly the same percentage was shot with roll-film; but rather over half were shot on 4 x 5in, and almost 20 per cent were shot on 8 x 10in. Just one was shot in 13 x 18cm (5 x 7in).

This preponderance of cut film reflects a number of things. One is the ease of focusing and (still more) of composing on a big ground glass. Another is the usefulness of camera movements. Studio-based still life photographers are normally addicted to monorails, with all the movements they can get, including back rise and cross. As one said, "Large format cameras are for

lazy photographers – you can always get the effect you want, one way or another." Yet a third reason is the way in which large formats can both render texture and "see into the shadows". The former is fairly easy to understand – 8 × 10in, in particular, can capture texture in a way which all but defies belief – while the latter is easy to recognize but hard to explain.

The popularity of cut film also reflects the fact that, normally, still life photographers spend more time setting up their shots than they do in actually shooting. Often, as few as two sheets of film may be the fruit of several hours' or even days' setting up, though many still life photographers will shoot a few spares if they suspect that the picture may be useful for more than one application. A reportage photographer simply could not afford to shoot 4 × 5in with the profligacy which is required by modern newspapers, even if he could carry the weight.

Polaroids are however of fundamental importance to the vast majority of still life photographers. Today it is quite usual to work towards precisely the right set-up and lighting by using several generations of Polaroids, and once again, this explains why 4 × 5in is so popular: the Polaroids are big enough to see (even 6 × 7cm Polaroids are pretty marginal for detailed analysis), but they are also affordable. After all, an 8 × 10in Polaroid costs close to three times as much as a 4 × 5in Polaroid, and even if you use only half a dozen Polaroids this can add up to a fairly significant expense. Some major photographers freely admit that, if cost was no object, they would shoot almost exclusively on 8 × 10in, but budgetary constraints force them to use 4 × 5in.

This may also explain why relatively few amateurs shoot still lifes: 4 × 5in is still not widely regarded as an amateur format, though it seems to be gaining ground surprisingly rapidly. This may be a reaction to automation and electronics: an old-fashioned large-format camera is by no means idiot-proof, but if you are not an idiot it gives you unparalleled opportunities for quality and control.

As for film, in this book it is very much a question of "the usual suspects": Kodak Ektachrome (mostly ISO 64 and ISO 100), Fuji RDP and RDP II ISO 100 and Fuji Velvia. There are also a couple of Kodachromes, some Polaroid originals, one or two colour negatives and even a Scotch 1000. Because close control of colour is normally possible in the studio, using CC filters if necessary, and because grain and sharpness are not really an issue at 4 × 5in and above, choice of film is commonly determined by habit; by how much saturation and contrast are needed; and by availability.

Interestingly, very few monochrome pictures were submitted for inclusion in this book. The monochrome still life appears to be an endangered species.

LIGHTING EQUIPMENT FOR STILL LIFE

The lighting set-ups in this book range from daylight to elaborate multi-head set-ups using considerable amounts of power. There is little point in attempting

to make generalizations as different photographers' approaches are so widely varied, but it is worth noting that over half the pictures in this book used only one or two lights, while only about 15 per cent used four or more lights. With two heads, preferably with two soft boxes in case of need, it seems that you can do a remarkable amount.

What is more, there is not even a pressing need for a great deal of power in many cases, as you can often use multiple "hits" of flash: several pictures in this book were taken this way, although most of them reflect the fact that very small apertures were in use with 8 x 10in cameras. If a particular set up gives you only f/11, though, and you want to shoot at f/22, then four "hits" will give you the aperture you need; eight "hits" will give you f/32.

If you want to adopt this approach, you may care to investigate "press" or "everset" shutters, which do not need to be re-cocked: we had one of our lenses re-mounted in a self-cocking shutter for precisely this purpose.

THE TEAM

It is quite possible to work on your own, but it is often vastly easier to work with an assistant who can move things while you look at the image on the ground-glass. Amateurs can press wives, children or friends into service without necessarily demanding too much of their time: the assistant spends most of his or her time doing nothing, but when they are needed they are indispensable.

Some still life photographers work with stylists, and others are heavily reliant on model-makers and set-builders, but it is worth remembering that in both cases the photographer has to work out what he wants and (in broad terms) how it must be done: the job of stylists, model-makers and set-builders is to execute his vision to the highest possible standard.

SHOOTING STILL LIFES

We have already covered most of this in what we have written above. Commercial still lifes can be subject to the same pressures as any other form of commercial photography, but (as ever) a good percentage of the pictures in this book were created by professional photographers just for the fun of it – for their portfolios, for self-promotion, and to explore new ideas and new photographic techniques.

Including those pictures which were originally shot for these reasons and which were subsequently used commercially, about half the pictures in the book were not specifically commissioned; and even where they were specifically commissioned, there must be another five or ten at least where the photographer was not working to a "scamp" or a rigid brief but was given a free hand to develop his or her personal vision.

In other words, shooting still lifes is technically demanding, but it is also fun; which is one of the things, surely, which keeps us all interested in photography.

1

inspired by
objects

Most photographers must recognize this scenario. You see something which makes you say, "That would make a great photograph" or "I'd love to photograph that." You then try to take the picture – and fail.

Needless to say, the photographers featured here have not failed; or (if like all of us, they have at some time failed) at least they did not submit their failures.

It is hard to say what makes any picture a success, but a good starting point is attention to detail. Certainly, many good concepts are spoiled by lack of attention to detail, as anyone who has ever judged a photographic competition can confirm. In these pictures, however, both the props and the lighting are carefully chosen to complement one another, and this is as true of the commercial shots as the portfolio and promotional shots: indeed, some of the commercial shots can stand as fine art, and others have considerable impact, even if you would not necessarily want to hang them on the wall.

As usual, the majority of the pictures (six out of eight) were shot on 4 x 5in, with one each on 6 x 6cm and 8 x 10in. Two useful exercises are, first, to look at the pictures and ask yourself how you would have tried to convey the same ideas; and, second, to try to duplicate (or at least emulate) any which you particularly admire: as Robert Louis Stevenson said of writing, learning to imitate the people whose work you admire is an essential part of developing your own style, and this is as true of pictures as of words.

GAS GRIP AND WRENCH

▼

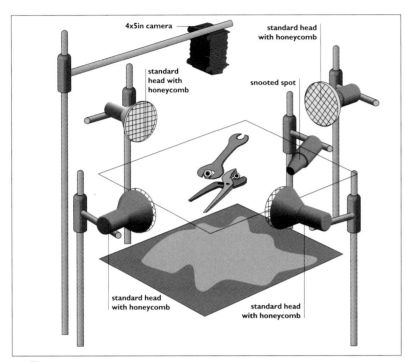

```
4x5in camera
                                        standard head
                                        with honeycomb
standard
head with
honeycomb
                     snooted spot

standard head                standard head
with honeycomb               with honeycomb
```

Photographer: **Ben Lagunas & Alex Kuri**

Client: **Meyer & Meyer**

Use: **Poster and magazine campaign**

Assistants: **Isak de Ita and George Jacob**

Art director: **Hans-Paulfreish**

Stylist: **Michel**

Production: **BLAK Productions**

Camera: **4x5in**

Lens: **210mm**

Film: **Kodak Ektachrome EPP ISO 100**

Exposure: **f/16**

Lighting: **Electronic flash: 5 heads**

Props and set: **Glass sheet, black velvet**

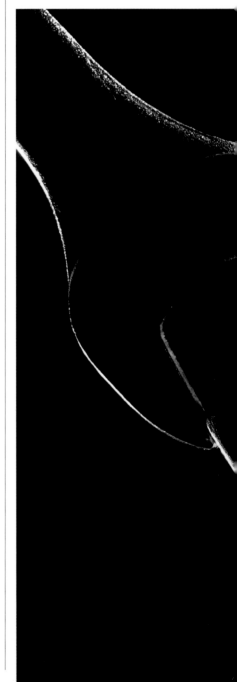

THIS IS ONE OF THOSE SHOTS WHICH LOOKS COMPARATIVELY EASY – UNTIL YOU HAVE TO SHOOT IT. YOU COULD WORK ON IT FOR AGES, EVEN IF YOU HAD A CLEAR IDEA OF HOW TO DO IT.

Four directional honeycombed heads provide bright rim-lighting, with highlights and shadows (or, more accurately, bright areas and less bright areas). If the tools were absolutely uniformly lit they would lack three-dimensionality and the superb texture would be lost. A large sheet of flawless and sparkling-clean plate glass supports the tools: setting them down without marking the glass is difficult in its own right. The four rim lights are positioned to give the most attractive effect. Finally, on the black background 1m (40 inches) behind the glass (and therefore well out of focus) a snooted spot adds a subtle purple-blue in the jaws of the gas grips.

Photographer's comment:

The art director wanted only the silhouette and we had to light very carefully to achieve this goal.

- ► *Rim-lighting on a glass sheet can be remarkably effective*

- ► *The glass must be flawless and sparkling clean*

- ► *Projecting a colour onto a black background may be subtle, but it can be made to read*

Plan View

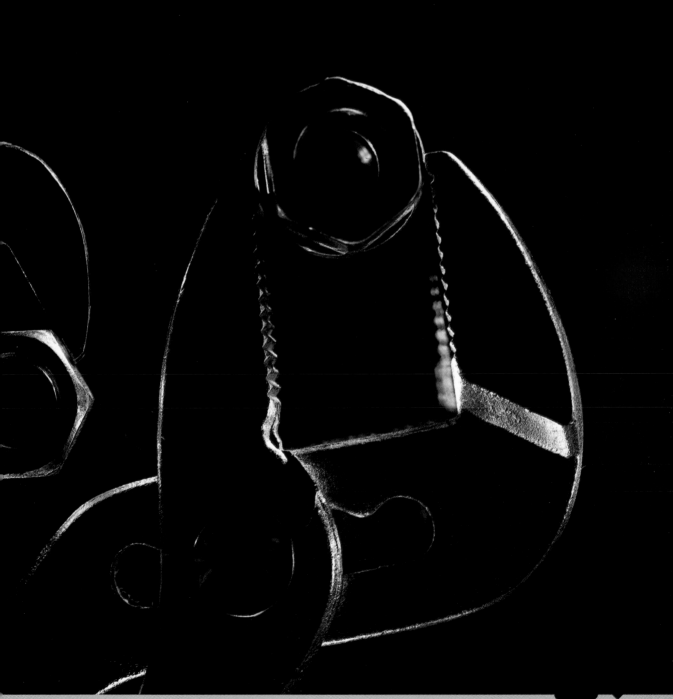

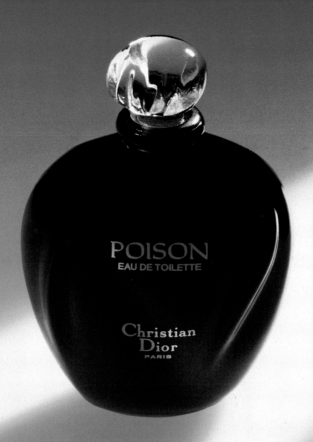

Photographer: **Massimo Robecchi**

Client: **Mondadori Editore**

Use: **Editorial**

Assistant: **Teresa La Grotteria**

Camera: **4x5in**

Lens: **240mm**

Film: **Kodak Ektachrome 6105**

Exposure: **f/16**

Lighting: **Electronic flash: 2 heads**

Props and set: **White plexiglass, Lee blue filter**

Plan View

P O I S O N

▼

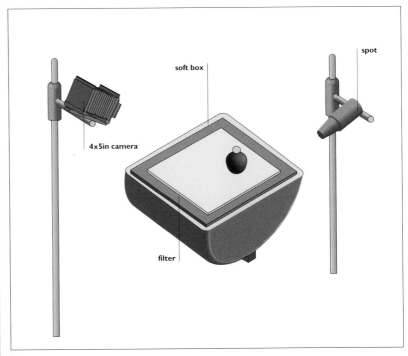

spot

soft box

4x5in camera

filter

AT FIRST SIGHT THIS IS A SIMPLE BACK LIT SHOT OF A BOTTLE OF PERFUME ON A PIECE OF BLUE PAPER. THEN YOU START WONDERING HOW MASSIMO ROBECCHI ACHIEVED THAT LUMINOUS QUALITY. THE ANSWER IS QUITE SIMPLE – BUT ALSO QUITE UNEXPECTED.

The bottle is standing on a sheet of white opaline acrylic, which in turn is on top of a blue Lee filter, which in turn is on top of a 60 × 100cm (24 × 40in) soft box with 3200 Joules going through it. The other light is a Superspot, also 3200 Joules, coming from camera right, as clearly seen in the picture. That is all. The highlights in the bottle are all the result of transillumination by the spot. To obtain this subtlety of gradation in any other way would be extremely difficult.

► There are many grades of white acrylic sheeting, from "translucent" to "opaline" to "opaque". The only way to find which is best is to try them

► Transilluminated backgrounds are normally used for shadowless lighting, but that is not the only application

► Reduce reflections (if necessary) with a layer of Kodatrace or similar frosted sheeting over polished acrylic

Photographer's comment:

There are no frontal lights: the white lights on the bottle are from the back light.

Photographer: **Ron McMillan**

Use: **Portfolio**

Assistant: **Paul Cromey**

Camera: **4x5in**

Lens: **210mm (+ orange filter + Softar + 81B)**

Film: **Fuji Provia 100/Mono not recorded**

Exposure: **f/32⅓**

Lighting: **Electronic flash: 2 heads**

Props and set: **Props arranged on old door**

Plan View

ATTIC

▼

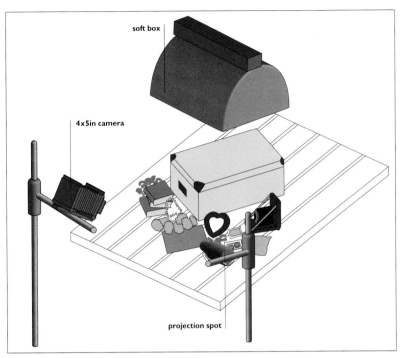

WHEN YOU SET UP AN ELABORATE PORTFOLIO SHOT IT OFTEN SEEMS TO MAKE SENSE TO SHOOT IT IN BOTH MONOCHROME AND COLOUR; BUT ONLY RARELY DOES IT "WORK" EQUALLY WELL IN MORE THAN ONE MEDIUM.

Each shot has a slightly different camera angle and crop. The lighting in both cases however is identical – again, this is unusual because you often need different lighting ratios in colour and monochrome – and consists of a soft box overhead and a projection spot some distance from the subject and to camera right. This throws the image of the "window" onto the postcard as well as illuminating the camera.

For the colour shot the filtration is chosen to re-create the warm, hazy, dusty sunlight which filters through an attic window; in the monochrome shot, only the soft-focus screen has any real effect. The hand-coloured image is almost more realistic than the full-colour shot: it represents things less as they are, and more as we remember them.

► *Lighting for monochrome can often be more contrasty than for colour because of the greater tonal range which can be acceptably represented on a black and white print*

► *Hand colouring often presents an opportunity for more "naturalistic" colouring than colour film: look at the flowers*

inspired by objects **23**

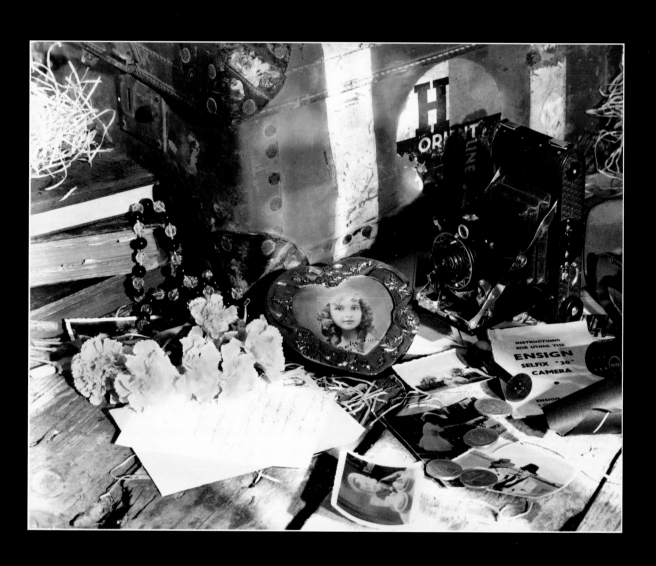

F L O W E R

▼

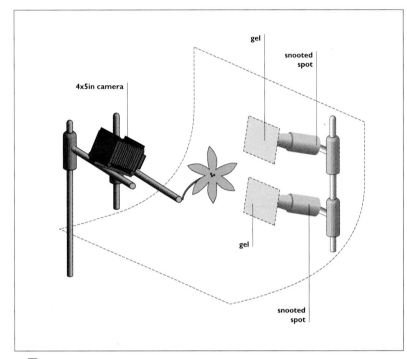

Photographer: **Terry Ryan**

Client: **Camel Advertising**

Use: **Corporate brochure**

Assistant: **Nicholas Hawke**

Art director: **Shaun Friend**

Camera: **4x5in**

Lens: **210mm**

Film: **Kodak Ektachrome EPP ISO 100/21**

Exposure: **Double exposure**

Lighting: **Electronic flash: 3 heads**

Props and set: **Transmitting light table, black velvet**

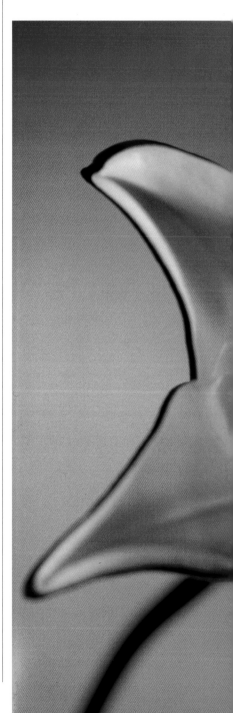

THERE ARE TWO EXPOSURES HERE. FOR THE FIRST THE FLOWER WAS EXPOSED AGAINST A BLACK VELVET BACKGROUND; FOR THE SECOND THE VELVET WAS REMOVED AND THE FLOWER WAS PHOTOGRAPHED UNLIT AGAINST A TRANSILLUMINATED BACKGROUND.

Between the two exposures the lens was refocused a little, which changed the size of the flower in the image and created the black surround – which looks like a shadow but isn't.

The light on the flower is a snooted spot to camera left and above the camera, giving strongly directional lighting and good texture. The background is transilluminated with two spots, each with coloured gels, one cerise, one red.

As with so many shots in the *Pro Lighting* series, this is surprisingly simple and obvious once you know how it was done. You may even be able to work out how it was done just by looking at the picture. But the trick lies in thinking of the idea in the first place.

Photographer's comment:

The art director needed something a little different and a more graphic image using shapes and colours yet still leaving the subject matter recognizable.

► Refocusing the camera between double exposures changes the image size

► Black velvet records about five stops darker than a mid-tone and will normally read as a pure black on colour film

Plan View

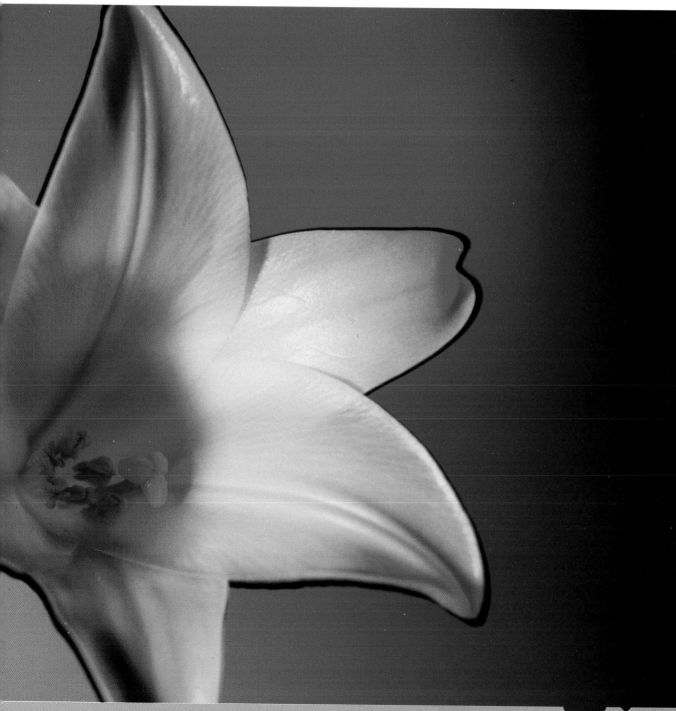

POISON

▼

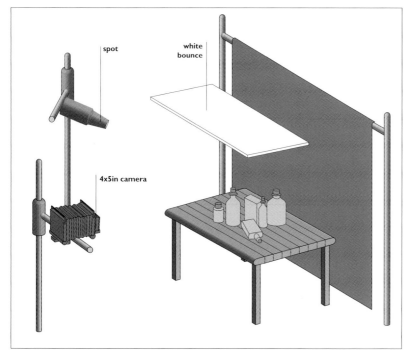

Photographer: **Ron McMillan**

Client: **Rentokil**

Use: **Advertising**

Camera: **4x5in**

Lens: **210mm**

Film: **Fuji Provia 100**

Exposure: **f/32**

Lighting: **Electronic flash: 1 head**

Props and set: **Old wooden door; bottles**

spot

white bounce

4x5in camera

THE IMAGE IS FAMILIAR: A DUSTY SHELF, DEEP IN A SHED, ILLUMINATED BY A RAY OF SUN. THE ONLY CATCH IS THAT, TO EVOKE SOMETHING SIMPLE, YOU HAVE TO DO IT PROPERLY.

A good part of the success of the shot is down to prop hunting: the dirty bottles, the labels, the broken-off corks. The POISON labels, and the internationally-understood skull-and-crossbones, are all the more effective for being clearly stated on the two left bottles. The others could contain anything . . .

The lighting, although simple, matches the mood. There is a single spot light from camera left, the precise position of which is revealed by the highlight on the leftmost bottle, and there is a white bounce overhead. After that it is a matter of adjusting both the angle and the height of the light, and of moving the bottles so that they catch the light best.

► Lighting bottles is always to some extent unpredictable: until you try it, you do not know how much light they will transmit, and how much they will reflect

► A black velvet background creates the illusion of dark recesses behind the bottles

Plan View

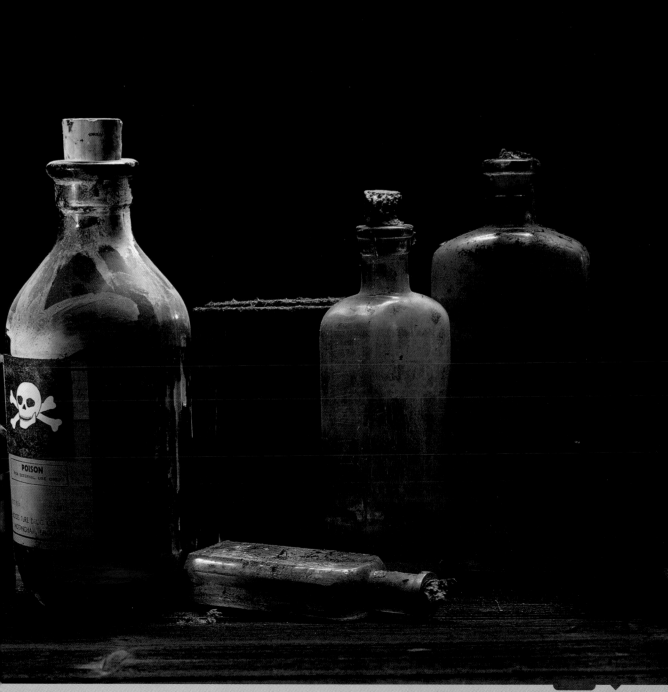

Photographer: **Maurizio Polverelli**

Use: **Portfolio**

Camera: **8x10in**

Lens: **300mm (+ Vaseline filter for second exposure)**

Film: **Kodak Ektachrome 6117, ISO 64/19**

Exposure: **Not recorded; double exposure**

Lighting: **Electronic flash: 2 heads**

Plan View

► *Making two exposures, one after the other, allows filtration or diffusion to be introduced for part of the overall exposure*

► *The technique of using a large soft box and a black bounce gives a unique quality of light*

THE ELEGANCE OF MUSIC

▼

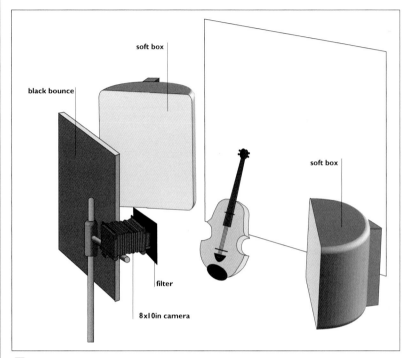

THE TWO LIGHTS SHOWN IN THE DIAGRAM WERE USED SEQUENTIALLY: THE FIRST (THE LARGE SOFT BOX TO CAMERA LEFT) WITHOUT ANY FILTRATION, AND THE SECOND (THE SMALLER SOFT BOX TO CAMERA RIGHT) WITH A VASELINE-SMEARED FILTER OVER THE LENS.

Both lights are carefully set to give the maximum impression of roundness. The left-hand set up uses the combination of an oblique soft light and a black bounce: the effect is similar to that of a strip, but subtly different in quality. Note particularly the emphasis on the moulding around the edge. The right-hand exposure better emphasizes the "belly" of the violin and the depth of the side: camera movements were used to control depth of field.

With either single or double exposures, soft focus effects are easier to achieve on large and very large formats: the greater the degree of enlargement, the harder it is to predict how the soft focus effect will be emphasized.

Photographer's comment:

Only light can exalt the elegance of a violin. On the right side I wanted a mystical atmosphere, which I achieved with a soft-focus exposure and some fuzziness. The large format helps to capture the warm feeling of the wood.

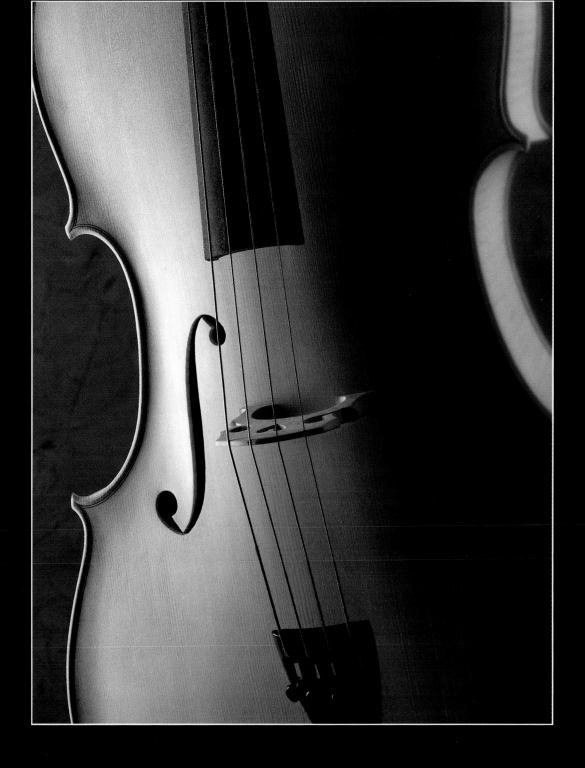

Photographer: **James DiVitale**

Use: **Shot for self-promotion; put into stock; used by printing company**

Designer: **Sandy DiVitale**

Camera: **4x5in**

Lens: **210mm**

Film: **Kodak Ektachrome EPP ISO 100**

Exposure: **f/32**

Lighting: **Electronic flash: 2 heads**

Plan View

▼

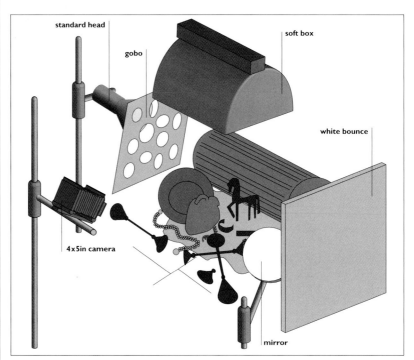

THE AIM OF THIS PICTURE WAS TO RECREATE THE IMPRESSION OF AN ARCHAEOLOGICAL DIG, WITH LIGHT COMING THROUGH THE ENTRANCE TO A CAVE OR TOMB. A SIMPLE ENOUGH CONCEPT – UNTIL YOU TRY TO REALIZE IT.

Jim DiVitale began with a standard head to camera left: the shadows make its position clear. Between the light and the subject, however, he interposed a sheet of black card with holes cut in it: in effect, a giant gobo or cookie. This was the key light. Above the set a soft box provided some fill but was set well down from the key in order to preserve the shadows. A sheet of foam core to camera right acted as a general bounce, but a mirror on a boom arm was necessary to throw some more light back onto the underside of the pot. Small mirrors, bounces and reflectors are more widely used in still life photography than many people realize.

► *Shaving mirrors and make-up mirrors can function as small, precise effects lights*

► *Small bounces and flags – the size of a cigarette packet or smaller – can add highlights and shadows*

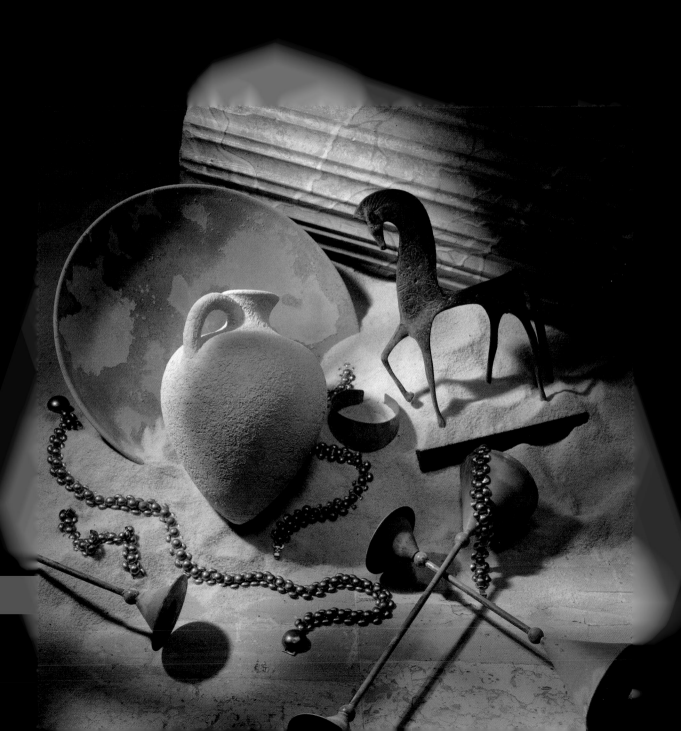

2 deceptive
simplicity

The dictum "less is more" has been attributed to many people (Le Corbusier is a strong contender). It is a phrase which irritates some people beyond measure, while others have an immediate and instinctive understanding of it: a few elements, handled with assurance, will almost always have more immediate impact and elegance than something more complex, no matter how competently those multiple elements are handled. Consider Picasso's head of a bull, made from a bicycle saddle and handlebars, and his *Guernica*: both great works, but the bull is far more immediately accessible in terms of line and form, and it carries no historical baggage in terms of the Spanish Civil War, bombing raids, or the like.

The pictures in this chapter are clear examples of "less is more," of simple picture elements masterfully handed. Often they sound decidedly unpromising – and many of us, if we were handed the subject matter and asked to arrange it into an attractive picture, would immediately feel our hearts sink. And yet these photographs are curiously akin to those in the last chapter: suddenly, we see an apparently unpromising subject in (literally) a new light, and we make a determined effort to recapture that little flash of whatever-it-is which enables us to see the extraordinary in the ordinary.

Again, six of the nine pictures were shot on 4 x 5in, with one each on roll film, 13 x 18cm and 8 x 10in. In most cases, the lighting is as deceptively simple as the subject, but there are also times when a deceptively simple result has been achieved only at the expense of some effort in lighting.

Photographer: **Michèle Francken**

Use: **Portfolio**

Camera: **4x5in**

Lens: **210mm**

Film: **Polaroid Type 59**

Exposure: **f/16; time not recorded**

Lighting: **Tungsten spots (2)**

Props and set: **2 chairs, canvas background**

Plan View

C H A I R S

▼

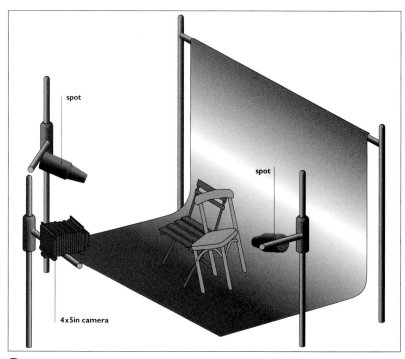

spot

spot

4x5in camera

POLAROID EMULSION TRANSFERS, IN WHICH THE IMAGE IS FLOATED OFF ITS ORIGINAL SUPPORT AND ONTO ANOTHER, ARE INHERENTLY FASCINATING; BUT WITHOUT GOOD PICTURES TO BEGIN WITH THEY ARE "EMPTY." THIS VERY SIMPLE STILL LIFE OWES A GREAT DEAL OF ITS CHARM TO THE LIGHTING.

The key light is the spot to camera right, which creates the strong pattern of shadows at the bottom of the picture as well as the superb modelling on the chairs. The second light, to camera left, is used to throw the structure of the folding chair into sharp relief. The whole composition is a good example of how something which sounds as if it could not work can, in fact, be extremely successful.

Because Type 59 is a daylight-balance film, it gives very yellow results when used with unfiltered tungsten lighting. Floating the image onto watercolour paper creates an impression of an ancient, yellowing poster from a time gone by – an impression which is reinforced by the old-fashioned design of the chairs – and the distortion of the emulsion makes the shape of the shadow much more interesting.

Photographer's comment:

Tungsten spot lights are used to create a deep, warm tone. I used Polaroid Type 59 to make a transfer onto aquarelle paper. With this technique you can distort the picture as much as you want, which gives a more artistic result.

► *Rather than using Polaroid originals, many photographers shoot originals on 4 x 5in or even 6 x 7cm transparency and duplicate these onto Polaroid for manipulation. Others feel that working with Polaroid originals gives more of an edge to their work.*

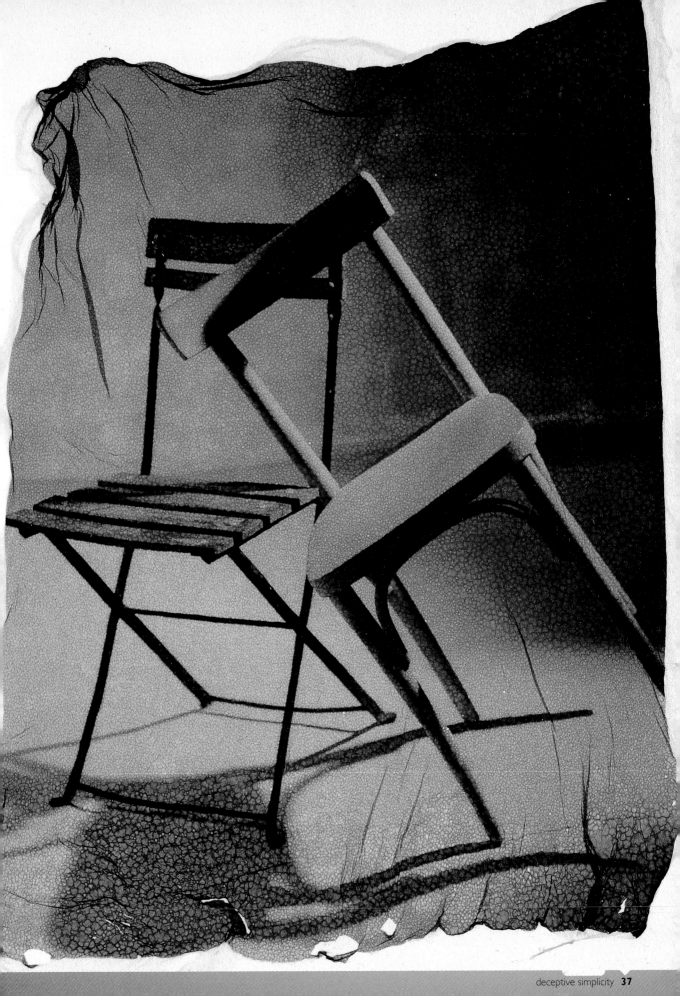

FÜLLER

▼

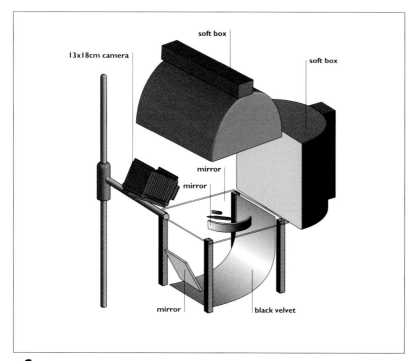

Photographer: **Rudi Mühlbauer**

Client: **Montblanc**

Use: **Catalogue**

Camera: **13x18cm**

Lens: **300mm**

Film: **Kodak Ektrachrome ISO 64/19**

Exposure: **f/22**

Lighting: **Electronic flash: two soft boxes**

Props and set: **Glass table, black velvet**

SHOOTING BLACK ON BLACK, WITH SPECULAR REFLECTIONS OF BOTH SILVER AND GOLD, IS A DEMANDING TEST OF THE PHOTOGRAPHER'S SKILL, THE SHARPNESS AND CONTRAST OF THE LENS, AND THE FILM.

The pen rests on a spotlessly clean glass table, lit from above with one 80 × 80cm (32 × 32in) soft box and from behind with another of the same size. A mirror under the table bounces light back up to fill the side of the pen nearest the camera, while a flexible plastic mirror to camera right creates modelling in the ends of the pen and cap. A third mirror, very small, is concealed behind the pen in order to brighten the clip on the cap. A black velvet curtain, draped under the table, takes care of the absolute blackness of the background.

In any picture like this, where the aim is to "see into the shadows", it is a good idea to use as large a format as possible. The larger ground-glass also makes it easier to see exactly where the highlights and shadows lie.

- Black on black and white on white are subjects which most photographers can profitably explore until they are proficient

- Pictures with bright metal and black on black are most easily tackled with lower-contrast film, and even then, exposure is very critical indeed

- Treat a picture as a boring catalogue shot, and it will be a boring catalogue shot. Treat it as a still life, and it will be one

Plan View

Photographer: **Marc Joye**

Client: **Broncolor**

Use: **Magazine**

Camera: **4x5in**

Lens: **90mm**

Film: **Kodak Ektachrome 64**

Exposure: **f/45**

Lighting: **Electronic flash: I head**

Props and set: **Paper models made by the photographer; painted background; "perspective" ground**

Plan View

▶ *Photographic quality can be independent of other aesthetic considerations, either complementing them or detracting from them*

▶ *The technique of double exposure to create "ghosting" is insufficiently explored by many photographers: it is (or can be) much more than merely a trick*

ILLUSTRATION

▼

T̲HIS SURREAL "LANDSCAPE" DEMONSTRATES THAT THERE ARE AESTHETIC CONSIDERATIONS WHICH ARE NOT FULLY EXPLICABLE INTELLECTUALLY: THERE IS A DALI-ESQUE QUALITY TO THIS PICTURE, YET IT IS MORE FORMAL THAN MOST OF DALI'S WORK AND VERY PHOTOGRAPHIC IN ITS NATURE.

The paper sculptures rest either directly on the base or are raised very slightly above it on supports. The only light is an 80 × 80cm (32 × 32in) soft box to camera left, but the secret of the picture lies in the exposure being split in two. For the first exposure (one flash) everything was in place except the small windowed piece of paper to the left. For the second flash this piece of paper was added. The 90mm lens explains the perspective, and the only other factor to note is the very careful exposure control needed to retain tone and differentiation in the dark face of the cube. Any less exposure and it would have merged with the shadow. Any more exposure would have meant that the bright face was overlit and might have flared.

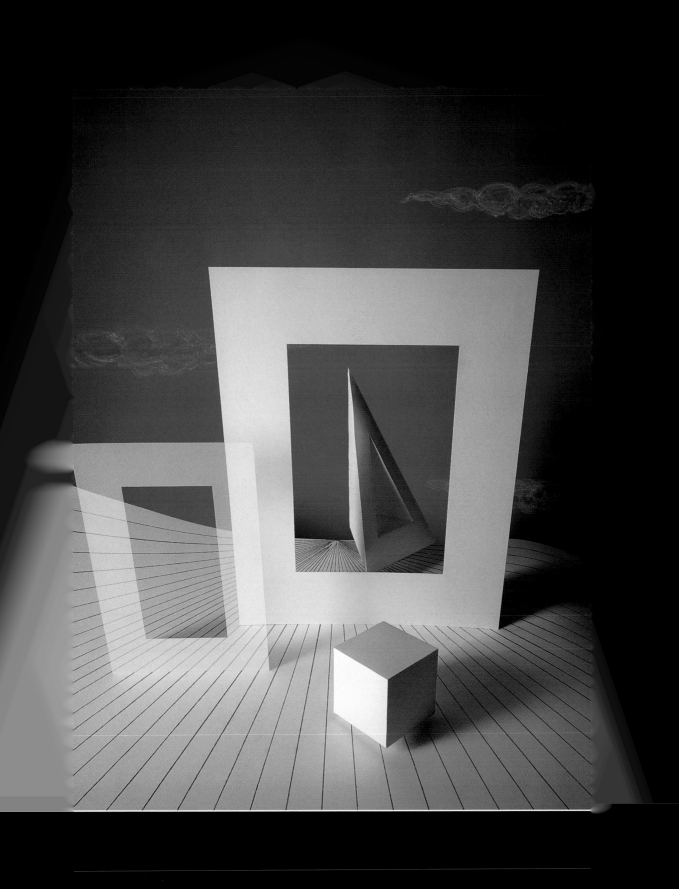

deceptive sim

CHANDELIER

▼

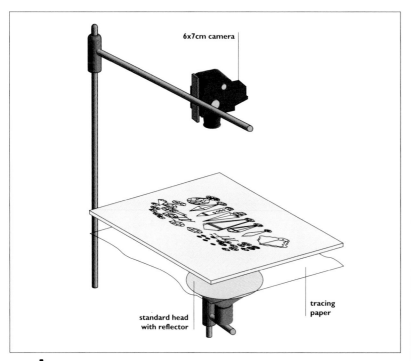

6x7cm camera

standard head
with reflector

tracing
paper

Photographer: **Mark Williams**

Client: *World of Interiors* magazine

Use: **Editorial**

Art director: **Barbora Hajek**

Camera: **6x7cm**

Lens: **180mm**

Film: **Fuji RDP ISO 100**

Exposure: **f/22**

Lighting: **Electronic flash: 1 head**

Props and set: **Chandelier parts; etched glass**

Aₛ Mark himself modestly says, "It wasn't particularly difficult to light, but I think we got a striking shot with a very simple set-up – it's a matter of layout and detail."

There is only one light shining through the subject. The chandelier components are resting on the shiny side of a piece of matte-etched glass, which acts as a diffuser in its own right, and there is a piece of tracing paper as further diffuser between this and the light – an Elinchrom 202 with an S2 head in a 45cm (18in) reflector. The camera is, of course, directly overhead. Both etched and polished glass can be very unforgiving media to work with, showing fingerprints mercilessly. Worse, although fingerprints are easy to clean off polished glass, they can be very hard to remove from etched or ground glass without smearing.

Photographer's comment:

World of Interiors *aims to show you how to achieve the effects you want, and what you need to help you achieve them.*

► *Capturing the brilliance of cut glass is often best achieved by emphasizing the precision and clarity of the facetting*

► *Grading the image from the centre (instead of using a uniform light box) adds interest and allows dramatic contrasts of light and dark within the cut glass*

Plan View

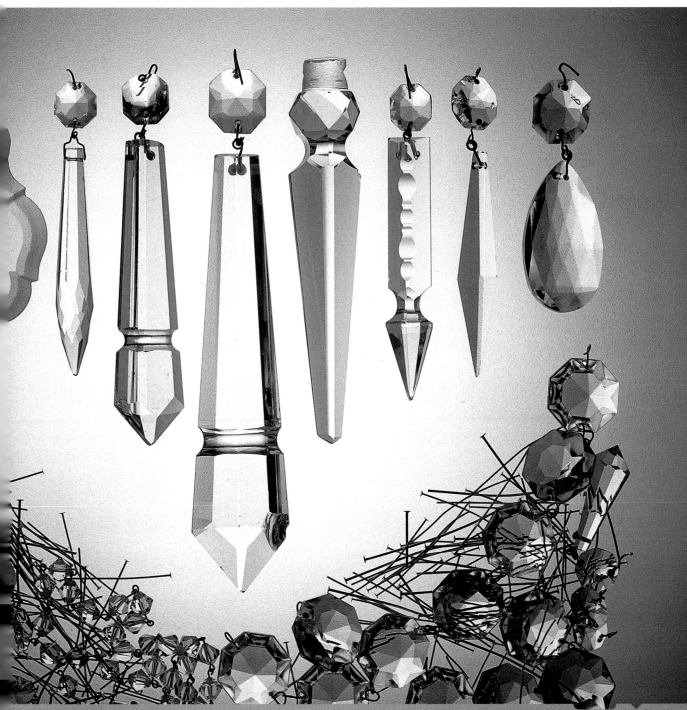

Photographer: **James DiVitale**

Use: **Self-promotion (Black Book)**

Designer: **Sandy DiVitale**

Camera: **4x5in**

Lens: **210mm (plus diffuser for first exposure)**

Film: **Kodak Ektachrome EPP ISO 100**

Exposure: **Double exposure: see text**

Lighting: **Electronic flash + light brush**

Props and set: **Backdrop by Rear Window Productions**

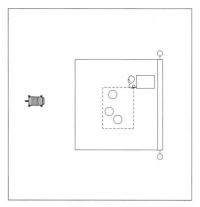

Plan View

► *Most people think of light brushes for adding highlights – but they can also transilluminate*

► *Complete darkness is not necessary for light brushing, but low light levels are*

► *Gary Regester's "Tallat" shutter can be used to insert or remove filters and soft-focus screens during an exposure*

S P R A Y

▼

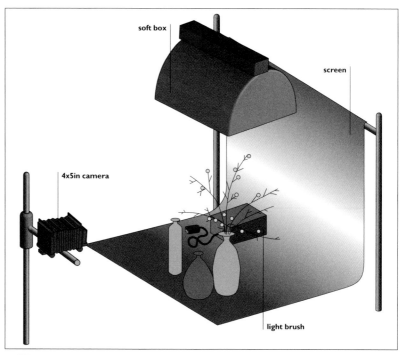

THIS HANGS IN THE STUDIO OF DIVITALE PHOTOGRAPHY, INC., AND IS THE FIRST THING PEOPLE SEE WHEN THEY COME IN. THEIR ALMOST INVARIABLE REACTION IS, "THAT LOOKS JUST LIKE A PAINTING."

There were two exposures, one using a soft box directly over the subject and the second using a Hosemaster light brush. The first was set slightly dark – f/32 – as exposure would inevitably build with the light brush. For this exposure, there was a heavy (#3) soft-focus screen over the lens.

The second light brush exposure took a total of three or four minutes and included painting highlights onto the subject as well as transilluminating the bottles. The soft-focus screen was removed for this exposure.

The bottles were of thick glass and required about 20 seconds for the orange one and about a minute for the blue one: they would have been very hard to transilluminate in any other way.

Photographer's comment:

This picture has done very well for us in promoting sales. It uses our "diffuse background – sharp highlights" technique.

Photographer: **James DiVitale**

Use: **Shot for self-promotion; put into stock; used by printing company**

Designer: **Sandy DiVitale**

Camera: **4x5in**

Lens: **210mm (plus diffuser for first exposure)**

Film: **Kodak Ektachrome EPP ISO 100**

Exposure: **Light-brush (see text)**

Lighting: **Electronic flash plus light brush**

Props and set: **Shell from Florida; earth from New Mexico**

Plan View

► *Light brushes are normally used in conjunction with other light sources*

► *Light brushes vary in power, and with some, working at very small apertures may involve inconveniently long exposures*

► *Streaks of light can be added with a light brush where there are no highlights, just to add interest*

CHAMBERED BEAUTY

▼

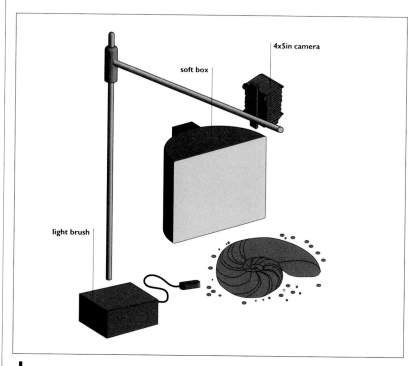

Lᴉᴋᴇ "Sᴘʀᴀʏ" ᴏᴘᴘᴏsɪᴛᴇ, ᴛʜɪs ᴘɪᴄᴛᴜʀᴇ ᴜsᴇᴅ ᴇʟᴇᴄᴛʀᴏɴɪᴄ ꜰʟᴀsʜ ꜰᴏʀ ᴀ ᴅᴀʀᴋ, ʙᴀsᴇ ᴇxᴘᴏsᴜʀᴇ, ᴀɴᴅ ᴀ ʟɪɢʜᴛ-ʙʀᴜsʜ ᴛᴏ "ᴄᴏʟᴏᴜʀ ɪɴ" ᴛʜᴇ sʜᴇʟʟ ᴀɴᴅ ᴀᴅᴅ ᴛʜᴇ sᴛʀᴇᴀᴋs ᴏɴ ᴛʜᴇ ᴇᴀʀᴛʜ. Tʜᴇ ᴛᴡᴏ ᴘɪᴄᴛᴜʀᴇs ᴀʀᴇ ʜᴏᴡᴇᴠᴇʀ ᴠᴇʀʏ ᴅɪꜰꜰᴇʀᴇɴᴛ.

The base exposure, with a strong diffuser over the lens, was made with a soft box side-lighting the shell; this was at f/32, two stops down from the exposure needed to get a good image. The Hosemaster light brush was then used for a series of exposures from 5 to 15 seconds to light the shell, to transilluminate it, and to add the streaks of light on the background. The result is that the shell seems to glow with an unearthly beauty against a deeply coloured background. Only very rarely is a light brush used on its own to light a whole picture: normally, it is used in conjunction with flash or (more rarely) with continuous lighting to give a base exposure.

Photographer's comment:

We found this dirt in New Mexico and I brought back several bags of it. My luggage was so heavy it had to be hand-carried: the conveyor could not handle it. We were surprised that no-one asked us what was in it.

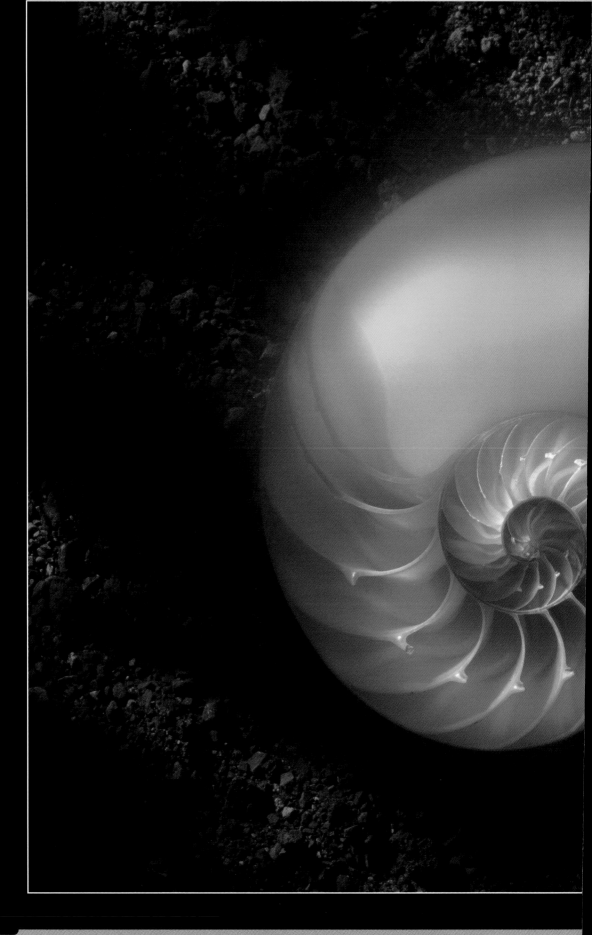

Photographer: **James DiVitale**

Client: **S. P. Richards company**

Use: **Corporate brochure**

Designer: **Sandy DiVitale**

Camera: **4x5in**

Lens: **210mm**

Film: **Kodak Ektachrome EPP ISO 100**

Exposure: **First: f/5.6; second: f/32½**

Lighting: **Electronic flash: 2 heads**

Props and set: **Fluorescent tubes, desk lamp**

Plan View

▼

soft box

standard head

4x5in camera

THIS USES THE "SPLIT-DIFFUSION" DOUBLE-EXPOSURE TECHNIQUE WHICH JIM DIVITALE HAS EXPLORED EXTENSIVELY. THE BACKGROUND AND FOREGROUND ARE LIT SEQUENTIALLY, THE FORMER WITH A DIFFUSER IN FRONT OF THE LENS, THE LATTER WITHOUT.

The background is 120–150cm (4–5ft) behind the principal subject and is lit with a standard head, high and to camera right; this casts a streak of light across the background. The first exposure, with this light only, was made with a heavy diffuser on the lens ("I probably cut up a plastic bag to make it") and with the lens at full aperture: the power to the light was turned right down. The main subject – three circular fluorescent tubes, and two angle-lamp brackets – is lit by a 30 × 60cm (12 × 24in) soft box to camera left and at about 45° to the line of sight: look at the highlights on the tubes. This shot was made without diffusion, and with considerably more power to the flash head.

► *"Press" or "everset" shutters, which do not need to be re-cocked between exposures, are useful for this sort of shot*

► *Even a seemingly unpromising subject can be turned into a good picture with skilled composition and lighting*

B O T T L E S O F W I N E

▼

Photographer: **Guido Paternò Castello**

Use: **Self-promotion**

Camera: **4x5in**

Lens: **210mm**

Film: **Kodak Ektachrome EPR ISO 64**

Exposure: **f/22**

Lighting: **Electronic flash: 1 soft box**

Props and set: **Black background**

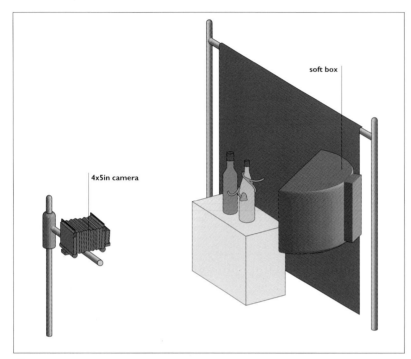

soft box

4x5in camera

A SOFT BOX ON ITS OWN CAN BE VERY BORING; BUT COMBINE IT WITH A COUPLE OF BOTTLES WHICH REFRACT, REFLECT AND COLOUR THE LIGHT, AND YOU HAVE THE POTENTIAL FOR A MUCH MORE INTERESTING SHOT.

Compositionally the picture is remarkably subtle: the use of "negative space," the contrast of the regular man-made form of the bottles with the organic vine (and the implication of the man made/organic wine within), the drop of water on one vine tendril . . . The more you look at it, the more elegant this picture becomes. The light, however, is nothing more than a large soft box to camera right, which both side lights and back lights the wine. Although this looks very simple, there is often a need for considerable jockeying of the light's position in order to get the right width in the streaks of colour showing through the bottles. A plain black backdrop, well behind the bottles, allows them to stand out against absolute blackness.

► *Often, the simpler a picture is, the more effort you have to make in order to get it exactly right*

► *If the bottles had labels on them, this would be a boring advertising shot; but this is a picture of Wine, not of any individual wine*

Plan View

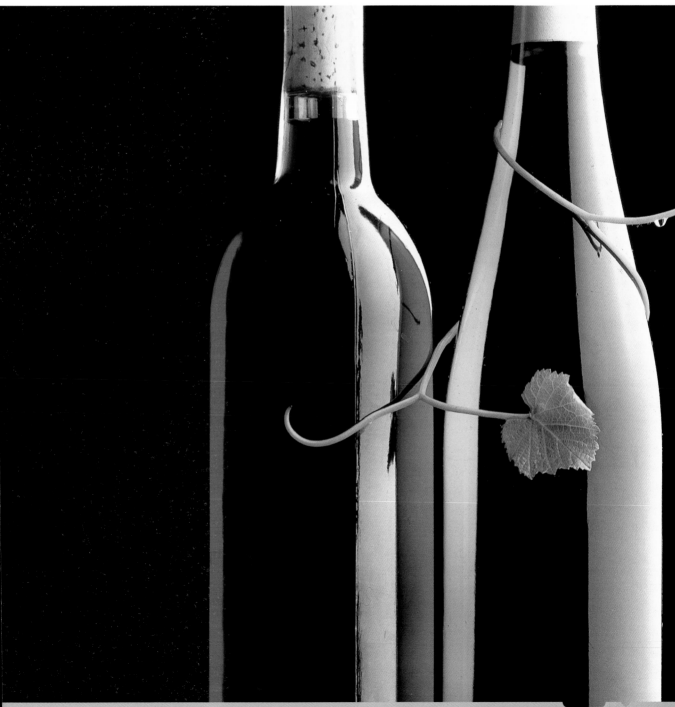

KEY MOUSE

▼

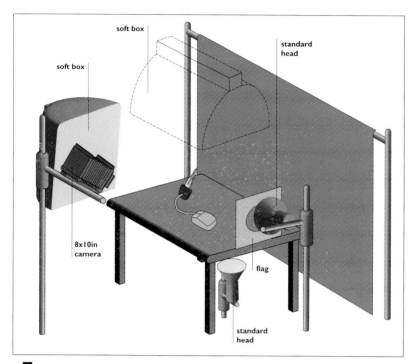

Photographer: **Jay Myrdal**

Client: **SPC Software**

Agency: **Kline Grey**

Use: **Press and trade advertising**

Art director: **Vic Hazeldine**

Camera: **8x10in**

Lens: **300mm**

Film: **Fuji Velvia rated EI 32**

Exposure: **f/64; double exposure, three "hits" each**

Lighting: **Electronic flash: 3 heads**

Props and set: **Oversize key made by Parallax**

THE "DECEPTIVE SIMPLICITY" IN THIS SHOT IS THAT THE LIGHTING WAS FAR MORE DIFFICULT THAN IT SHOULD HAVE BEEN. THE ANSWER WAS TO MAKE ONE EXPOSURE FOR THE RING AND ANOTHER FOR THE KEY AND MOUSE.

The first exposure was made with the overhead soft box alone, very close to the subject. Everything except the ring was masked off. A circle of velvet sat inside the ring; more velvet was used to mask the rest of the background, the key and the mouse; and the edges of the picture were flagged off at the camera rather than at the subject.

For the second exposure the soft box was raised up out of the way and the masks were removed. A small soft box to camera left lit the key; a standard head, heavily flagged, was set very low to provide a glancing light and a long shadow on the mouse; and a standard head below the set transilluminated the background.

Photographer's comment:

I shot this on both Kodak Ektachrome 64 and Fuji Velvia — I like Velvia for the greens.

- ► *Precision masking with velvet may be tiresome, but it can be very useful*

- ► *Where precision is not needed, flagging at the camera lens is quicker and easier*

- ► *Seemingly simple shots can be surprisingly demanding when it comes to lighting*

Plan View

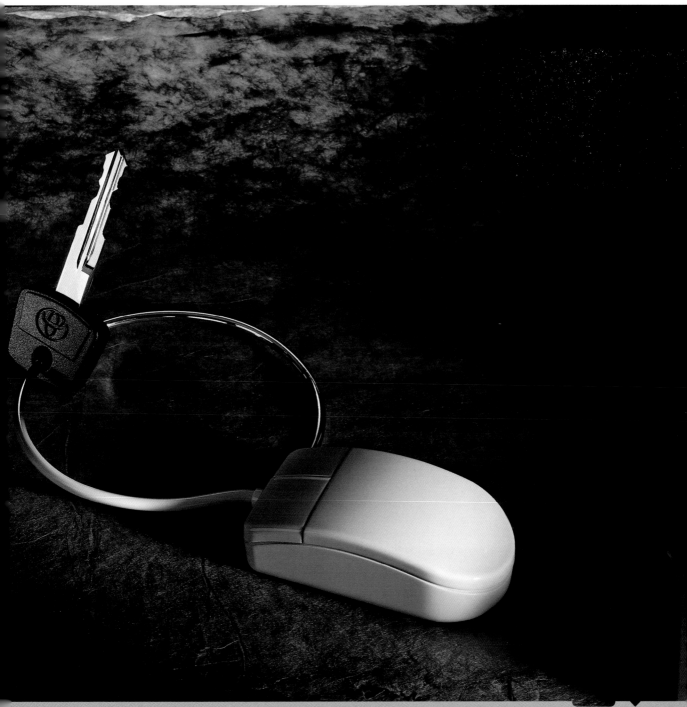

3 found images and

abstractions

In some ways, these are the "purest" still lifes in this book: they are things which stand alone, not particularly as a symbol of anything, but as representations of themselves alone – even if it is not immediately obvious what is represented. A semiotician could have a field day with these images, which are for the most part neither signs nor symbols but which can at least in some cases be taken as archetypes.

Almost half the 35mm images in the book are to be found here, as well as one of the only two black and whites. They are somewhat outside the main stream, it is true, but then, so were Weston's peppers or the geometrical compositions which flourished between the two World Wars.

In the Introduction to this book we remarked on our surprise at getting no traditional still lifes with dead pheasants and Rembrandt lighting. Once again, we were surprised in this chapter not to receive more extreme close-ups and studies of line, texture and form; but, again, this may indicate present fashions. Certainly the most luxurious representations of texture and form to be seen in fine-art photography today are mainly of plant life, often captured on 8 x 10in – a reaction, perhaps, against the glorification of the man-made, which began so dramatically with the Vorticists and which was developed with equal panache in Lenin's Russia and Weimar Germany.

We felt, though, that pictures of living plants were outside our brief: we would no longer be dealing with *nature morte* (a term which rings somewhat chillingly in non-French ears) but with a branch of landscape photography.

Photographer: **Marc Joye**

Client: **Printing Office Roels**

Use: **Calendar**

Camera: **4x5in**

Lens: **150mm**

Film: **Kodak Ektachrome 4 x 5in**

Exposure: **f/45**

Lighting: **Electronic flash: 3 heads**

Props and set: **Built set**

Plan View

► *The camera can distort scale and conflate built sets with naturalistic photographs*

► *Polaroid tests are often the easiest way to confirm the balance of "indoor" and "outdoor" lighting*

► *Some photographers keep libraries of pictures to be combined, either by traditional photographic means (as here) or electronically*

C A L E N D A R I M A G E

▼

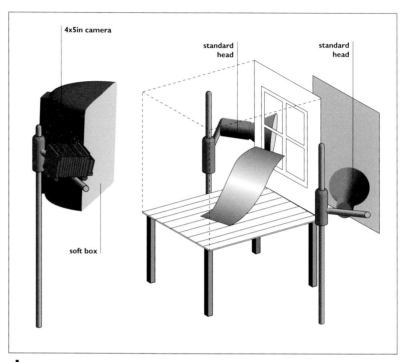

4x5in camera

standard head

standard head

soft box

LIKE MANY OF MARC JOYE'S PICTURES THIS ONE RELIES ON MULTIPLE EXPOSURE AND A BUILT SET. WITH MULTIPLE EXPOSURES IT IS PARTICULARLY IMPORTANT TO MAINTAIN CONSISTENT LIGHTING, OR TO USE LIGHTING WHICH IS "NEUTRAL", WITHOUT INCONSISTENCIES OF DIRECTION.

The basic set is the small, built "room" with the sheet of paper supported on a rod which passes through the back of the room and is concealed from the camera by the paper. This whole set is lit by a soft box 1m (39in) square.

Through the window there is a poster of a forest scene which is lit by two standard heads. Needless to say, the lighting of the poster and the room need to be carefully balanced, and this can be difficult to judge by eye or even by metering: Polaroid tests are the best route here.

The three pigeons – actually, three exposures of the same pigeon, slightly enlarged each time – were then exposed sequentially onto the same piece of film: they had previously been printed onto lith film to give a bright, contrasty image.

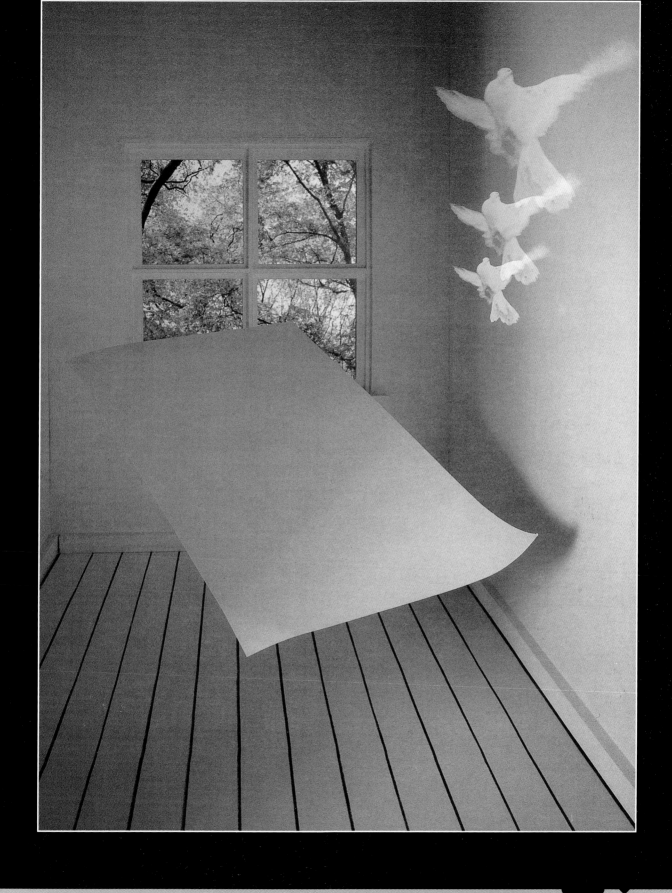

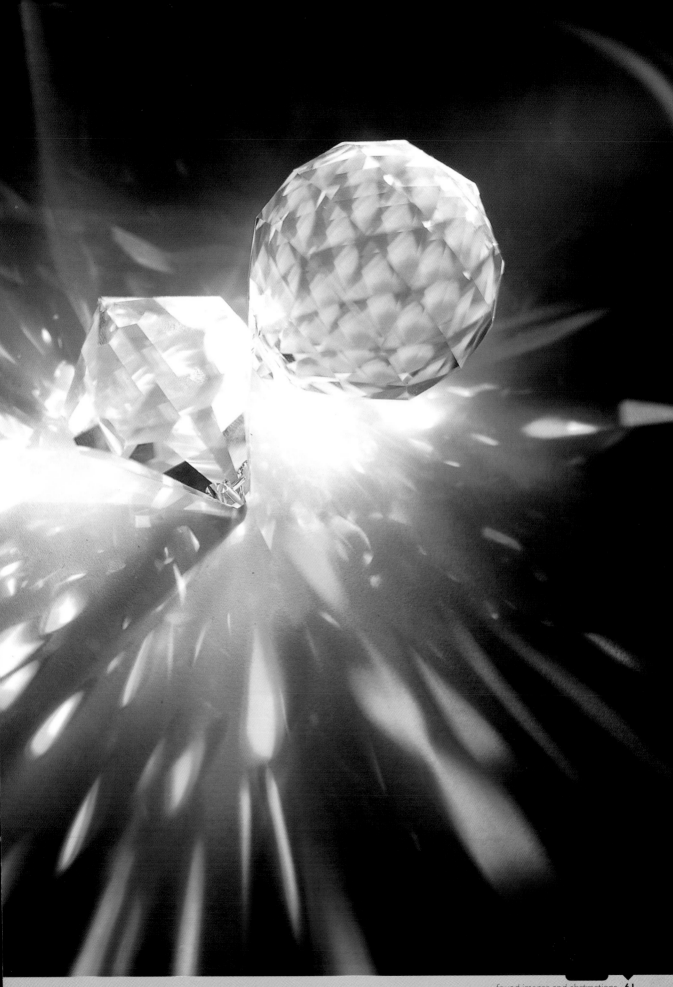

Photographer: **Raymond Tan**

Client: **Words Worth Media Management Pte Ltd**

Use: **Corporate brochure front cover**

Assistant: **Faizal**

Art director: **Shirley**

Camera: **6x7cm**

Lens: **250mm with extension tube**

Film: **Fuji Velvia RVP ISO 50**

Exposure: **15sec at f/5.6**

Lighting: **Light brush**

Props and set: **2 pieces clear crystal on white foreground**

CRYSTAL BEAMS

▼

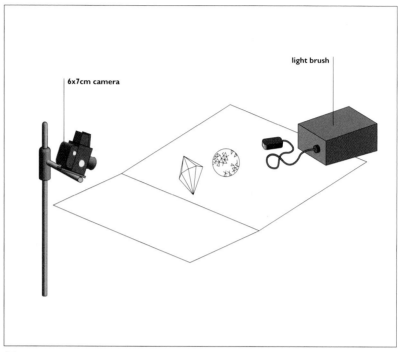

Plan View

THE PHOTOGRAPHER EXPLAINS THE TECHNIQUE VERY WELL: "AS NORMAL LIGHTING WILL 'KILL' THE CRYSTAL BEAMS – THE WHOLE FOREGROUND WOULD BE LIT – A 15-SECOND EXPOSURE FROM A LIGHT-PAINTING SET IS USED TO ACHIEVE THE DESIRED EFFECT."

▶ *Beams of light are hard to capture because they are easily swamped by general illumination*

▶ *"Sparkle" and "fire" are very difficult indeed to capture because they are normally most obvious when the eye moves slightly relative to the facetted stone or crystal*

▶ *Precise focus is by no means essential when photographing a projected spectrum*

A white foreground is essential to capture the beams of light from the crystal, but where there are no beams absolute blackness is equally essential. It might be possible to achieve a similar effect by using some other form of light pipe, such as one of the macro lighting systems available from a number of manufacturers (Marco in Moscow, Novoflex in Germany, etc), but the light brush is a more familiar tool to most photographers. To achieve this effect it was set for a "small telescope" beam.

The relatively wide aperture of f/5.6 is all that is needed: as long as the two pieces of crystal are in focus, a modest amount of loss of focus on the light beams is not important. Because the results are not totally predictable, it would be wise to shoot several versions and to select the best.

Photographer: **Kazuo Kawai**

Client: **Toyo Roshi**

Use: **Calendar**

Camera: **4x5in**

Lens: **210mm**

Film: **Kodak Ektachrome EPY**

Exposure: **1 sec at f/22**

Lighting: **Tungsten: 2 heads**

Props and set: **Stainless steel; ball-bearings; grey paper**

Plan View

M Y S T E R I O U S B A L L

▼

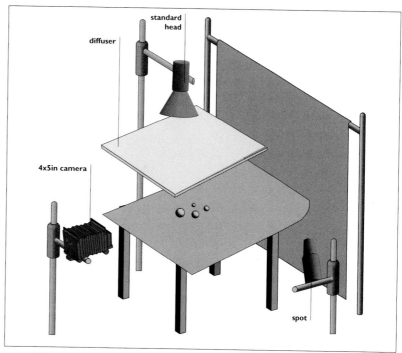

THIS IS FROM THE SAME SERIES AS THE OTHER KAZUO KAWAI SHOT ON PAGE 69
— AND, LIKE THE OTHER SHOT, IT IS A SIMPLE IDEA SUPERBLY EXECUTED. JUST KEEPING
FINGERPRINTS OFF SUCH A SET-UP IS FAR FROM EASY.

The four ball-bearings are on a sheet of coloured stainless steel, which is curved up towards the back. A diffused 500W lamp casts a very even light, which is not reflected from the stainless steel: that reflects the dark background, which is partially lit by a 500W spot light. This all sounds very easy, and in a sense it is; but the secret of the success of the shot lies in very precise positioning of the balls, the steel sheet, the diffuser, the background and, of course, the lights.

► *Highly reflective mirror-bright surfaces will not be illuminated by what is above them: they will reflect only what is behind them, relative to the camera viewpoint*

► *Stopping ball-bearings rolling about on a stainless steel sheet is not easy*

Photographer: **Kazuo Kawai**

Client: **Toyo Roshi**

Use: **Calendar**

Art director: **Koji Kojima**

Camera: **4x5in**

Lens: **180mm**

Film: **Kodak Ektachrome EPY ISO 64/19**

Exposure: **1sec at f/22**

Lighting: **Tungsten floods (two)**

Props and set: **Chromium plated steel**

Plan View

W A T E R B E A D S

▼

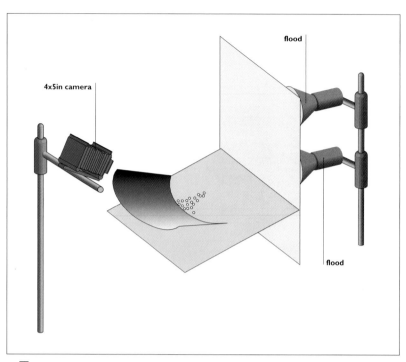

THIS IS AN IMAGE WHICH FAIRLY SCREAMS "HIGH TECHNOLOGY" AND IMPLIES COMPUTER MANIPULATION, ELABORATE SETS AND COMPLICATED LIGHTING. NOTHING COULD BE FURTHER FROM THE TRUTH. IT IS A STUNNINGLY SIMPLE PICTURE, BEAUTIFULLY EXECUTED.

► To get good definition on water droplets you normally need a combination of strong highlights and strong shadows. This can be achieved with highly directional lighting, or with diffuse lighting and skillfully used black and white bounces

► Whenever you see something unexpectedly beautiful, ask yourself, first, how you would photograph it as it stands and, second, how you could re-create it in the studio

► Never assume that complex equipment is required to create a picture which you have in your mind's eye: instead, try to work out the simplest way to shoot it

The water droplets in the upper part of the picture are on a piece of thin, chrome-plated steel, like an old-fashioned glazing (ferrotype) sheet. A second, similar piece of steel is flexed nearer the camera, and reflects the droplets on the first piece. The lighting is nothing more than two photoflood bulbs, one 500W and the other 300W, behind a sheet of diffusing material: the whole set is back lit. Of course, getting the droplets where

you want them is not easy. Nor is finding precisely the right composition. Nor is exactly the right exposure. But this picture illustrates unusually clearly that vision is what photography is about. From a purely technical viewpoint this shot is well within the reach of any competent amateur. From an artistic viewpoint, and from the brilliant simplicity of its realization, it is far, far beyond mere competence.

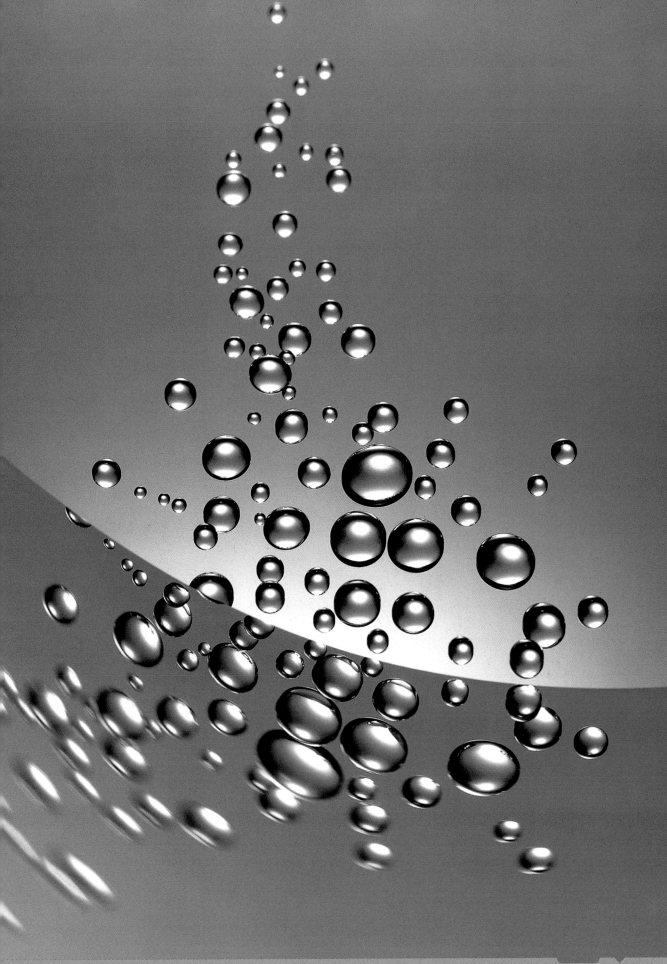

HOOD ORNAMENT

▼

Photographer: **Roger Hicks**

Use: **Editorial**

Camera: **35mm**

Lens: **90mm**

Film: **Kodachrome 64**

Exposure: **1/125sec at f/5.6**

Lighting: **Overcast daylight**

Props and set: **Location; Pontiac hood ornament**

IS THIS A STILL LIFE? IF NOT, WHAT IS IT? STRICTLY, IT IS NOTHING MORE OR LESS THAN A DETAIL FROM THE ORNAMENT ON THE HOOD (BONNET) OF A CAR; ONLY THE PHOTOGRAPHER'S EYE SEPARATES IT FROM A SNAPSHOT.

The lighting was a hazy-but-sunny day in Kentucky; the occasion was a vintage car meet. As is usual on such occasions, it was next to impossible to get good photographs of the cars as a whole because they were too close together, surrounded with people and adorned with placards giving their history and specifications. The only real possibility was to shoot details, which are for the most part clichés: the huge wheel filling the frame is a staple of magazines and reports. This old-fashioned Pontiac ornament is however unusual, handsome, and very clearly a part of an automobile.

It was shot for an article to demonstrate film latitude and the ways in which slight over- and under-exposure can enhance mood, but it has since appeared in a couple of books on photography and in one on graphic art.

Photographer's comment:

I shot this with a Leica rangefinder camera – not the best tool for close-ups, but it was what I had with me.

► Often, the only way to get good detail shots is to shoot plenty of film

► Incident-light metering makes exposure easy: a through-lens reading would have meant that the subject was too dark

Plan View

Photographer: **Frances E. Schultz**

Client: ***Shutterbug* magazine**

Use: **Editorial**

Camera: **35mm**

Lens: **90mm**

Film: **Ilford HP5 Plus**

Exposure: **1/500sec at f/8**

Lighting: **Daylight**

Props and set: **Greenwich Village, New York**

Plan View

B O O T S

▼

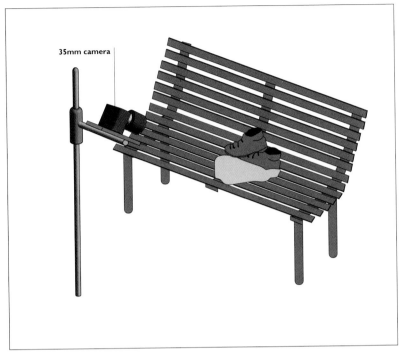

35mm camera

"I WAS IN NEW YORK FOR VISCOMM, THE PHOTO SHOW, AND (AS USUAL) I TRIED TO GET SOME PICTURES FOR SUBSEQUENT USE IN *SHUTTERBUG* MAGAZINE. I HAD NO PRECONCEPTIONS – I WAS JUST LOOKING FOR GOOD PICTURES."

This was shot at about two o'clock on a surprisingly warm and sunny day in late October; there was enough haze in the air to diffuse the contrast of the light somewhat. The boots are entirely "as found"; they were not re-arranged by the photographer. The bag (again "as found") acted as a bounce to provide fill on the lower boot.

The attraction clearly lies in the variety of textures, and this proved to be one of those negatives which bears out the truth of Ansel Adam's celebrated dictum that the negative is the score and the print is the performance: it can be interpreted in a number of ways, with more or less radical burning and dodging, and with or without toning.

► *The exhortation to carry a camera at all times may pay better dividends to the still life photographer than to anyone hoping for a news "scoop"*

► *A light tripod can greatly enhance the sharpness of pictures*

► *Lenses with closer-than-normal focusing ability are often very useful to those who shoot still lifes on 35mm*

Photographer's comment:

I find it best to work with another photographer or an assistant on the streets of New York. We can watch one another's backs when we are shooting.

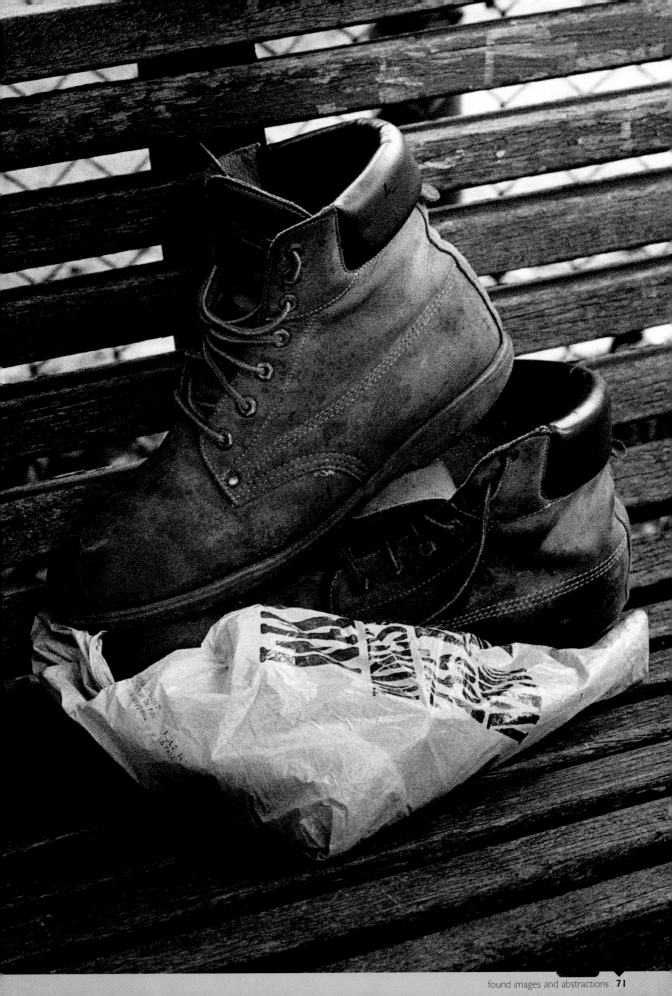

Photographer: **Roger W. Hicks**

Use: **Editorial**

Camera: **35mm**

Lens: **70–210mm zoom**

Film: **Fuji RDP ISO 100**

Exposure: **Not recorded: probably 1sec at f/8**

Lighting: **Sunlight, firelight**

Props and set: **Location: Auberge St.-Hubert**

Plan View

FIREPLACE, BURGUNDY

▼

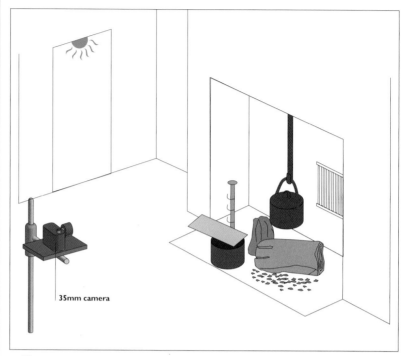

CONSTRUCTING STILL LIFES IN THE STUDIO CAN BE FUN, BUT IT IS ALSO A GREAT PLEASURE WHEN YOU RUN ACROSS THEM — WHEN THEY ARE JUST "FOUND" — AS ARE SEVERAL OF THE IMAGES IN THIS CHAPTER.

"We noticed this fireplace on the night we arrived, and I vowed to take a picture of it the next morning, when daylight would provide some fill. The weather the next day was unsettled: shafts of weak sunlight would shine through the window to the left of the fireplace for a few seconds, and then disappear for minutes on end. Also I wasn't sure just how much to increase the exposure in order to capture the black-on-black without losing the lighter parts of the image altogether – though, as can be seen, parts of the soot were surprisingly reflective. What I eventually did was to bracket furiously, ranging from the value indicated by an incident light reading to three or four stops over. A range of exposures was acceptable, but this is the one I like most."

► *There is a considerable difference between internal contrast – the ability of a lens to separate tones – and film contrast*

► *Fujichrome 100 was able to hold the tonal range in this picture: Velvia, from the same manufacturer, might not have*

Photographer's comment:

We were on our way back from a shoot in Italy, where we had been involved in an accident within an hour of arriving. We spent a few days in Burgundy to recuperate.

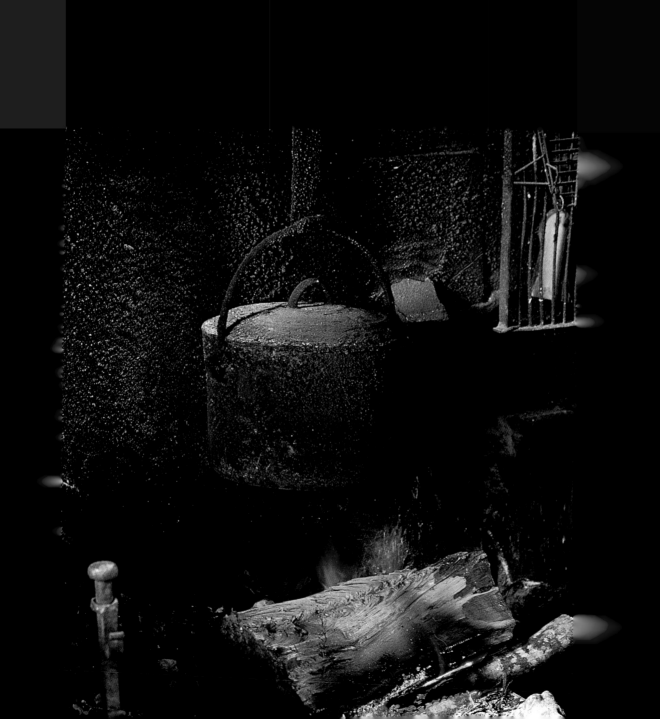

4

form, colour and
texture

In one sense the previous chapter was concerned with form, colour and texture; but the difference between the pictures on the last few pages and the ones in this chapter is that these are much more representational. In most of the pictures grouped under this heading the photographer is showing us something as if for the first time: he or she is making us more aware of something which we might not have noticed in the ordinary course of things, and reminding us of its qualities. In other words, it is the thing itself which is being shown to us, as a teapot, or an ear of corn, or even a stack of paper, and our attention is being drawn to its form, colour or texture.

This is not all that is here, though. In particular, Maurizio Polverelli's Aries, the Ram uses form, colour and texture as a symbol rather than as a representation, and his Gemini is arguably both symbol and sign – the latter, of course, in both the semiotic sense and in the joky double-meaning sense which is so beloved of (for example) Umberto Eco.

But such talks of semiotics reveals, all too clearly, that while photography is a multi-layered undertaking where even the most abstruse concepts may be brought into play, its feet remain firmly on the ground even as its practitioners reach for the sky: essentially, the pictures here show us how to transfer an idea onto film, leaving the idea to speak for itself through the image. We can all understand the beauty or

Photographer: **Johnny Boylan**

Client: **S.M.I./Powergen**

Use: **Advertising**

Assistant: **Annie Howard Phillips**

Art director: **Roy Brooks**

Camera: **4x5in**

Lens: **210mm**

Film: **Kodak Ektachrome EPR**

Exposure: **f/11½**

Lighting: **Flash: I head**

Plan View

► *Quality of light is a question of source size, directionality and diffusion*

► *Hard lighting reveals fine detail and texture*

► *Camera movements allow a receding plane to be held in focus without stopping down (the Scheimpflug rule)*

C O R N

▼

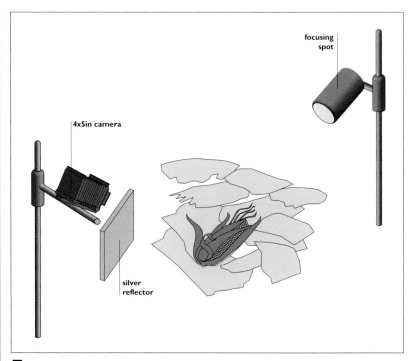

THE LIGHTING HERE IS DECEPTIVE. CLEARLY IT IS VERY HARD AND CONTRASTY, BUT EQUALLY IT IS QUITE BROAD: IT IS NOT A CONVENTIONAL SMALL FOCUSING SPOT. ALSO THERE IS SOME SLIGHT FILL FROM THE LEFT AND ON THE STEM END OF THE COB.

The secret is a big, old 2K focusing spot which the photographer adapted to take a flash head. The beam is tight, in the sense that the sides are close to parallel, but it is also quite a large light source. "Quality of light" is one of those terms which is easier to recognize than to analyze, but obviously the quality here is different from a small focusing spot, a large reflector, or of course a soft box.

There is also a small silver reflector to camera left to throw some light back onto the end of the cob, which would otherwise be dark and without roundness. This throws a little light into the shadows on the left, still further emphasizing their texture.

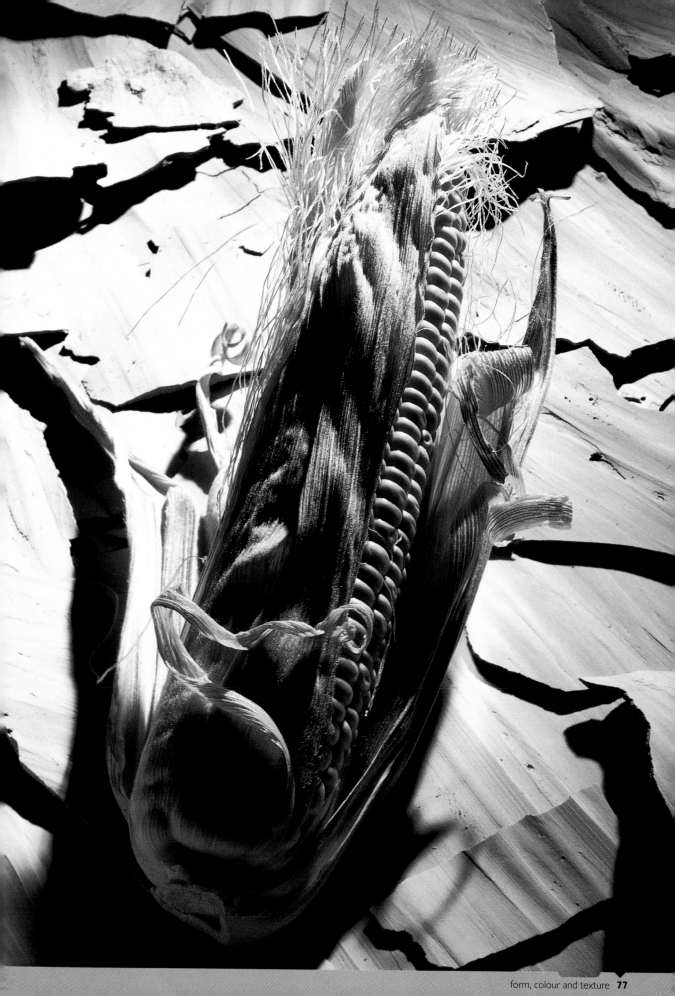

Photographer: **Frances E. Schultz**

Client: **David & Charles**

Use: **Editorial (*The Film Book*, 1994)**

Camera: **35mm**

Lens: **35mm**

Film: **Ilford XP-2**

Exposure: **1/500sec at f/8½**

Lighting: **Sunlight, close to noon**

Props and set: **Collapsible walking stick**

Plan View

► *Sometimes, a particular kind of light cries out to be used*

► *Shadows move surprisingly quickly, so you have to work fast when shooting in bright sun*

► *Ilford XP2 captures a wider tonal range than any other monochrome film on the market*

S T I C K A N D W A L L

▼

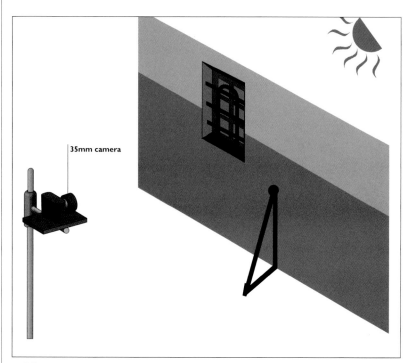

35mm camera

Most photographers set up a picture and then light it. Here, Frances Schultz saw the lighting and set up the picture, adding the walking stick to balance the composition and emphasize the shadows.

The tonal range of the image is enormous, from specular reflection of sunlight on the brass head of the cane to pitch darkness through a broken pane in the window. As can be seen, the sun was almost directly overhead – this was around noon in April at Aosta, in the Italian Alps – and the light is very contrasty. The picture was made to illustrate the range of tones which can be recorded with a black and white film, especially with XP-2. Devotees of the Zone System will be able to find every single zone in this picture. The same picture, shot in colour as a reference, is very different.

Photographer's comment:

What attracted me to this picture was the grey patch which runs diagonally across the top right, and the shadow on the lower left. I added the stick to balance the composition.

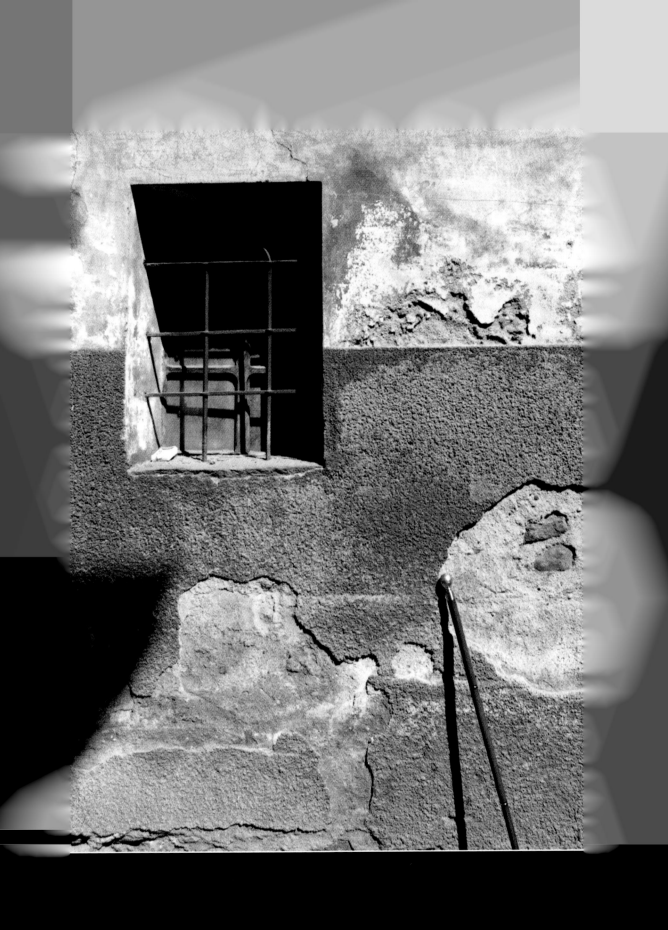

form, colour and t

Photographer: **Mark Williams**

Client: **RSCG Conran Design**

Use: **Point-of-sale advertising**

Art director: **Emma Hall**

Camera: **4x5in**

Lens: **75mm**

Film: **Fuji Velvia**

Exposure: **f/32**

Lighting: **Electronic flash: five heads**

Props and set: **S-curve light table**

Plan View

P O U R I N G O L I V E O I L

▼

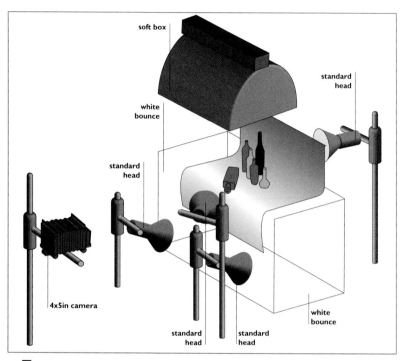

"THIS WAS ONE OF THOSE REALLY ENJOYABLE JOBS WHERE THE ART DIRECTOR HAD A FREE HAND AND I COULD CREATE A PICTURE TO BE PROUD OF, RATHER THAN JUST WORKING OUT HOW TO MEET A BRIEF."

This is one of Mark's favourite pictures, and it is easy to see why. All the bottles are on a Perspex (Lucite) shooting table, the sort which has an up-curve at the back and a down-curve at the front. There were white bounces on either side and at the back, and a 1m (39in) square soft box overhead. Two 1500-Joule heads were bounced down onto a sheet of white paper on the floor under the table to create a very soft, even light, and another head shone through the up-sweep at the back of the table. The fifth light was a standard head with a spill kill, mounted just to camera right to create highlights.

► Mark shot 20 sheets of film, choosing the one where the oil looked best. The bottle had to be refilled for each shot

► Extensive movements are often necessary in shots like this to control both perspective and sharpness

Photographer's comment:

We pulled the movements all over the place in order to get the perspective right and the bottles in the back group upright.

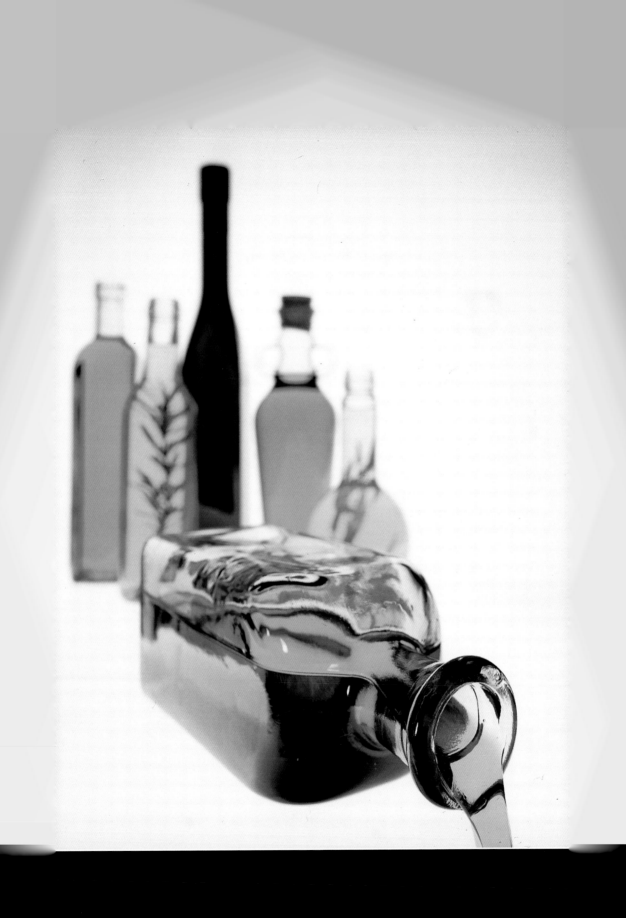

Photographer: **James DiVitale**

Use: **Shot for self-promotion; put into stock; used by printing company**

Designer: **Sandy DiVitale**

Camera: **4x5in**

Lens: **210mm**

Film: **Kodak Ektachrome EPP ISO 100**

Exposure: **f/45**

Lighting: **Electronic flash: one head**

Props and set: **Black felt background**

Plan View

T E A P O T

▼

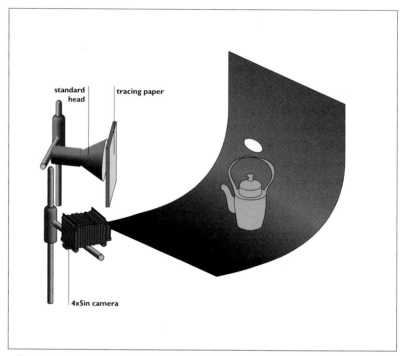

SOMETHING LIKE THIS TEAPOT WOULD INSPIRE MANY PHOTOGRAPHERS: A COMBINATION OF FORM, COLOUR AND TEXTURE WHICH JUST BEGS TO BE PHOTOGRAPHED. IT WOULD BE INTERESTING TO SEE HOW (SAY) SIX DIFFERENT PHOTOGRAPHERS TACKLED IT.

If you examine the highlights closely you can pretty much see what sort of light was used on the teapot. It was a frame about 30cm (12in) square with a single standard head behind it – nothing very complicated. This is an important lesson. Although it is useful to be able to draw on a full range of lighting equipment, there are times when all that is needed is very simple indeed. The "steam" is actually a small white smudge on the background, well out of focus, lit by spill, which reads as a puff of steam: a classic example of using people's expectations to persuade them that they are seeing something other than what is there.

► *A simple wood frame, covered in tracing paper and with a light behind it, can surprisingly often substitute for an expensive soft box*

► *People see what they expect to see: the reflection of a window in the teapot, a puff of steam at the spout . . .*

► *An assistant makes it easier to position things like the puff of steam so that they are "set to camera"*

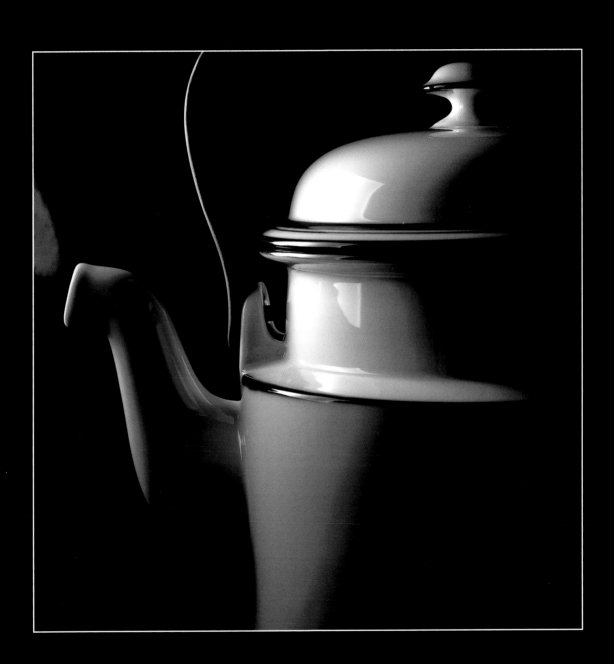

Photographer: **Maurizio Polverelli**

Client: **Mario Formica spa**

Use: **Calendar**

Stylist: **Emanuela Mazzotti**

Camera: **8x10in**

Lens: **360mm**

Film: **Kodak Ektachrome 6117 ISO 64**

Exposure: **f/32½; 8 "hits"**

Lighting: **Electronic flash: 2 heads**

Props and set: **Stone and sandblasted stone**

Plan View

ARIES, THE RAM

▼

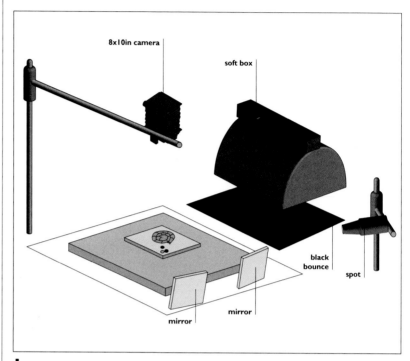

IT IS HARD TO SAY WHAT IS SO ATTRACTIVE ABOUT THIS MINIMALIST STILL LIFE; AND YET THERE IS SOMETHING ABOUT IT. YOU CAN FEEL THE TEXTURES, SMELL THE MUSTY TAR ON THE ROPE… CHOOSING AN 8 × 10IN CAMERA HELPED, OF COURSE: VERY LARGE FORMATS AND AN APOCHROMATIC LENS RENDER TEXTURE LIKE NOTHING ELSE CAN.

Improbably, unless you are familiar with Maurizio's work, the key light is a large, powerful soft box (2500 Joules) sandwiched with a big, black bounce: the light which escapes from the side of the sandwich is soft yet directional. This is at about 10 o'clock from the subject. A much smaller head, just 500 Joules, is set at 2 o'clock: this helps to delineate the precious stones, and it is further supplemented by a couple of small mirrors, as shown. Interestingly, the outer stone rests on a black backdrop to keep flare into the lens to a minimum.

► The "black bounce" technique is seen elsewhere in Maurizio Polverelli's work in the Pro Lighting series

► Setting a subject on a black background can reduce flare, even if the black background is entirely out of shot

► Multiple "hits" of the flash were necessary in order to work at the desired aperture

Photographer's comment:

The image represents two precious stones: one of the month (April) and one of the zodiacal sign. The rope represents the ram's horn. The entire image is based on geometrical shapes.

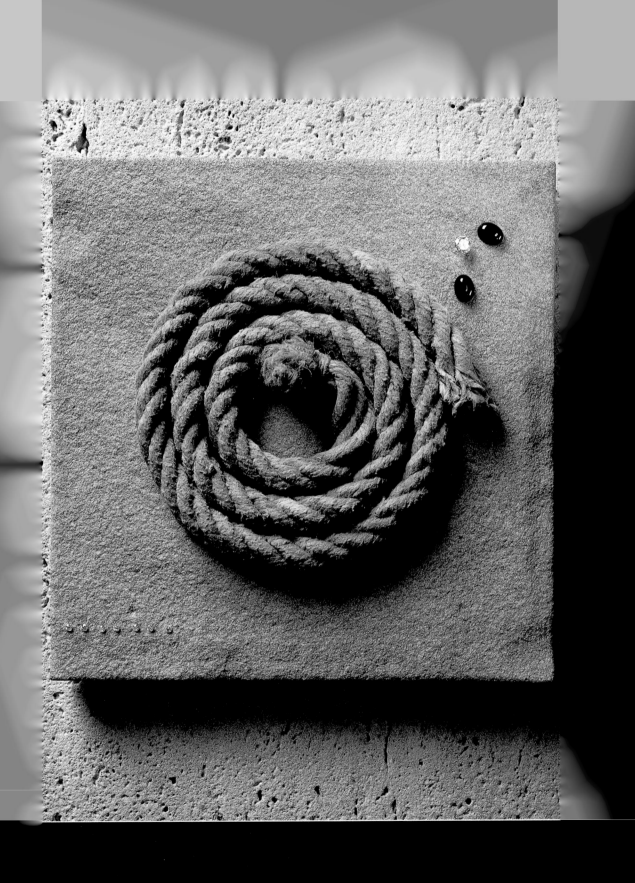

form, colour and t

Photographer: **Maurizio Polverelli**

Client: **Mario Formica spa**

Use: **Calendar**

Stylist **Emanuela Mazzotti**

Camera: **8x10in**

Lens: **360mm**

Film: **Kodak Ektachrome 6117 ISO 64**

Exposure: **Not recorded**

Lighting: **Electronic flash: 4 heads**

Props and set: **Sandblasted stone, broken mirror**

Plan View

▼

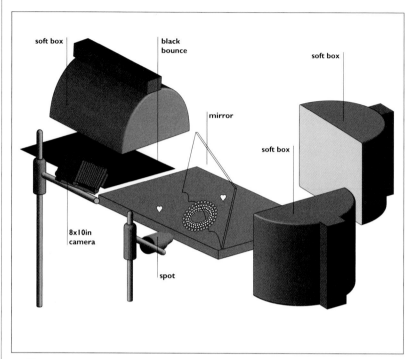

THIS IS NOT A PICTURE WHOSE "MEANING" IS IMMEDIATELY OBVIOUS: A PIECE OF BROKEN MIRROR, OVERARCHING THE SET, DIVIDES THE COMPOSITION INTO TWO NOT-QUITE-EQUAL PARTS. INTO IT YOU CAN READ BOTH CONFLICT AND COOPERATION.

Arguably there is no true key light – the more so as the mirror reflects light from one side, and allows it to pass through the gap from the other. One soft box directly behind the mirror gives one set of highlights; another, on the right at 90° to the camera's line of sight, adds another set; the spot to camera right adds a third set; the soft box with black bounce (something of a Polverelli trade-mark) adds a fourth set; and then there are the reflections from the mirror

The broken edge of the mirror is a powerful design element. The mirror links the two parts of the image (the "Looking-Glass Twin"), but the jagged, razor-sharp edge divides them.

► *Mirrors are tricky to handle – and this is not even a front-silvered mirror*

► *Multiple small points of light are good for creating the illusion of sparkle*

Photographer's comment:

I wanted to show the brightness and the twinkling of the precious stones, so I used a lot of lights. The strange thing is the heart: it's alone, but the mirror creates its duplicate. And the necklace is not a true circle.

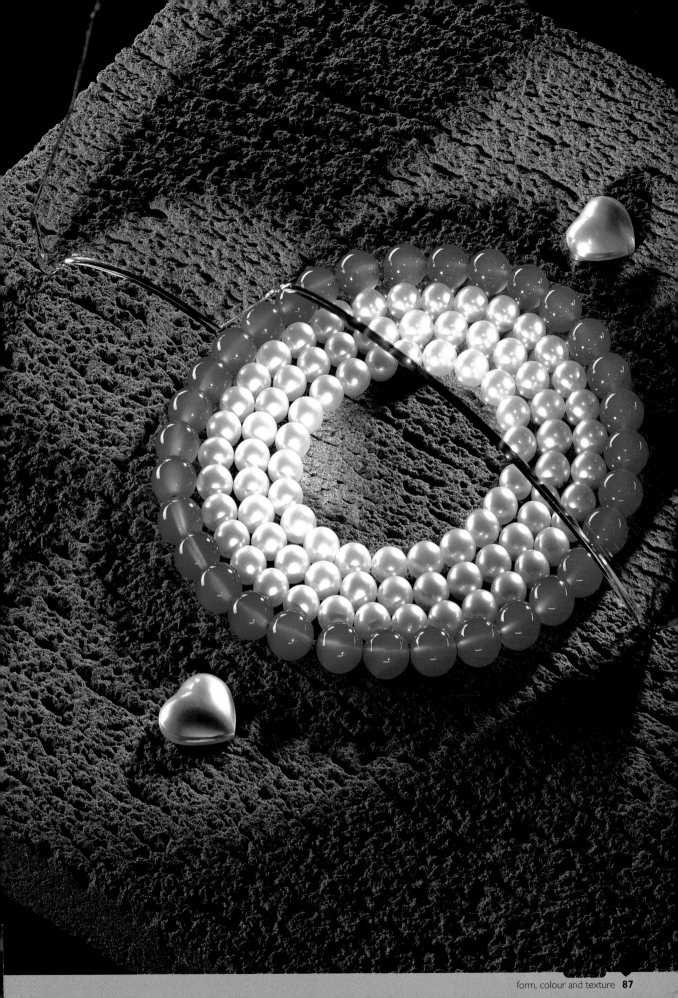

RICOH 66

▼

Photographer: **Jay Myrdal**

Client: **Ricoh**

Agency: **Leopard**

Use: **Press Advertising**

Art director **John Batty**

Camera: **8x10in**

Lens: **155mm**

Film: **Kodak Ektachrome 6117 ISO 64**

Exposure: **f/64; 23 "hits"**

Lighting: **Electronic flash: 6 heads**

Props and set: **Painted backdrop**

Tʜᴇʀᴇ ɪs ᴀ ᴄᴜʀɪᴏᴜs sᴇɴsᴇ ᴏꜰ ᴇɴᴅᴜʀᴀɴᴄᴇ ɪɴ ᴛʜɪs ᴘɪᴄᴛᴜʀᴇ; ᴏꜰ sᴏᴍᴇᴛʜɪɴɢ sᴛʀᴏɴɢ ᴡʜɪᴄʜ ʜᴀs ᴇɴᴅᴜʀᴇᴅ ꜰᴏʀ ᴀ ʟᴏɴɢ ᴛɪᴍᴇ. Tʜɪs ɪs ᴠᴇʀʏ ᴍᴜᴄʜ ᴛʜᴇ ǫᴜᴀʟɪᴛʏ ᴡʜɪᴄʜ ᴛʜᴇ ᴍᴀɴᴜꜰᴀᴄᴛᴜʀᴇʀ ᴏꜰ ᴀ ᴘʜᴏᴛᴏᴄᴏᴘɪᴇʀ ᴍɪɢʜᴛ ᴡᴀɴᴛ ᴛᴏ ᴘʀᴏᴊᴇᴄᴛ!

The key lights are four spots to camera right, which together create the hard shadows and the impression of sun coming from infinitely far away: the shadows in the "66" and on the stacks of paper to the left are an essential part of this. They are all filtered half blue, while there is an 80-series blue filter on the camera too. The "sky" is a painted backdrop, lit with two standard heads behind the far stacks.

The stacks of paper are built to create a false perspective – the ones at the back are only 2.5–5cm (1–2in) high – and a 155mm lens still further exaggerates the effect; it is the equivalent of 75mm on 4 x 5in or 21mm on 35mm.

Photographer's comment:

We shot this in plain white, which was the one the client used, and this version, which is the one in my portfolio.

- ► *Filtration of lights and filtration on camera can be mixed*

- ► *When working at very small apertures (for depth of field), numerous "hits" of flash are often required*

- ► *Large formats are ideal for capturing texture*

Plan View

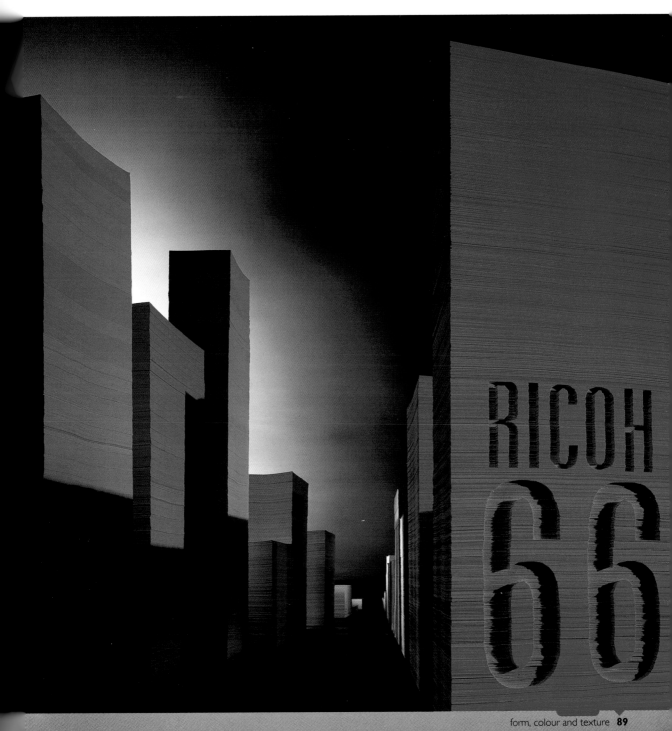

Photographer: **Eros Mauroner**

Use: **Portfolio**

Camera: **8x10in**

Lens: **360mm**

Film: **Polaroid 809**

Exposure: **Not recorded**

Lighting: **Electronic flash: 6 mini spots plus light brush**

Props and set: **Painted-glass backdrop**

Plan View

S E L T Z E R & C O F F E E

▼

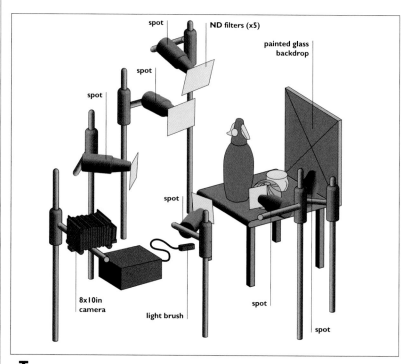

THE PRICE OF 8 × 10IN POLAROIDS IS FRIGHTENING, BUT THE QUALITY OBTAINABLE CAN BE WONDERFUL — AND ENLARGEMENTS UP TO 40 × 50CM (16 × 20IN) ARE QUITE FEASIBLE WITHOUT LOSS OF QUALITY. THIS WAS SHOT ON TYPE 809.

Although a light brush was used for a good deal of the exposure, creating an aesthetic effect which is incontrovertibly interesting, the main technical interest lies in the use of no fewer than six mini spots, all but one with one-stop (2x, ND=0.3) neutral-density filters.

The one which was not filtered was used to illuminate the backdrop of painted glass – in itself an unusual material – while others immediately raise the question: why?

The answer is that, while lights can be moved farther away, this changes the quality of the light and the size (and shape) of the reflections: using ND filters was the easiest way to get exactly the right sort of reflections on the soda syphon, while retaining the desired working aperture for light-brushing.

► *Balancing light-brushing with other sources can sometimes be demanding*

► *Light intensity and balance can be altered by changing power, by changing distance, by adding filtration (as here), or by making multiple exposures at different apertures*

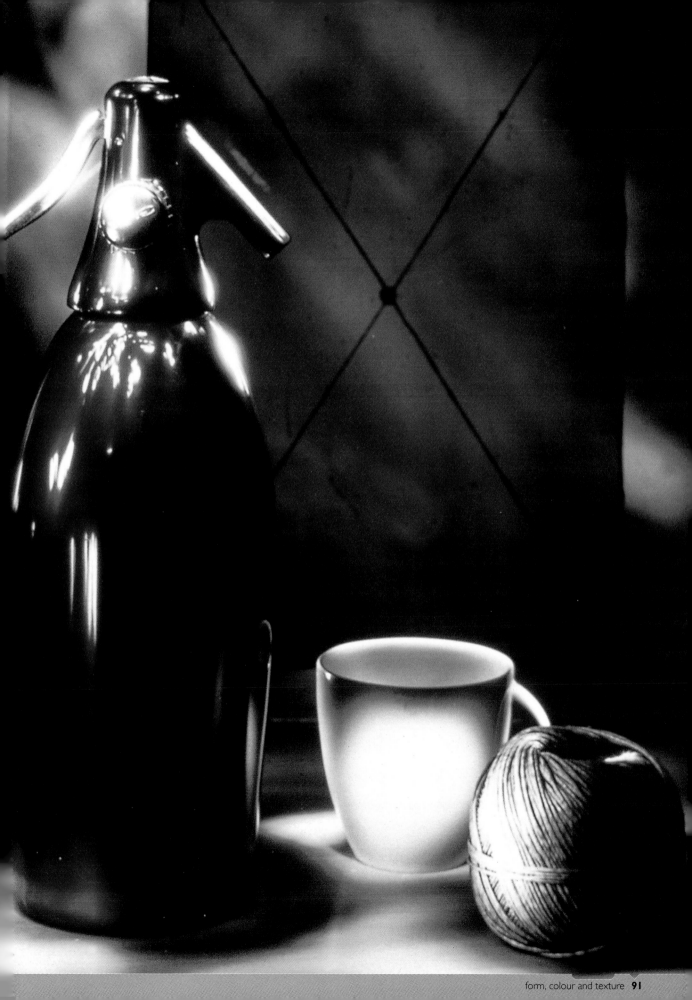

5

still life with

food

It is extremely instructive to compare the pictures In this chapter with the pictures in an earlier Pro-Lighting book on food photography. In food photography the aim is to make the food look appetizing. In a still life the edibility of the food is secondary: we are invited to look at shapes, colours, contours, rather than asked to imagine tastes, smells, textures on the tongue. A different range of senses is engaged, visual rather than tactile or gustatory.

And yet it was not ever thus. Look at painted still lifes: there is typically an attempt to engage far more of the senses. The archetypal rendition of bread, cheese, onion and a tankard of beer is not just an arrangement of shapes: it is very much an arrangement of food that is meant to be eaten. It is quite likely, in fact, that many artists painted their lunch: few artists are rich, especially at the beginnings of their careers, and if you can get double mileage out of cheap, tasty food as both visual inspiration and sustenance it makes excellent sense.

The reason for the separation into food photography and still life probably lies in commercial pressures rather than artistic ones; indeed, many great food photographers describe themselves as still life photographers. And yet, when it came to publication (as already noted elsewhere), we had received far fewer traditional still lifes with food than we had expected.

Photographer: **Michèle Francken**

Use: **Portfolio work**

Camera: **4x5in**

Lens: **210mm**

Film: **Polaroid 559**

Exposure: **f/22**

Lighting: **Electronic flash: 3 heads**

Props and set: **Fruit, artisanal plate**

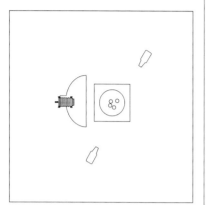

Plan View

► *"Quality" of light is easier to recognize than to describe or analyze*

► *Different aspects of "quality" include directionality, harshness and gradient: a light near a subject will fall off more rapidly than a distant light*

► *Different qualities of light can be combined either naturalistically or in a contrived manner*

F R U I T

▼

A PROBLEM OFTEN FACED BY THE INEXPERIENCED PHOTOGRAPHER IS WHEN TO USE HARD LIGHT AND WHEN TO USE SOFT LIGHT – AND WHEN (AND HOW) TO MIX THEM. MICHÈLE FRANCKEN WELL DEMONSTRATES THE TECHNIQUES HERE, ALONG WITH THE POLAROID EMULSION TRANSFER PROCESS.

The overall lighting ratio is very tight but, because it is a mixture of diffuse and directional lighting, each type of light plays its part. The diffuse light from the overhead soft box gives plenty of detail and texture, while the lower flash head to camera right gives modelling and roundness: look at the shadows on the fruit. Finally, a second spot to camera left is used to back light the dark citrus leaves, which are always a problem to photograph alongside the fruit.

A perfume spray added the water droplets, and careful choice of props, colours and composition gives the picture considerable impact. All too often photographers experiment with techniques like emulsion transfer using dull images; but if the technique is worth exploring at all, then it must (after the very first experiments to see how it is done) be worth exploring with good pictures.

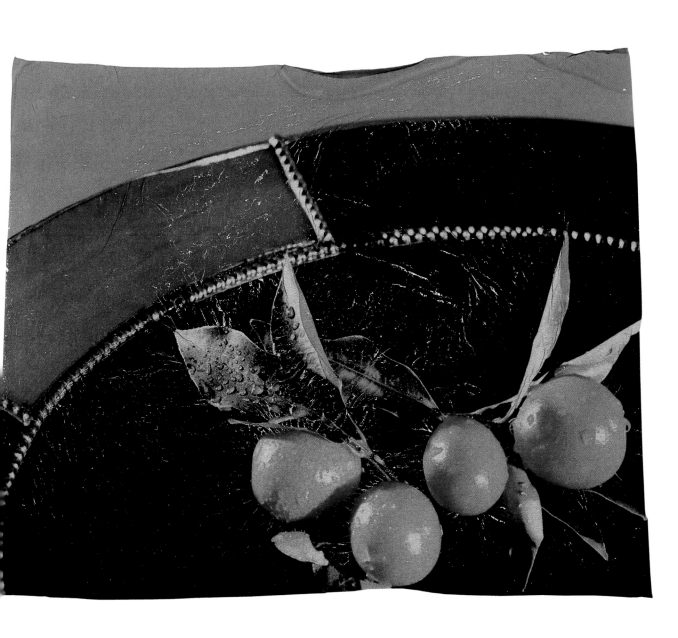

Photographer: **Arici & Mauroner**

Use: **Portfolio/test**

Assistant: **Cristina Canesella**

Camera: **4x5in**

Lens: **180mm**

Film: **Not recorded**

Exposure: **f/16; time not recorded**

Lighting: **Tungsten: one 500W spot**

Props and set: **Pears, hessian**

Plan View

P E A R S

▼

MOST PEOPLE GLANCING AT THIS PICTURE WOULD GUESS THAT IT WAS DONE WITH A LIGHT BRUSH. THE TRUTH, HOWEVER, IS THAT THE SHOT IS BACK LIT WITH A SINGLE 500W SPOT: THE TONALITY IS DUE TO THE USE OF TWO BOUNCE CARDS.

The spot is high, slightly to the left, and slightly back lighting the pears: look at the shadows. The bright highlights are due to the extremely directional nature of the light: they are on the edge of being burnt out, the more so in this duplicate transparency. Their position, which looks subtly wrong (often the sign of light brushing) is due to the shape of the pears, which are strangely asymmetrical.

A silver bounce card to camera left fills the shadow on that side – look at the left-hand pear – but the black bounce to camera right, very close to the camera, absorbs all light from the spot and leaves the shadows below the pears very dark indeed.

Often, just playing with lighting like this – just seeing what will happen – is a successful route to new techniques and portfolio shots.

► A single light source is often a good departure point for experiment

► When experimenting, contrast textures such as hessian and pear-skin; the natural world with the man-made; harsh light and soft light

► Black bounces frequently have far more effect than you expect

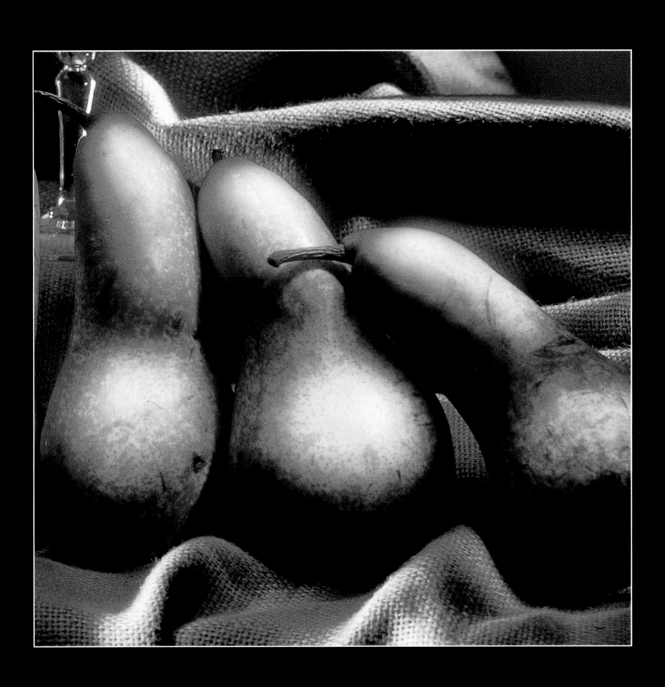

Photographer: **Angelou Ioannis**

Use: **Self-promotion**

Assistant: **Soulis Ioannis**

Camera: **6x7cm**

Lens: **90mm**

Film: **Fuji Velvia RVP ISO 50**

Exposure: **12sec at f/11**

Lighting: **Ultra-violet "black" light**

Props and set: **Garlic (one spray-painted);
brown wrapping paper background**

Plan View

G L O W I N G G A R L I C

▼

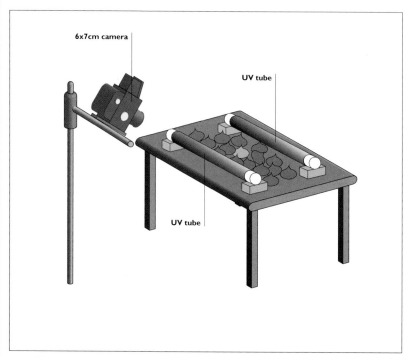

AGAIN AND AGAIN, IN THE COURSE OF PUTTING TOGETHER THESE BOOKS, THE
ORIGINALITY AND INQUISITIVE NATURE OF PHOTOGRAPHERS KEPT COMING THROUGH – AS
DID THE RANGE OF OPTIONS FOR WORKING WITH CONVENTIONAL PHOTOGRAPHY
RATHER THAN ELECTRONICS.

One head of garlic was spray-painted with (red) fluorescent paint, which glows under ultra-violet illumination. It was carefully placed among the other, unsprayed pieces on a sheet of wrinkled brown wrapping paper. The two UV tubes were set up on short strands, about 10cm (4in) high, as shown in the diagram. Exposure was based on a spot meter reading from the glowing head of garlic, but with extensive bracketing in the direction of overexposure: from two stops to four stops more than indicated. The most successful exposure was 3½ stops over the one indicated by the meter.

► *"Black" (UV) light is of wavelengths
shorter than about 400nm. Shots in the
near ultraviolet are possible with most
standard lenses down to about 320nm,
and most films are sensitive to this: they
will record it as a very deep violet*

► *Beyond 320nm, UV light is absorbed by
glass, and quartz lenses are required*

► *UV filters on the camera lens will stop
UV recording on the film but will not
affect visible light produced by UV-
fluorescent objects*

Photographer's comment:

*Black light offers a lot of creative opportunities. One can't expect to have similar results with
back lighting, transillumination or a spot. Objects seem to have a life of their own. Colours are
very vivid and unnatural. I wanted a breath of life, a pulse of blood, in a typical still life. Still,
yes; but alive.*

Photographer: **David Dray**

Use: **Stock/library**

Camera: **35mm**

Lens: **100mm + 12mm extension tube**

Film: **Fujicolor ISO 100 (negative)**

Exposure: **f/11**

Lighting: **Electronic flash: 1 head**

Props and set: **Garlic; black background paper**

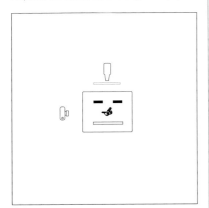

Plan View

G A R L I C

▼

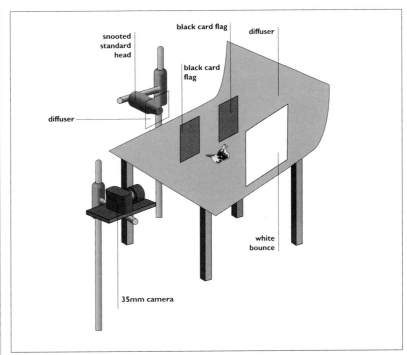

COLOUR PHOTOCOPY TRANSFERS INVOLVE MAKING A COLOUR PHOTOCOPY OF THE SUBJECT, TREATING IT WITH AN ORGANIC SOLVENT, THEN PLACING IT IN CONTACT WITH A SHEET OF WATERCOLOUR PAPER AND RUBBING THE BACK SO THAT THE IMAGE TRANSFERS TO THE NEW SUPPORT.

Colours are usually degraded, but they can also be enhanced in unpredictable and often attractive ways. The original image does not necessarily need to be very sharp because fine detail is lost both in the copying and in the transfer process: the system works best with simple compositions. Because of the transfer the image is laterally reversed.

The lighting is surprisingly complex for a single-head set-up. A snooted standard head to camera left, about 90cm (3ft) from the garlic, is further shaded by a "gate" of black card with a gap some 15cm (6in) wide, but a diffuser is hung over the end of the snoot. A white bounce about 45cm (18in) from the garlic to camera right provides fill.

► *Watercolour paper adds its own texture to that of the image*

► *The image is laterally reversed (flop transparencies or negs when making the photocopy)*

► *Use bold, simple compositions with colour copy transfer*

Photographer's comment:

The use of the colour photocopy technique enhances the simplicity of the study.

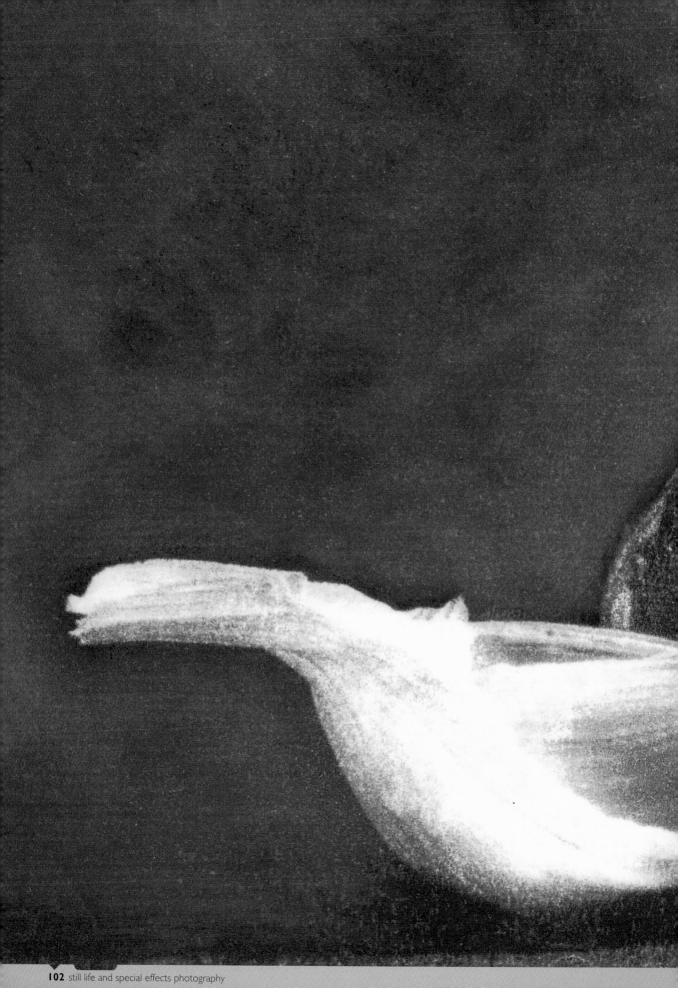

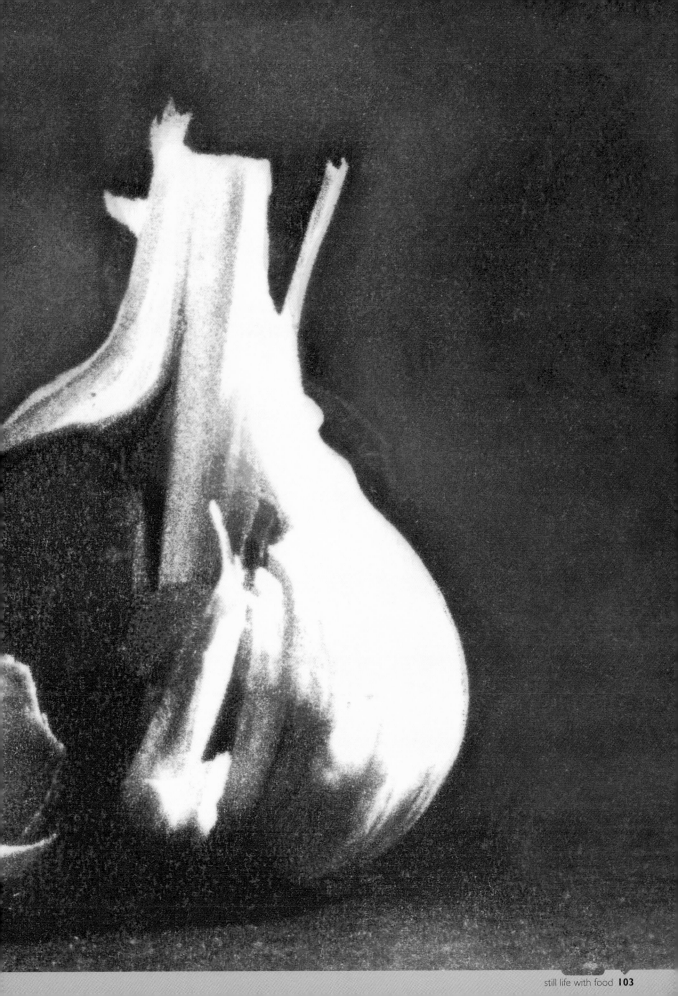

Photographer: **Ron McMillan**

Client: **Millenium**

Use: **Catalogue**

Assistant: **Paul Cromey**

Camera: **4x5in**

Lens: **210mm**

Film: **Fuji Provia 100**

Exposure: **f/32½**

Lighting: **Electronic flash: 2 heads**

Props and set: **Red to white graduated ground**

Plan View

PLATE

▼

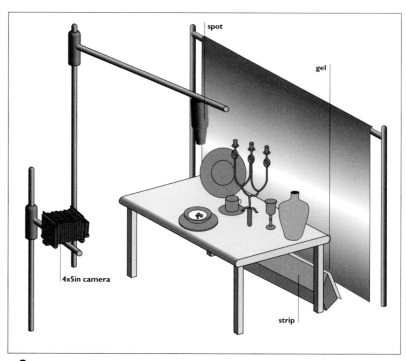

"**S**POT LIGHT" AND "SPOTLIT" ARE VERY RELATIVE TERMS. A PROJECTION SPOT GIVES AN ABSOLUTELY HARD EDGE, WHILE A CONVENTIONAL FOCUSING OR SNOOTED SPOT GIVES A MUCH SOFTER EDGE. OR YOU CAN DEFOCUS A PROJECTION SPOT

Regardless of exactly how you achieve the desired hardness of edge, the success of a picture like this relies heavily on the surroundings to the spotlit area being absolutely dark – which is all the harder to achieve when there is potential spill from the background, as here. Fortunately, there is a psychological phenomenon at work which makes juxtaposed light and dark areas seem to differ more than they actually do.

The lighting set up is a spot overhead, very precisely positioned, and a strip light on the floor behind the table. The strip light is fitted with a yellow gel which transforms the red/white graduated ground to a yellow/orange ground.

▶ *A dark area next to a very light area will often seem darker than an area of the same dark tone next to a mid-tone*

▶ *Reflections from the white area (as in the strawberries and the glass) can complement the picture, as here, or they can be an intractable nuisance*

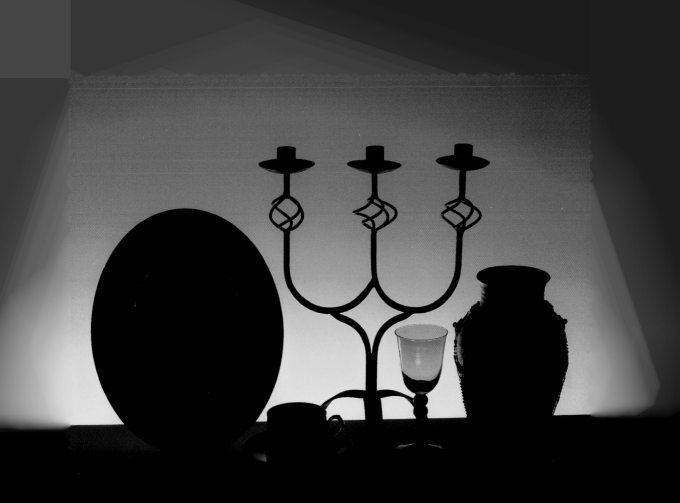
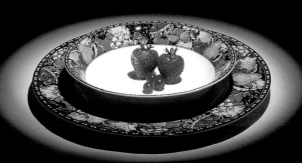

Photographer: **Matthew Ward**

Client: **The Medicus Group (advertising agency)**

Use: **Promotional shot for agency**

Assistant: **Martin Breschinski**

Art director: **Trevor Chapman**

Camera: **4x5in**

Lens: **360mm**

Film: **Kodak Ektachrome EPP**

Exposure: **f/22**

Lighting: **Electronic flash: 5 heads**

Props and set: **120cm (4ft) diameter globe; chilli peppers**

Plan View

▶ *Logistics such as prop hunting and preparation can often be far more time-consuming than the actual shoot*

▶ *When you have gone to that much trouble it often makes sense to shoot back-up copies (including 35mm and roll-film) for reproduction later*

▶ *Very large, soft light sources are wonderful as fill lights*

H O T S T U F F

▼

"If we'd known what we were getting into, I'm not sure we'd have bothered. It took four of us – the art director, the assistant, Julie Nicholls and me – a week to stick those chillies on."

Thus Matthew Ward on the logistics of the shot: finding the globe, transcribing the map onto it ("The problem was, we suddenly realized it had to be accurate"), sticking the chillies on, realizing that because the chillies had depth they had to go around behind the globe

After that the lighting was not particularly difficult, though it did take up quite a lot of space: a very large – 120 × 180cm (4 × 6ft) soft box to camera right at 45°, and two standard heads diffused by a huge, 180 × 300cm (6 × 10ft) screen to camera left at right angles to the line of sight. As Matthew put it, "I'm really into soft light sources." The background is lit by two vertical strips.

S T I L L L I F E W I T H P E A R S

▼

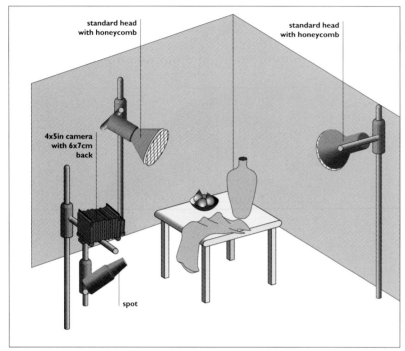

Photographer: **Maria Cristina Cassinelli**

Client: **Alba Paint "One Coat"**

Use: **Packaging**

Designers: **Estudio Avalos & Bourse**

Art Director: **Carlos "Tito" Avalos**

Camera: **4x5in with 6x7cm roll-film holder**

Lens: **210mm**

Film: **Fuji Velvia 120**

Exposure: **$\frac{1}{8}$ sec at f/22**

Lighting: **Electronic flash: 3 heads**

Props and set: **Everything painted a creamy off-white, including the pears**

Mᴀʀɪᴀ Cʀɪsᴛɪɴᴀ Cᴀssɪɴᴇʟʟɪ ɪs ɴᴏᴛ ᴊᴜsᴛ ᴀ ᴠᴇʀʏ ᴀᴄᴄᴏᴍᴘʟɪsʜᴇᴅ ᴘʜᴏᴛᴏɢʀᴀᴘʜᴇʀ; sʜᴇ ɪs ᴀʟsᴏ ᴠᴇʀʏ ɢᴏᴏᴅ ᴀᴛ ᴅᴇsᴄʀɪʙɪɴɢ ʙᴏᴛʜ ᴡʜᴀᴛ sʜᴇ ᴅɪᴅ ᴀɴᴅ ᴡʜʏ ɪᴛ ᴡᴏʀᴋᴇᴅ. Hᴇʀᴇ ᴀʀᴇ ʜᴇʀ ᴄᴏᴍᴍᴇɴᴛs ᴏɴ ᴛʜᴇ ʟɪɢʜᴛɪɴɢ sᴇᴛ-ᴜᴘ ɪɴ ᴛʜɪs sʜᴏᴛ:

"All the light was provided by two honeycomb grids and one spot. In spite of such contrasty sources there was no need to use any fill-in foam boards. As the set was almost all white, light would bounce all over, creating its own fill-in for the shadows." A further note appears as the "photographer's comment," below, but this is a remarkable example of white-on-white. Each of the three lights performs a very different function. The key light is a honeycombed standard head from camera left, lighting the pears, the pot and the sackcloth. The second light, again a standard head with a honeycomb, illuminates the walls and the corner. Finally, a third light, this time a spot on the floor, lights the side of the table.

Photographer's comment:

The low shutter speed allowed the model lights to warm the picture. I experimented with different speeds and changed a few objects in the set, so I could have a wide variety from which to choose the final shot.

► White-on-white is not synonymous with high key; indeed, there must be strong chiaroscuro if it is to work at all

► The picture would be much weaker if the stems of the pears were also painted white

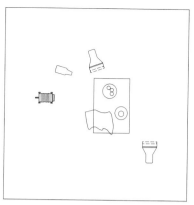

Plan View

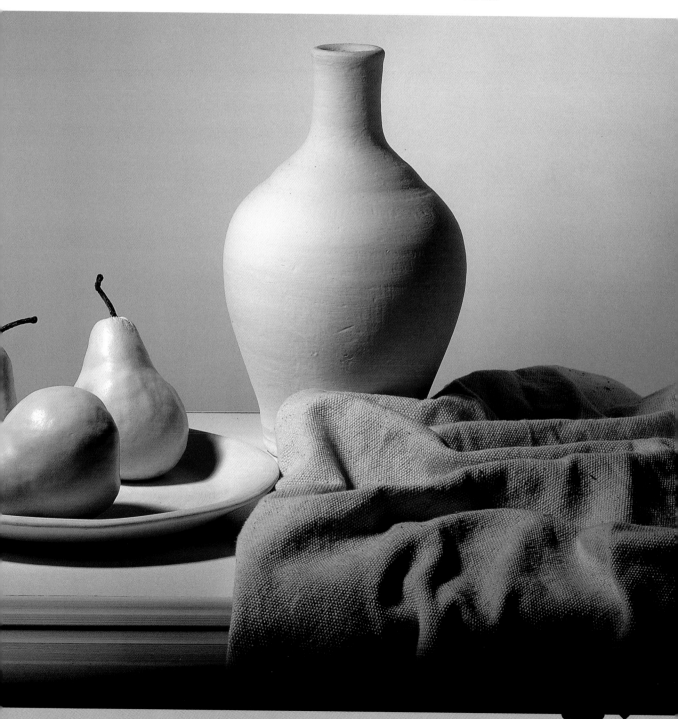

GRAINY BOWL OF FRUIT

▼

Photographer: **James DiVitale**

Use: **Shot for self-promotion; put into stock; used by printing company**

Designer: **Sandy DiVitale**

Camera: **35mm**

Lens: **135mm**

Film: **Scotch 1000**

Exposure: **f/22**

Lighting: **Electronic flash: 1 head**

Props and set: **Painted background**

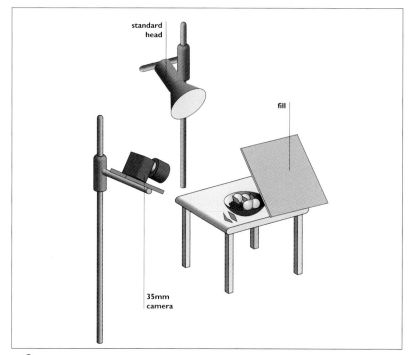

Sᴄᴏᴛᴄʜ/3M ISO 1000 ꜰɪʟᴍ (ᴍᴀᴅᴇ ɪɴ Iᴛᴀʟʏ ʙʏ Fᴇʀʀᴀɴɪᴀ) ᴡᴀs ʙᴇʟᴏᴠᴇᴅ ᴏꜰ ᴍᴀɴʏ ᴘʜᴏᴛᴏɢʀᴀᴘʜᴇʀs. Iᴛs ᴇɴᴏʀᴍᴏᴜs ɢʀᴀɪɴ ᴀɴᴅ ᴅᴇsᴀᴛᴜʀᴀᴛᴇᴅ ᴄᴏʟᴏᴜʀs ᴇᴀʀɴᴇᴅ ɪᴛ ᴛʜᴇ sᴏʙʀɪǫᴜᴇᴛ "ᴛʜᴇ ꜰɪʟᴍ ᴛʜᴀᴛ's sᴏ ʙᴀᴅ, ɪᴛ's ɢᴏᴏᴅ."

The lighting is clear from the illustration: a single standard head, high and to camera left (look at the shadow) and a fill card to camera right (look at the highlights on the "dark" side of the fruit). Positioning the card at an angle lightened the fruit without detracting from the effect of the strong shadow cast by the bowl. To emphasize the grain of the film still further Jim composed the picture in the central area of the 35mm frame, with plenty of room all around – the equivalent, roughly, of shooting on a half-frame (18 x 24mm) camera. Today, though, as he points out, "I can add all the grain I want, or change tonal values or saturation, by using the computer – I just don't need different films any more."

Photographer's comment:

Whenever I work with any materials or equipment, I try to make a virtue out of what others call limitations.

► *The relationship between grain and resolution is complex: a grainy film gives a different effect from a big blow-up off a less grainy film*

► *A grain screen will not work in colour, as the grains are of different colours*

Plan View

Photographer: **Jay Myrdal**

Use: **Project: "Photographers Do It Both Ways"**

Art director: **Martin Negus**

Camera: **4x5in**

Lens: **210mm**

Film: **Kodak Ektachrome 64**

Exposure: **Not recorded**

Lighting: **Electronic flash: 2 heads**

Props and set: **Built set; backdrop painted by Gordon Aldred**

Plan View

► *Model makers can do a great deal – but the photographer has to brief them first*

► *Even after you have the model, it can take a day or more to get everything to work properly*

► *A good enough painter can paint the "lighting" into the backdrop*

FLYING DINNER

▼

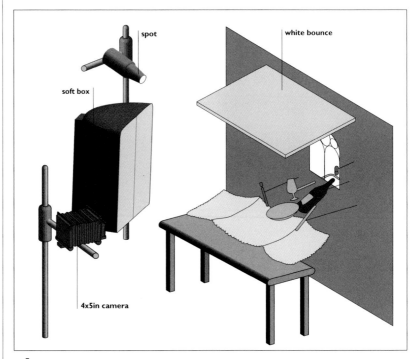

AS SO OFTEN WITH JAY MYRDAL'S PICTURES, WHAT YOU SEE IS WHAT WAS THERE: AN INGENIOUSLY BUILT SET, WITH CONSIDERABLE THOUGHT AND INGENUITY BEHIND IT, PHOTOGRAPHED RELATIVELY "STRAIGHT". EVEN THE LABEL ON THE BOTTLE IS SPECIALLY MADE.

The "table" is a relatively narrow board, only about 15cm (6in) in front of the painted background. The "flying" components are suspended by rods or wires through the background, with the exception of the glass, which is suspended on a hollow tube through which water can be pumped. A baffle inside the glass deflects the water so it will splash up as seen here. The glass is suspended behind the "table" and in front of the background, so that spills fall harmlessly to the floor.

The key light is a Fresnel spot to camera left and high, while a big soft box lights the overall set including the background. A rubber tube behind the backdrop holds the water; a hand-bulb squeezes it out. The best exposure was selected from a number of attempts.

Photographer's comment:

This was made for a project in which art directors took the picture while photographers acted as art directors – hence "Photographers Do It Both Ways."

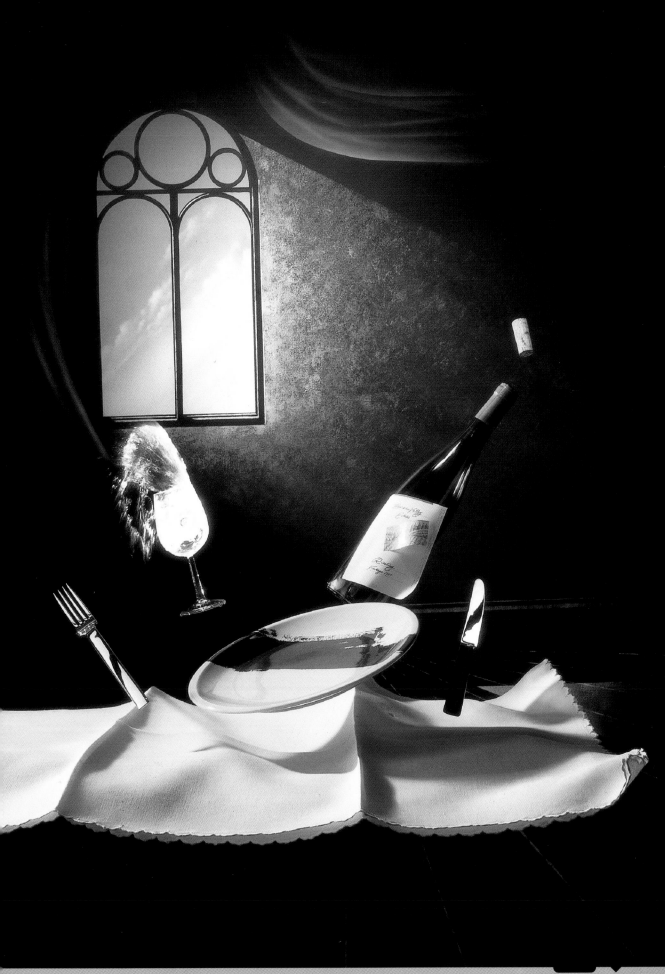

6 commercial considerations

Most of the photographers whose work is featured in the Pro-Lighting series earn their livings either in the field covered by the book or in some closely related field. Thus photographers of the nude may well submit portfolio or personal work for a book on nudes, but they will also shoot nudes commercially – for pharmaceutical ads, perhaps, or for cosmetics, or even to advertise the benefits of orthopaedic mattresses.

So it is with still lifes, except that there is, if anything, even more of an interplay between commercial work and personal work. Each feeds off the other, as it must. A commercial shoot may prompt the question, "What would happen if I shot it this way?" while a personal shoot may well result in a picture which catches someone's eye and leads to commercial work.

The main thing which distinguishes this chapter from the others is that in most cases trade names are more or less clear in the picture. There are one or two other examples of this in other chapters – Massimo Robecchi's "Poison" in Chapter 1, for example – and of course there are plenty of other commercial pictures in the book; but here the emphasis is on commerce and on turning an attractive but not necessarily photogenic subject into a picture which captures some of its glamour, as in Gérard de St. Maxent's "Bijou." A perennial problem in commercial photography, after all, is that many things are designed to be used or worn or consumed or touched, rather than to be photographed, and the photographer's task is to make something of the essence of the subject leak over into the picture.

Photographer: **Nick Wright**

Client: **Which? Car**

Use: **Editorial**

Assistant: **Kirsty Ashton-Bell**

Art director: **Wayne Campbell**

Camera: **4x5in**

Lens: **180mm**

Film: **Fuji Velvia**

Exposure: **f/32**

Lighting: **Electronic flash: 2 heads**

Props and set: **Built model**

Plan View

W H I C H ? C A R

▼

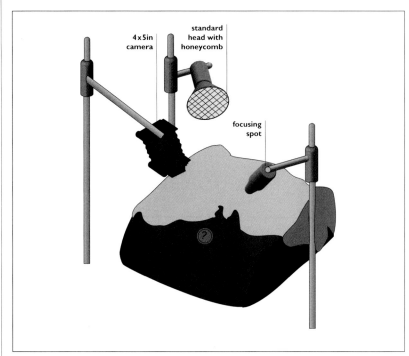

4 x 5in camera

standard head with honeycomb

focusing spot

?

THERE COMES A MOMENT IN THE RELEASE OF ANY NEW CAR WHEN THE PARACHUTE SILK IS PULLED ASIDE AND THE SLEEK AND CURVACEOUS BODYWORK IS REVEALED. THE MANUFACTURER'S BADGE IS OBVIOUSLY OF PARAMOUNT IMPORTANCE – AND HERE IT IS REPLACED WITH A QUESTION MARK.

► *White satin and silk can be fascinating materials to photograph because of their very high reflectivity, which creates dramatic highlights*

► *Re-creating a particular type of lighting is often a question of mood, rather than of detail. Try to imagine that you are present at the type of event which you need to evoke*

► *This model is only about 50cm (20in) square – but the brain "recognizes" it as part of a car*

The difficulty of the shot lay in portraying the ripple of the fabric, without making it look static. As so often, the solution to the problems lay in the lighting. One 3000-Joule head, in a standard reflector with a honeycomb, provided directional lighting with strong highlights. The other, a 2000-Joule focusing spot, was aimed principally at the badge – an obvious symbol for *Which? Car* magazine, a consumer publication – and is still more

directional. Also it overexposes the fabric very slightly, re-creating the mood when the lights go down, the spot lights flare up, and the new model is revealed.

Although this could have been done with a real car and a custom-made badge, the bonnet (hood) is also custom-made. In real life it was elegantly curved, but this proved to be the most dramatic angle – with the (expensive) curves invisible.

Photographer's comment:

We also shot this with the shadows of some branches falling on the red metal, but the plain, dramatic red proved to be much more effective.

Photographer: **Marc Joye**

Client: **Browning Sports Division**

Use: **Catalogue, editorial**

Camera: **8x10in**

Lens: **300mm**

Film: **Kodak Ektachrome**

Exposure: **f/22½ (f/27)**

Lighting: **Electronic flash: 1 head**

Props and set: **Maple leaf, dried insect, water**

Plan View

BORON FISHING ROD

▼

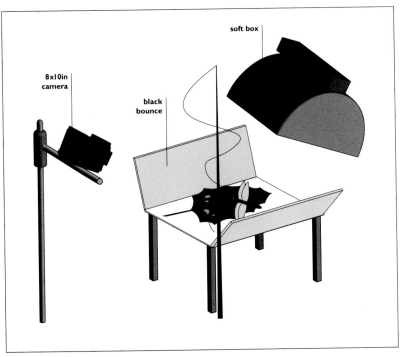

THE SUCCESS OF THIS PICTURE OWES AS MUCH TO THE ART DIRECTION (DONE BY THE PHOTOGRAPHER) AS TO THE LIGHTING. AND YET THE LIGHTING MUST COMPLEMENT THE PICTURE: SIMULATED SUNLIGHT, FOR EXAMPLE, WOULD HAVE BEEN INAPPROPRIATE.

To make life more interesting the rod is very shiny and reflective, but the maker's name and the rod name had to "read". The answer is a straightforward large soft box, but with large black bounce cards on either side of the set. As the photographer put it, "the soft light gives a reflection in the water drops, and makes the gold lettering on the rod shine; the two black panels were used to give more volume in the fishing rod."

This is an excellent example of the way in which the photographer needs some sympathy with his subject matter. Someone with less imagination than Marc Joye might have found it difficult to create the mood which this shot evokes: you can almost smell the damp air of autumn in this picture, with the fish biting.

► *Colour harmony is often enhanced more by diffuse lighting than by strongly directional lighting*

► *Both black and white bounces may find extensive employment when you are trying to create an impression of roundness*

► *Prop hunting – "styling," when you pay someone else to do it – is an essential part of many types of photography*

Photographer's comment:

The Boron 1500 fishing rod was a newly-created, super-light, super-strong, very flexible rod. I had a free hand to create a photo of it.

▼

Photographer: **Angelou Ioannis**

Use: **Self-promotion**

Assistant: **Soulis Ioannis**

Camera: **6x7cm**

Lens: **90mm**

Film: **Fuji Velvia RVP ISO 50**

Exposure: **3sec at F/3.8**

Lighting: **Ultra-violet "black light"**

Props and set: **Paper with papyrus texture, fluorescent spray paint**

Plan View

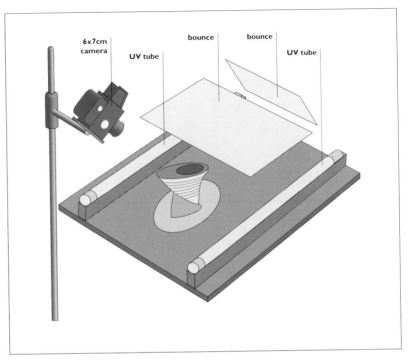

THERE ARE SOME PICTURES WHERE YOU CAN WORK OUT QUITE QUICKLY, AND WITH A FAIR DEGREE OF ACCURACY, HOW THEY WERE SHOT. THEN THERE ARE OTHERS THIS IS DEFINITELY ONE OF THE OTHERS.

The key lights – insofar as the term has meaning – are two 90cm (3ft) "black light" fluorescent tubes either side of the subject. The light-coloured paper background was sprayed with red fluorescent paint in a circle about 15cm (6in) in diameter. When the paint was dry, the perfume bottle was placed in the centre of the circle. Small bounce cards, suspended with Manfrotto (Bogen in the United States) "Magic Arms", reflected some of the fluorescent light back onto the bottle top to lighten it and onto the background to stop it going too dark blue.

Shooting at maximum aperture (f/3.8) for minimum depth of field means that attention is concentrated on the lettering on the top of the bottle – which was emptied, so that it would not be too dark in the picture.

► *"Magic arms" are jointed rods with an "elbow" in the middle and a clamp or other interchangeable support (including camera platforms and lighting holders) at each end. They are immensely useful*

► *Different films may respond very differently to UV light: testing is essential, and Polaroid tests may not necessarily be as informative as usual*

Photographer's comment:

I wanted to portray a colourful yet elegant and ethereal feeling. Using this alternative type of light (black light) I was pleased with the results and the Cibachromes [now Ilfochrome Classic] looked great.

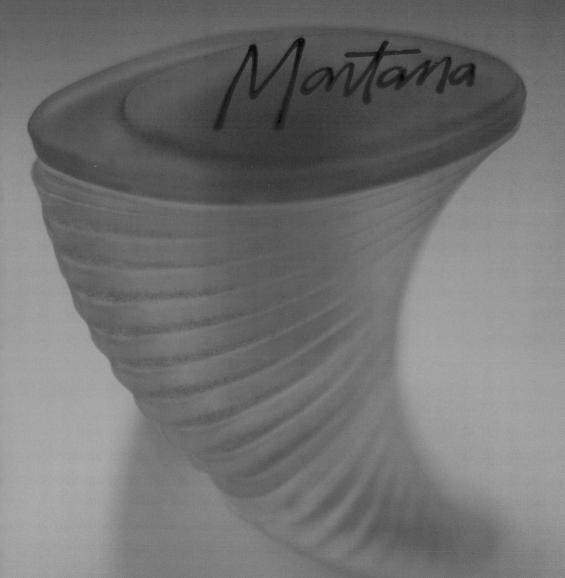

Photographer: **Ben Lagunas & Alex Kuri**

Client: **Corona Beer**

Use: **Poster, magazine advertising**

Assistants: **Dalila Sturat, Isak de Ita, George Jacob, Claudia Vaz**

Stylist: **Michel**

Art director: **Mario Agatti**

Production: **BLAK Productions**

Camera: **4x5in**

Lens: **210mm**

Film: **Kodak Ektachrome EPP ISO 100**

Exposure: **1/60sec at f/16**

Lighting: **Available light + flash**

Props and set: **Artificial beach**

Plan View

THE NATURAL BEER

▼

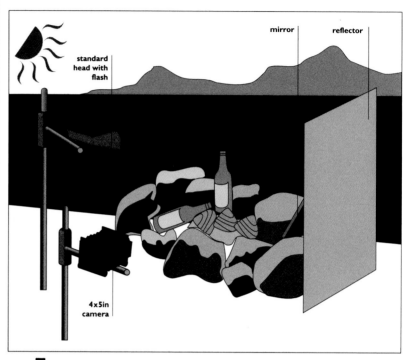

THE BEACH IS "ARTIFICIAL" ONLY INSOFAR AS THE ROCKS WERE ASSEMBLED IN THE FOREGROUND; THE BACKGROUND IS ENTIRELY REAL. THE FOREGROUND IS LIT RATHER MORE BRIGHTLY THAN THE AMBIENT LIGHT, IN ORDER TO MAKE IT STAND OUT.

A large reflector panel to camera right, just out of shot, bounces the sunlight from camera left onto the beer; it is supplemented by a mirror just behind the rocks. Additional lighting came from a standard flash head about 1.5m (5ft) from the subject, just behind the camera and rather above it. The extra height of the flash was necessary to avoid casting shadows from the rocks. The overall exposure is fairly rich, about ⅓ stop below the meter reading: too bright a foreground would look too contrived.

► *There is a fine line between making a foreground stand out and over-lighting it*

► *Slight under-exposure of the foreground, and still more under-exposure of the background, is often most effective*

► *Control of highlights and reflections is important in mixed daylight/flash shots like this*

Photographer's comment:

The ambient light was changing so fast that we had to work quickly and accurately to find the right moment for the shot.

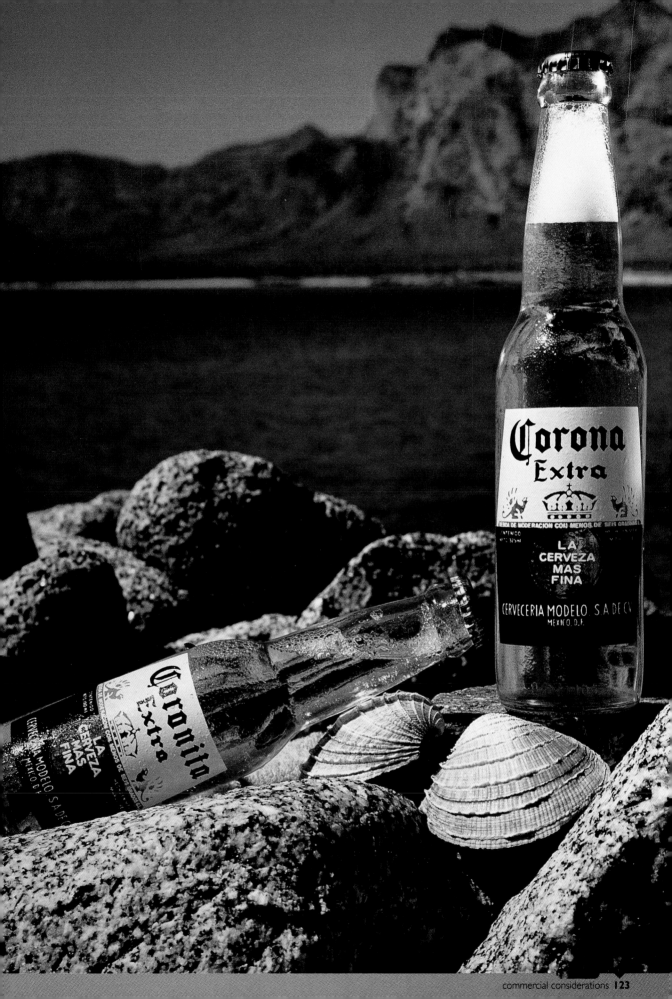

B I J O U

▼

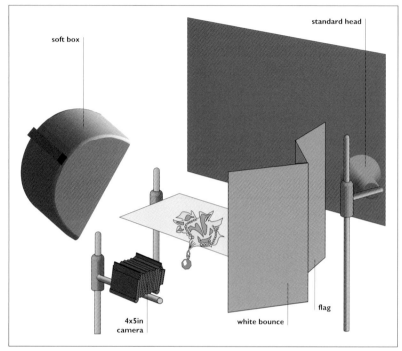

Photographer: **Gérard de St. Maxent**

Client: **Roudier**

Use: **Poster**

Camera: **4x5in**

Lens: **210mm**

Film: **Kodak Ektachrome EPP**

Exposure: **f/8**

Lighting: **Electronic flash: 2 heads**

Props and set: **Glass shelf; blue paper background**

THE CONTRAST OF THE TEXTURES AND FORMS OF THE JEWEL WITH THE ORGANIC FORM AND COLOUR BEHIND IT IS CRUCIAL; SO IS THE USE OF A SOFT BOX INSTEAD OF THE DIRECTIONAL LIGHT OFTEN ADVOCATED AS A MEANS OF CATCHING THE "FIRE" OF PRECIOUS STONES.

The big soft box, 1.5m (5ft) square, to camera left emphasizes the colours and shapes of the jewel – the diamonds are of secondary importance – and contrasts them with the colours and shapes of its support. A white bounce to camera right adds further roundness to the image. The background is lit very dark to further concentrate attention on the jewel. A flag grades the background and another flat stops light bouncing back from the background.

Photographer's comment:

A very wide aperture was used to ensure minimal depth of field.

► Most "fire" comes from the movement of the eye relative to the stone, which does not happen in a photograph, so highly directional lighting is less important than it might seem.

► Techniques and tools for positioning flags and bounces are very important to the still life photographer

Plan View

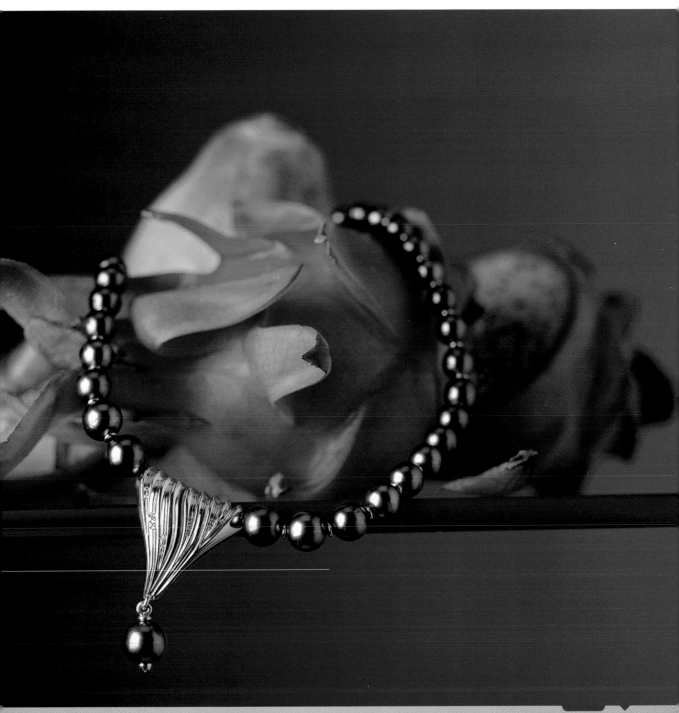

Photographer: **Guido Paternò Castello**

Use: **Self-promotion**

Assistant: **Fernando Ribeiro dos Santos**

Camera: **4x5in**

Lens: **210mm**

Film: **Kodak Ektachrome EPP ISO 100**

Exposure: **f/32**

Lighting: **Electronic flash plus light brush**

Props and set: **Marble slab; after-shave; fishes**

Plan View

▼

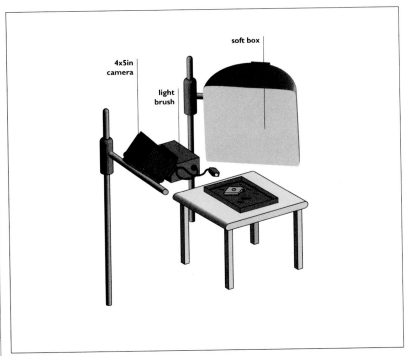

THIS SHOT IS ALL THE MORE REMARKABLE WHEN YOU REALIZE THAT IT IS A SELF-PROMOTIONAL
PIECE: A SUPERB CONCEPT, AS EVERYONE ASSOCIATES SMALL FISH WITH COOL, CLEAN WATER.
YOU CAN ALMOST FEEL THE FRESHNESS.

As is normal in a light-painted image there is a base exposure – made, in this case, with an electronic flash, which also helps to freeze the movement of the fish and avoids over-heating them – which was then supplemented with the light brush, creating the apparently sunny directionality of the light. The angle of the soft box can clearly be seen from the shadows below the two small fishes in the lower right-hand corner.

The only drawback to this shot is that it violates the old actors' adage never to work with children or animals: those fish will go just about anywhere except where you want them. The image as printed here is taken from a computer output.

► *Creating "sunlight" with a light-brush can take a lot of practice and a lot of Polaroids*

► *With a shot like this, introduce the fish only when you are satisfied with the Polaroids for the rest of the shot*

► *Transillumination with hot lights has been known to kill small fish*

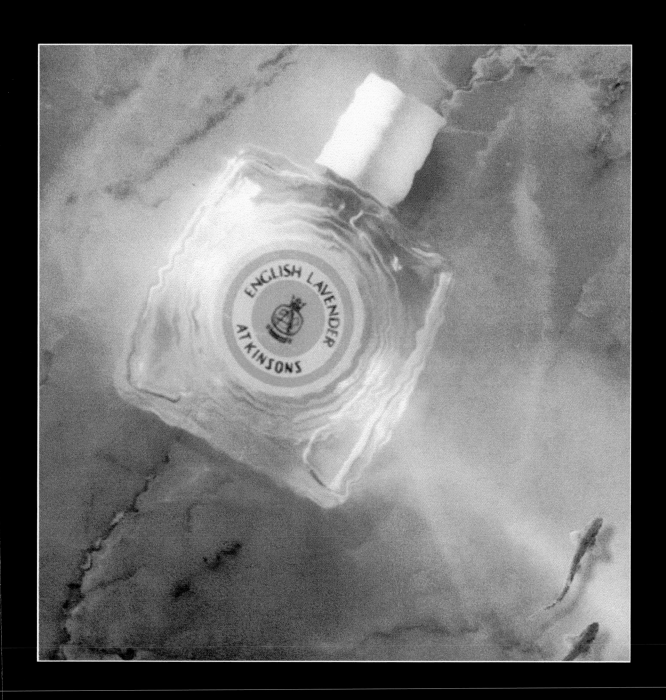

Photographer: **Jay Myrdal**

Client: **Ricoh**

Agency: **Leopard**

Use: **Trade press**

Assistant: **Peter Day**

Art Director: **Roland Haynes**

Camera: **8x10in**

Lens: **155mm**

Film: **Kodak Ektachrome 6117 ISO 64**

Exposure: **f/32½; multiple/long exposure**

Lighting: **Electronic flash: 8 heads**

Props and set: **Photocopier; paper; tables to hold paper**

Plan View

P H O T O C O P I E R

▼

T HE ILLUSION IS, OF COURSE, OF A COPIER SURROUNDED BY STACKS OF PAPER AS HIGH AS IT IS
— AND NO DOUBT IT COULD DO IT. BUT FOR PHOTOGRAPHY A QUICKER, EASIER ROUTE
WAS NECESSARY.

The copier is surrounded with tables on which the copies are stacked. Under the tables, in front of the machine and to camera right, there were two standard heads to light the front and side of the machine.

A big overhead soft box provided general illumination (look at the soft shadows on the copier), while three more heads also light the copier – two standard heads with spill kills, and one spot slightly back lighting the machine from the right to create the modelling and the highlights on the top. Two more spots create the pools of light on the background. After multiple "hits", the lights were all killed and the machine was run for at least 50 times to record the light on the control panel.

► *Very long exposures are frequently necessary to record warning lights, illuminated control panels and the like*

► *With a shape as complex as the top of the copier, multiple shadows are rarely too obvious*

Photographer: **Struan**

Use: **Portfolio**

Camera: **35mm**

Lens: **24mm lens + close-up lens**

Film: **Kodak Ektachrome EPN 100**

Exposure: **1/4sec at f/16**

Lighting: **Daylight**

Props and set: **Translucent cellophane**

Plan View

▼

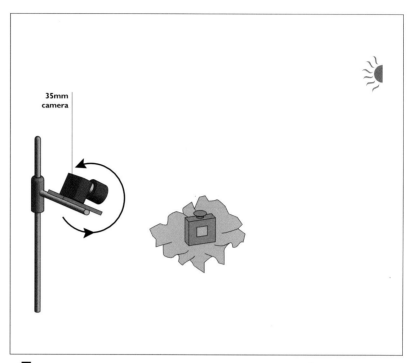

"**T**RY IT!" IS THE MESSAGE FROM THIS PICTURE. IF YOU SAY TO YOURSELF, "I WONDER WHAT WOULD HAPPEN IF . . .", THEN IT IS GENERALLY QUICKER AND MORE RELIABLE TO TRY IT FOR YOURSELF THAN TO ASK SOMEONE ELSE.

The technique is unbelievably simple. The perfume bottle was resting on translucent cellophane, and the camera was spun very quickly anti-clockwise around the optical axis for a range of exposures form $1/15$ to $1/2$ sec – always keeping the label in the centre of the field, thereby minimizing the impact of the spin at that point while maximizing it at the outer edge of the picture. This was the exposure which worked best.

The lighting is even simpler: daylight. It is the sort of picture which inspires you just to go out with your 35mm camera and a wide-angle lens and start spinning it at things. The wide-angle lens reduces the effect of camera shake and increases the apparent movement at the outer edge.

► *Deliberate camera movement can be very effective*

► *Try movement-induced blur with and without flash*

► *If you can, try second-curtain synch as well as normal first-curtain synch*

Photographer's comment:

This was originally to be used for a promotion for a new printing company, but it never ran.

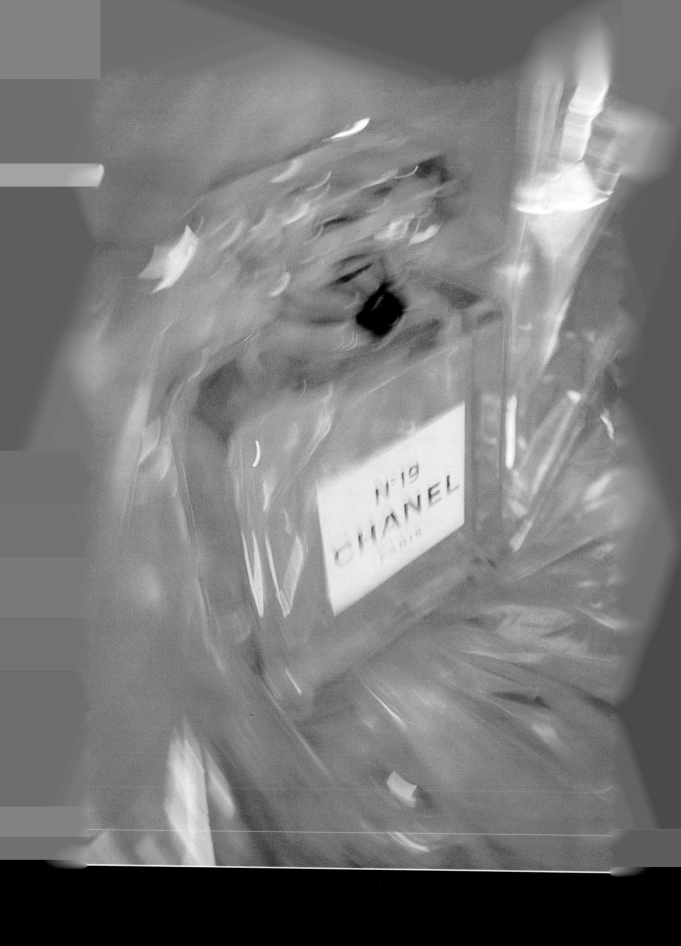

Photographer: **Jay Myrdal**

Client: **British Airways**

Agency: **Equator**

Use: **Brochure cover, world-wide advertising**

Assistant: **Peter Day**

Art director: **Simon Panton**

Camera: **8x10in**

Lens: **210mm**

Film: **Kodak Ektachrome 6118 ISO 64 Tungsten**

Exposure: **Multiple exposure at f/45**

Lighting: **Tungsten: 4 heads**

Props and set: **Model aircraft fuselage; built reflector**

BA CARGO

▼

Plan View

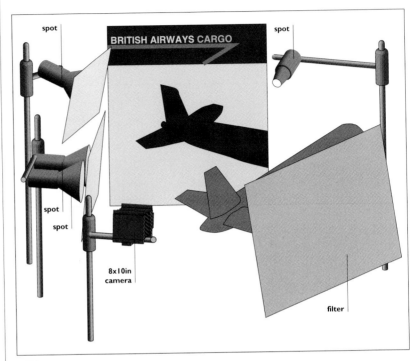

TUNGSTEN WAS USED FOR A VERY HARD LIGHT ON THE TAIL, TO CREATE THE ILLUSION OF SUNLIGHT: LOOK AT THE SHADOWS. THE LIGHT WAS ALSO WARMED SLIGHTLY WITH FILTERS.

Reference 1

Reference 2

Two more tungsten lights, diffused through tracing paper, light the "sky", and another (again diffused) provides fill on the tail. You can work out a lot from the accompanying reference shots, taken during the shoot. Reference 1 is shot from the camera position: you can see how diffused tungsten lamps light the "sky" (out of shot to camera right) and the tail. Reference 2 shows the "sky" (upper left),

the tail-piece and camera, and the back of the panel as shot (centre right).

The tail-piece is about 4m (13ft) long and was on loan from BA. The thing in which it is reflected – seemingly another aircraft – was built by Model Solutions from metallized Formica. There is also a large screen, painted blue with black fabric along the bottom, which is reflected as the "sky".

► Jay used three exposures in sequence with different lights on the tail and the sky in order to balance the intensities of the three lights

► Tungsten diffused through tracing paper can be used in much the same way as a soft box

7

exploring

concepts

► Because of the extraordinary range of subject matter, techniques, and ideas inherent in a book about still life photography, this last chapter is something of a catch-all for ideas which do not quite fit elsewhere.

Insofar as there is a unifying factor – and we admit that it is on occasion tenuous – the thing about the pictures in this chapter is that they are designed to create a mood rather than to represent physical objects. The physical objects are of course essential, but they are in a sense secondary to the message they carry: Maurizio Polverelli's "Suburban Sport" is about the streets of New York rather than being a mere representation of some clothing; Jay Myrdal's "Exploding Pig" is about saving and spending; Johnny Boylan's "Lost Property" is about timelessness and nostalgia, days and values now only half-remembered.

One thing that most of these pictures have in common is that they involve more or less elaborately contrived assemblages of objects – though the size of the subject is not necessarily any guide to the complexity or difficulty of setting it up, as Peter Laqua's "Durchblick" illustrates. Some sets are relatively simple; some required fairly demanding prop-hunting; and some involve models, and more than touch upon special effects. As in the other chapters, the photographers have employed a wide variety of lighting techniques, so no generalizations can be drawn there, and the chapter reflects the overall composition of the book as far as formats are concerned, with four 4 x 5in images, two 8 x 10in and two rollfilm.

Photographer: **Benny De Grove**

Use: **Exhibition**

Stylist: **An De Temmerman**

Camera: **6x6cm**

Lens: **50mm**

Film: **Polaroid (emulsion transfer)**

Exposure: **f/22**

Lighting: **Electronic flash: 2 heads**

Plan View

E V O L U T I O N O F M A N K I N D

▼

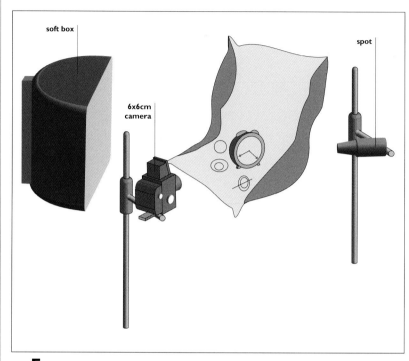

EMULSION TRANSFER – WHICH INVOLVES PHYSICALLY FLOATING THE EMULSION OFF A
POLAROID PRINT AND TRANSFERRING IT TO ANOTHER SUPPORT, USUALLY WATER-COLOUR
PAPER – OFFERS CONSIDERABLE OPPORTUNITIES FOR IMAGE MANIPULATION.

The shadows are important, so the key is a highly directional spot, from camera right, very slightly back lighting the subject. An 80 x 80cm (32 x 32in) soft box to camera left provides some fill, but principally adds highlights on the left side of the image around the rim of the battered clock.

Some photographers prefer to work with originals, while others shoot an original on conventional chrome and then duplicate it onto Polaroid in order to allow several different manipulations to be tried on a single identical image. Of course, the shot can be left set up, and several originals can be shot.

► A highly directional spot will still cast distinct shadows in the face of quite a strong fill, if the fill is soft enough

► Highlights on battered metal can be very effective

Photographer's comment:

As I wanted long shadows, the light had to be very low. The figures on the clock were reversed to accentuate the impression that something is going wrong in the evolution.

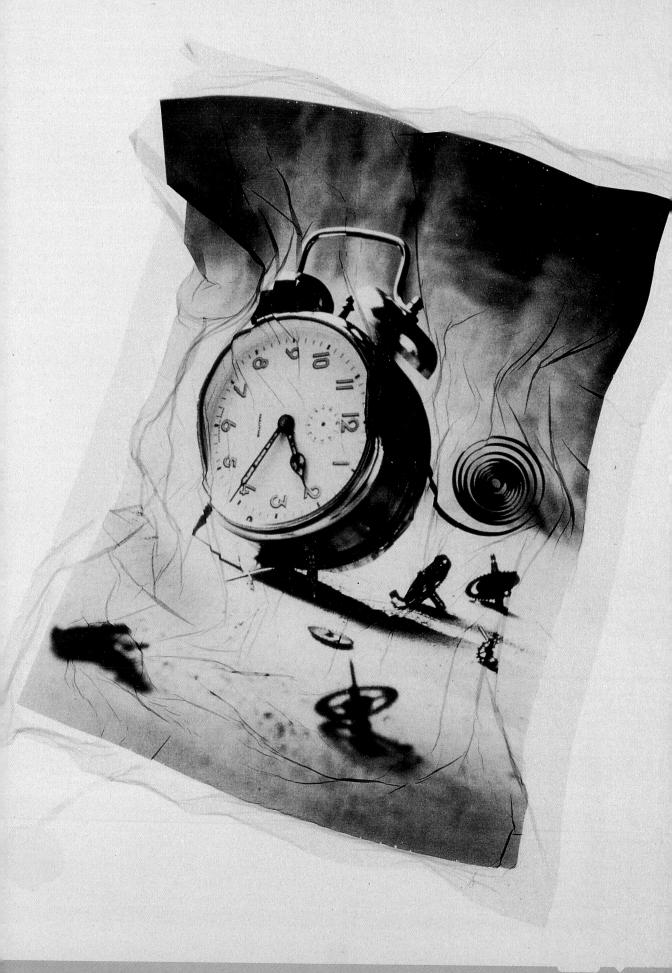

Photographer: **Roger Hicks**

Client: *Shutterbug* **magazine**

Use: **Editorial**

Assistant: **Frances Schultz**

Camera: **6x7cm**

Lens: **135mm**

Film: **Fuji Velvia RVP**

Exposure: **1sec at f/11**

Lighting: **Mixed: see text**

Background: **1930s wooden table top**

Plan View

A V I A T O R

▼

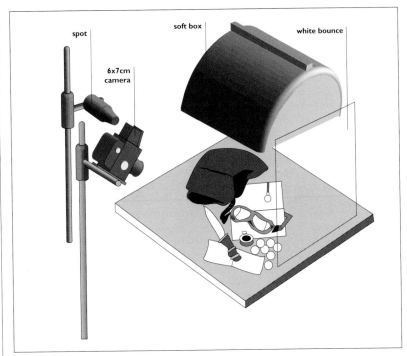

VELVIA IS AN UNFORGIVING FILM BUT IT DELIVERS REMARKABLE SATURATION AND SHARPNESS IF YOU GET IT RIGHT. THIS WAS SHOT TO SEE HOW IT REACTED TO MIXED LIGHTING: A 1200-JOULE SOFT BOX OVERHEAD AND AN 800W TUNGSTEN LIGHT TO CAMERA LEFT.

The two lights were "juggled" by varying the shutter speed, which increased or decreased the effect of the tungsten light without varying the effect of the flash, which depends solely on aperture. The only easy way to do this is with plenty of Polaroid: eight or 10 sheets must have been used up on this project.

The key light is the 800W focusing spot to camera left, set as tight as possible to create the illusion of the setting sun, while the fill is the overhead soft box for the "sky". Two small white bounces, one behind the shot and one to camera right, helped to differentiate the flying helmet from the similarly coloured table.

► *Careful positioning of picture elements may be needed to minimize (or maximize) reflections*

► *One of the coins is held in position with a small piece of silicone putty*

► *A miniature technical camera (Linhof) allowed control of depth of field*

Photographer's comment:

The knife, coins and text are Tibetan; the linen-backed map dates from the 1920s.

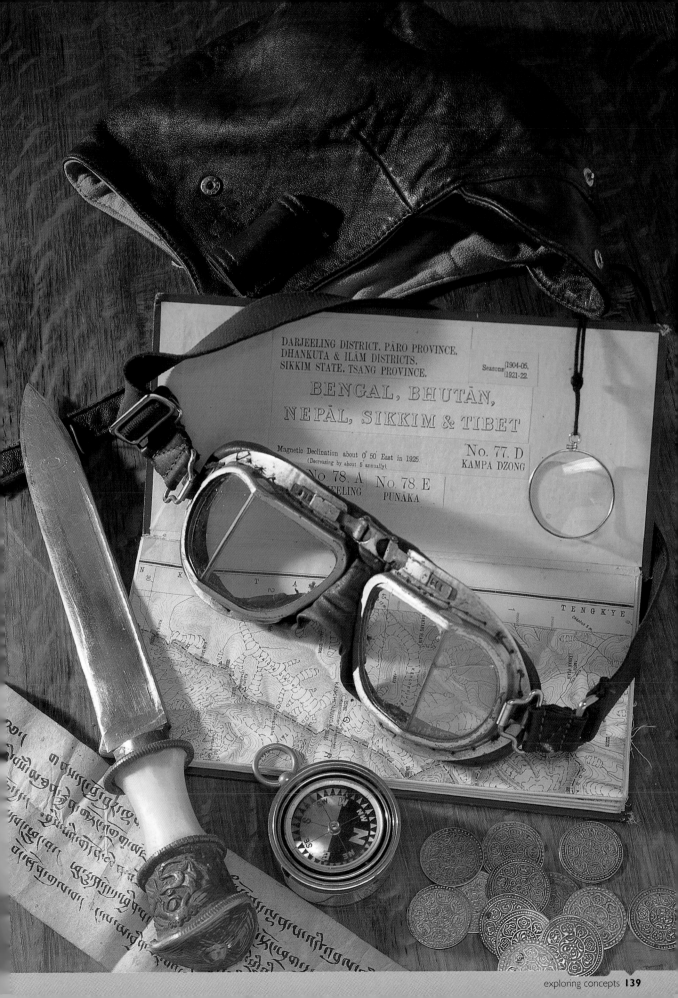

DURCHBLICK

▼

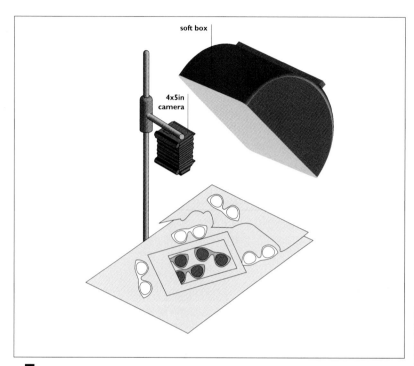

soft box

4x5in
camera

Photographer: **Peter Laqua**

Client: **Brillen-Optiker**

Use: **Poster**

Camera: **4x5in**

Lens: **210mm**

Film: **Fuji Provia**

Exposure: **Not recorded**

Lighting: **Electronic flash: one soft box**

Props and set: **Sunglasses, corrugated cardboard, white spray**

THIS IS A TRIUMPH OF SET-BUILDING. ANY PHOTOGRAPHER WHO GLANCED AT THE IMAGE WOULD "SEE" A POLAROID. EXCEPT, OF COURSE, THAT IT ISN'T A POLAROID. THE "POLAROID" FRAME IS CUT FROM CARDBOARD, AND THAT PART OF THE IMAGE IS NOT SPRAYED WHITE.

The only give-away (and you have to examine the picture closely to see it) is the shadow of the upper part of the "Polaroid", opposite the tear-off tab. The sole light is a 1 × 1m (39 × 39in) soft box as illustrated; the highlight on one spectacle lens gives you a pretty good idea of where it is. Once you have an idea like this, the real secret lies in working out how to do it and in trying different materials (this looks very like special-effects snow) to realize your vision.

► *Companies catering to the movie business often offer a wide array of special-effects materials*

► *A simple soft box gives very different effects on dull, matte surfaces and on shiny surfaces*

► *A large soft box, used close, minimizes unwanted shadows from the frame but gives clear shadows on the glasses and cardboard*

Plan View

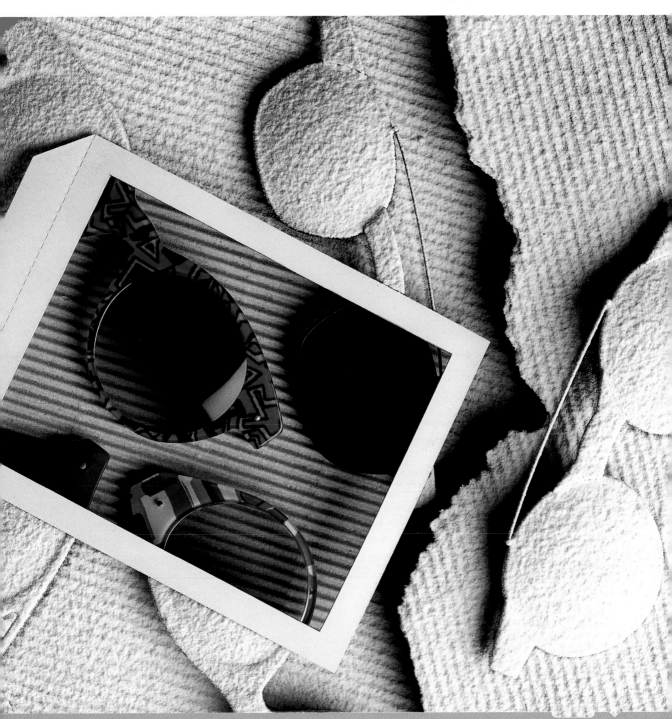

ANNÄHERUNG

▼

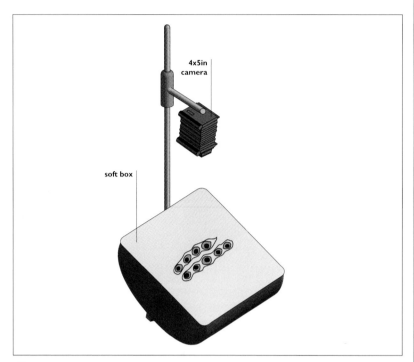

Photographer: **Peter Laqua**

Use: **Exhibition**

Camera: **4x5in**

Lens: **210mm macro**

Film: **Kodak Ektachrome**

Exposure: **Not recorded**

Lighting: **Electronic flash: 1 head**

4x5in camera

soft box

A GERMAN PHOTOGRAPHER GIVES THE LIE TO AN OLD ENGLISH SAYING, "ALIKE AS TWO PEAS IN A POD". THE APPEAL OF THIS PICTURE LIES IN PRESENTING SOMETHING VERY RECOGNIZABLE IN A FORM WHICH IS MOST UNUSUAL.

The lighting is exactly what it seems to be: a soft box used as a light table. The peas are obviously chosen to give the right combination of transparency and opacity: for such a shot, it is sometimes necessary to haunt the shops for several days until precisely the right product comes in. Then you need to select the peas carefully, and persuade the shop not to damage them as they weigh and pack them. After the logistics come the aesthetics . . .

It may also be necessary to mask the area outside the shot with black paper in order to avoid flare, although this is less of a problem with multi-coated lenses.

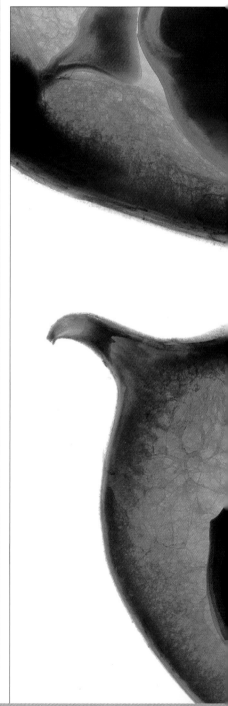

► It is sometimes difficult to anticipate the effects of powerful transillumination

► Massive depth of field is not essential, as you do not see "into" the subject: you see shadows on the surface of it

Plan View

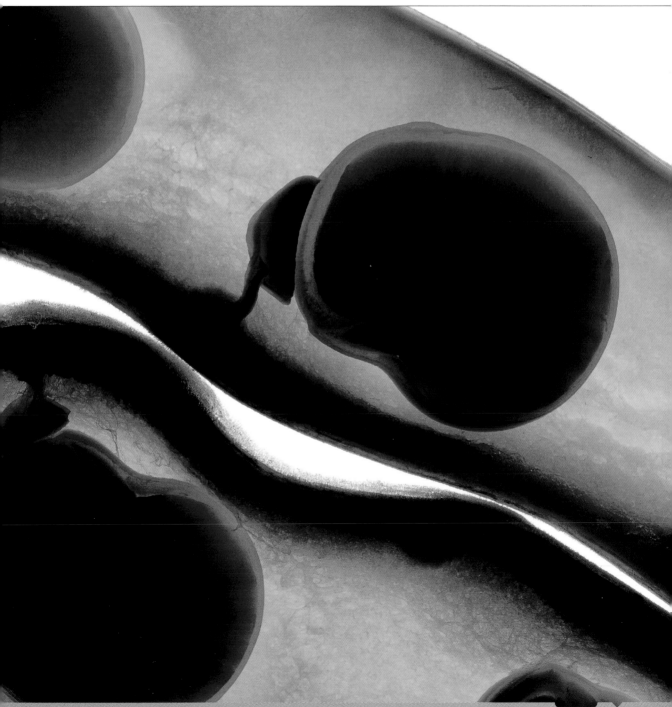

Photographer: **Maurizio Polverelli**

Client: **Champion**

Use: **Portfolio**

Stylist: **Emanuela Mazzotti**

Camera: **8x10in**

Lens: **300mm**

Film: **Kodak Ektachrome 64**

Exposure: **Not recorded**

Lighting: **Electronic flash: 5 heads**

Props and set: **Painted wall**

Plan View

SUBURBAN SPORT

▼

THE LIGHTING ON THIS SET IS SURPRISINGLY COMPLEX, WITH TWO SPOTS, TWO SOFT BOXES AND A STANDARD HEAD – AND THE KEY LIGHT IS THE PHOTOGRAPHER'S UNUSUAL BUT ALMOST TRADE-MARK SET-UP OF A SOFT BOX PLUS A BLACK BOUNCE.

This key is a large soft box 100 × 150cm (40 × 60in) to camera left, directly opposite a black bounce. It provides the highlights on the satin shorts and the support poles; the quality of light is different from either a strip light or a plain soft box. The other soft box acts principally as a fill; you can work out its precise location from the reflections on the right-hand side of the support poles.

A blue filtered spot to camera right increases the intensity of the colour of the outfit, while another spot throws the shadows of the support poles onto the background: these echo the shapes of the poles (which themselves are reminiscent of builders' scaffold poles) but they are not the shadows of the poles in shot. Finally, another blue filtered head lights the background.

► *Using separate poles to create the background shadow solves the awkward problem of the shadows of the clothes on the poles*

► *The shot reflects the old newsman's adage: when faced with a choice between truth and legend, print the legend*

Photographer's comment:

Basketball is an American game; people play it in the streets, surrounded by painted walls.

LEO

▼

Photographer: **Maurizio Polverelli**

Client: **Mario Formica spa**

Use: **Calendar**

Stylist: **Emanuela Mazzotti**

Camera: **8x10in**

Lens: **360mm**

Film: **Kodak Ektachrome 64 (6117)**

Exposure: **Not recorded**

Lighting: **Electronic flash: 2 heads**

Props and set: **Scratched stone; chain; semi-precious stones**

Lᴉᴋᴇ "Sᴜʙᴜʀʙᴀɴ Sᴘᴏʀᴛ" ᴏɴ ᴛʜᴇ ᴘʀᴇᴠɪᴏᴜs ᴘᴀɢᴇ ᴛʜɪs ᴘɪᴄᴛᴜʀᴇ sʜᴏᴡs ᴛʜᴇ ᴜsᴇ ᴏꜰ Mᴀᴜʀɪᴢɪᴏ Pᴏʟᴠᴇʀᴇʟʟɪ's ᴜɴᴜsᴜᴀʟ ʙᴜᴛ ᴇꜰꜰᴇᴄᴛɪᴠᴇ ᴛᴇᴄʜɴɪᴏ̨ᴜᴇ ᴏꜰ ᴄᴏᴍʙɪɴɪɴɢ ᴀ sᴏꜰᴛ ʙᴏx ᴀɴᴅ ᴀ ʙʟᴀᴄᴋ ʙᴏᴜɴᴄᴇ ꜰᴏʀ ᴀ sᴏꜰᴛ ʏᴇᴛ ᴅɪʀᴇᴄᴛɪᴏɴᴀʟ ꜰɪʟʟ.

The key, is however, the snooted spot to camera right, back lighting the image; look at the highlights on the chain. The soft box is to camera left, with the black bounce on the same level as the table. A white bounce directly over the subject further softens and diffuses the light, while still leaving it clearly directional.

The direction of the key echoes the direction of the scratch marks, and compositionally the picture is interesting because of the conflicting diagonals of the scratch marks and the right-hand chain with the left-hand chain. It is one of those pictures where everything looks obvious – and where you suddenly realize that, to make a picture that natural, you have to take a lot of trouble.

Photographer's comment:

All of us remember the lion as the strong animal which fought the slaves in the days of the Roman Empire. The positioning of the stones helps emphasize the movement of the lion's arm.

- ► The simpler the still life, the stronger the composition must be

- ► The ultra-large 8 x 10in format captures texture beautifully

- ► Good prop hunting is essential; it would be all too easy to realize this idea only partially

Plan View

LOST PROPERTY

▼

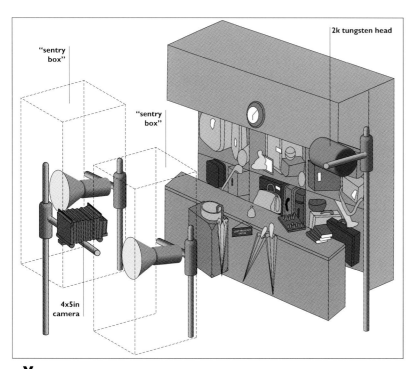

Photographer: **Johnny Boylan**

Client: *Southside* **Magazine**

Use: **Editorial**

Camera: **4x5in**

Lens: **180mm**

Film: **Fuji Velvia ISO 50**

Exposure: **1½sec at f/22½**

Lighting: **Mixed flash and tungsten**

Props and set: **Client's luggage in built set**

YOU CAN ALMOST SMELL THE DUST ON A TIMELESS AFTERNOON; SOME OF THIS STUFF HAS BEEN HERE SINCE THE 1930S OF COURSE, IT IS A BUILT SET, FOR AN "ADVERTORIAL" FEATURE ON LUGGAGE.

The main light comes from a lot of flash power – about 10,000 Joules – bounced into "sentry boxes" of white expanded polystyrene sheets 240 × 120cm (8 × 4ft) and faced with tracing paper. The effect is to create a giant soft box, for a very flat, soft light. Then, a 2K tungsten light from camera right was set to graze along the front of the set as if it were late afternoon or early evening sun coming through a window. The overall effect is as if the sun were being diffused in dusty air, perhaps supplemented by a couple of dusty skylights in the ceiling. The colour of late sunlight is similar to that of tungsten lighting, so this flash-plus-tungsten technique on daylight-balanced film is of general application.

► Building big soft boxes is a useful
technique but requires a lot of power

► Tungsten lights run at 3200° or
3400°K; setting sun can run as low as
2800°K

Plan View

Photographer: **Jay Myrdal**

Client: **Ilford Master Class**

Use: **Lecture; subsequently placed in**
***Telegraph* library**

Assistant: **Marcos Lima**

Camera: **4x5in**

Lens: **150mm**

Film: **Kodak Ektachrome 6117 ISO 64**

Exposure: **f/32½**

Lighting: **Electronic flash: 6 heads**

Props and set: **Built set: see text**

Plan View

EXPLODING PIG

▼

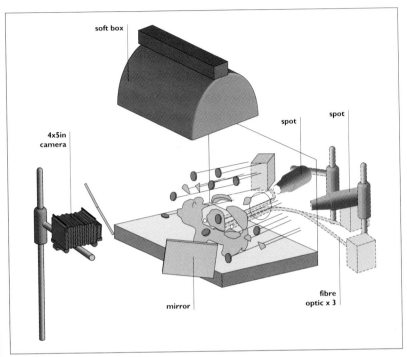

THIS IS AN IMAGE WHICH SCREAMS "COMPUTER MANIPULATION" — AND YET, IN ALL ESSENTIALS, IT IS AN ABSOLUTELY STRAIGHT SHOT CREATED IN CAMERA. THE ONLY COMPUTER MANIPULATION INVOLVED IS THAT THE COLOUR OF THE PIG WAS CHANGED AFTERWARDS . . .

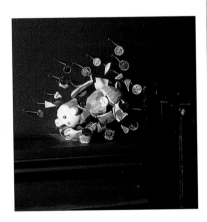

The pig – including its fragments – and the coins were all part of a set built to camera, with concealed wires as shown in the set-up shot.

The main lighting came from two powerful spots, and three fibre optics, all coming through a hole in the background behind the pig: the intention was to get as much light "inside" the pig as possible. The only light from the front was a 45cm (18in) square soft box, although it was supplemented by mirrors to light specific areas.

Also passing through the hole was an air-line. Inside the pig, there was a little dust and some torn up paper. Releasing a trigger on the air-line also fired the flash via a Mazov trigger. The debris from the explosion is this dust and paper.

► *Mazov triggers can be set to react to pressure, sound, light and more*

► *There are often non-electronic ways of creating pictures which are apparently "comped" together*

Photographer's comment:

We did this about 50 times at FOCUS, the annual UK exhibition, and then several more times in the studio. I also used this picture as a test-ground for my earliest computer manipulations, changing the colour of the pig and substituting other countries' coins for the British originals.

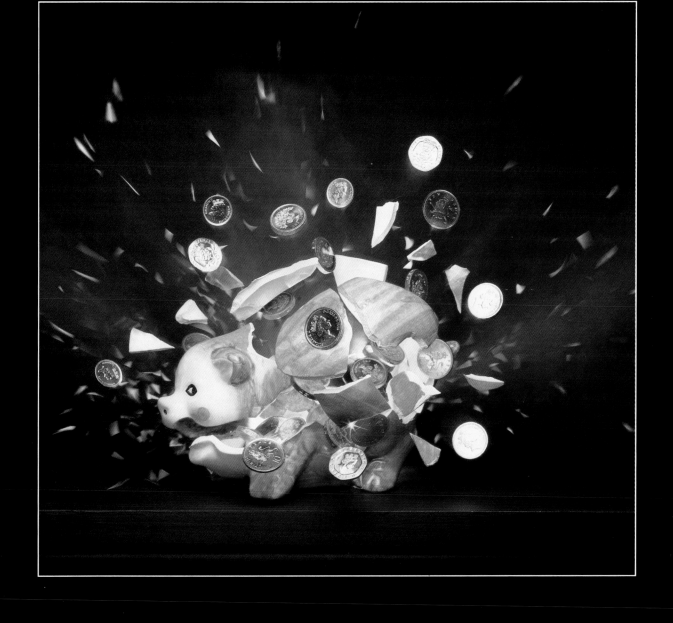

SECTION TWO:
SPECIAL EFFECTS

▼

THE CAMERA IS A NOTORIOUS LIAR. ANYTHING WHICH REDUCES THE THREE-DIMENSIONAL, MULTI-SENSUAL WORLD TO SHAPES ON A FLAT SURFACE CAN HARDLY BE OTHERWISE. EVEN WITHOUT RESORTING TO TRICKERY, IT CAN TELL A GOOD DEAL LESS THAN THE WHOLE TRUTH. A ONE-EYED MAN, PHOTOGRAPHED IN PROFILE FROM THE SIDE OF HIS GOOD EYE, IS INDISTINGUISHABLE FROM A MAN WITH TWO EYES. FOR THAT MATTER, BY CAREFUL SELECTION OF VIEWPOINT, EVEN "IMPOSSIBLE OBJECTS" CAN BE PHOTOGRAPHED, CREATING THE KIND OF ILLUSIONS AND REVERSALS OF PERSPECTIVE ON WHICH M.C. ESCHER'S FAMOUS DRAWINGS AND ENGRAVINGS DEPEND.

Nor is viewpoint the only way in which photography can be persuaded, in the famous British phrase, to be "economical with the truth." It takes a tiny slice of time, and freezes it for posterity. Again, no trickery need be involved. Consider a wedding photograph, the loving couple staring into one another's eyes. It does not show the subsequent arguments, the bitterness, the divorce. Like any "special effects" picture, it shows a scene, a situation, which existed only at one particular moment in time.

The slice of time that is frozen by the camera may however be of widely varying duration – and once again, this can be used to create a wide variety of different impressions. Two examples, neither of them in this book, come to mind. One is a long exposure of someone eating dinner. The knife and fork are blurred in his hands, creating the impression of lightning speed and massive greed. The other is an arctic explorer, his arm outstretched, who has just flung a cup of water into the air where it has

frozen into a veil of ice which hangs suspended. This scene existed for just a thousandth of a second, but this was long enough to take a picture.

In the former case, time has been compressed: action which normally takes a second or two has been compressed into something which we can take in with the blink of an eye. In the other, time has been stretched: something which would normally be too fast for the eye to see has been captured so that we can examine it at our leisure. It is no exaggeration to say that all photographs are examples of special effects.

And thus far, we have only considered straightforward photography, which more or less mirrors the way that the human eye sees. What of double exposure? We are all familiar with the "ghost" picture, where a figure is reduced to an incorporeal wreath through which the background is clearly visible.

Nor is the "ghost" the only way to use double exposures. Objects can be photographed sequentially against a black

background – black velvet and black flock are the favourites – and there will be no trace of that background, though the objects which were in real life sequential will be represented as simultaneous.

Another way in which photography's vision differs from that of its user is the way in which it records colours. It may of course not record them at all, reducing the image to monochrome, or it may record them with greater or lesser intensity. Perhaps most notably, films cannot adjust to different light sources: tungsten will always record warmer than daylight or flash. Normally, we take no notice of these differences, but photography can draw them to our attention.

What is more, a photograph is a picture which can be physically manipulated. Every child must have cut pictures from magazines and created collages; the photographer can shoot the pictures specially, and collage them together afterwards. This may involve little more than the scissors and paste

approach of the child, or it may involve the application of artwork to blend the images together. Historically, this was achieved with airbrush; today, it is increasingly often done with a computer.

THE SPECIAL EFFECTS STUDIO

Many special effects shots can be accomplished in relatively tiny studios, just a few metres square: they are effectively "table-top" shots, which could be duplicated by many amateurs in their living-rooms or garages. Again, about half the shots in this book fall into this category: they could be accomplished in a space maybe four metres by five metres, though in some cases this would involve very careful use of space. Other pictures require a lot of room: a large studio, sometimes a very large studio.

When it comes to equipment, overwhelmingly the most popular format is 4x5 inch: over half the pictures in this section were made on 4x5 inch cameras, with more than ten per cent on 8x10

inch and three on 5x7 inch.

The reasons for the predominance of 4x5 inch are simple. First, the big ground glass makes it easier to see and to plan a shot on the focusing screen – and a 4x5 inch Polaroid is (just) big enough to give plenty of meaningful information. Second, the complete absence of interlocks makes multiple exposures easy. Third, if the image must be subsequently manipulated (which means an inevitable loss of quality, as compared with a camera original) then there is a reserve of quality available. Fourth, there are times when camera movements are all but essential, especially when a receding plane is to be held in focus using the Scheimpflug rule.

Admittedly some of these arguments apply *a fortiori* to still larger formats such as 5x7 inch, 8x10 inch and even 11x14 inch, but there are counter-arguments of expense (especially of Polaroids) and of depth of field: where 4x5 inch is typically used at around f/22 to f/32, larger formats are commonly used at f/45. This

translates into a requirement for significantly more power in lighting.

LIGHTING EQUIPMENT

Because the term "special effects" embraces such a wide range of subjects, it is not really possible to lay down hard and fast rules about what is needed in the way of lighting – except to say that you are likely to need plenty of it. With flash, many studios have 10,000 watt-seconds or more, and resources of 20,000 watt-seconds and above are not unusual. In tungsten, which is mixed with flash surprisingly often, the minimum would normally be two or three "inky dinky" 500-watt spots, three or four bigger "redheads" or 750 to 800-watt focusing lights, and two or three still bigger lights, from 2000 to 5000 watts.

Having said this, many of the pictures in this book are very simply lit with just two or three flash heads, sometimes just with one. The soft box is ubiquitous, while standard reflector heads are the most common of all. Comparatively few

pictures use strip lights. A surprise, however, is the number of photographs which make use of a slide projector. In most cases, this is used to back project backgrounds, as in Francesco Bellesia's *White Bird* (page 173) or James DiVitale's *Door on Sky* (page 250), but Peter Barry used three slide projectors in his *Wooden Model* (page 266). A handful of pictures use light brushes, though not as many as one might expect, and two or three use projection spots.

Lights are quite often filtered with gels, and bounces of all sizes are commonplace. Combined with judicious use of both tungsten-balance and daylight-balance films, and filtration on the camera lens, the balance of "warm" and "cold" lighting effects can be of considerable importance in special effects photography.

There is just one picture in this section which was taken by daylight, Frances Schultz's *Harbour* (page 190), though there are two or three others which could have been taken by daylight.

LOGISTICS, PROPS AND BACKGROUNDS

As with lighting, so with logistics, props and backgrounds: the range of the category "special effects" is such that it is impossible to lay down hard-and-fast rules.

It is however necessary for the photographer to be even more of a handyman than most. Although specialist model-makers and set-builders are frequently employed, there are plenty of times when neither time nor budget can justify this and the photographer must make things up himself.

Also, like food photography, special effects photography tends to consists of a very great deal of preparation and a comparatively small amount of actual shooting time. While the glamour photographer or portraitist can often set up his background in a few minutes, and shoot within a few minutes of the model's arrival, the special effects photographer may well take hours or even days to set up a shot. There are plenty of improvisations, to be sure, but they are tackled one after the other as the concept is developed: there are far fewer opportunities to "wing it" when one is actually shooting, because unlike (say) fashion one is rarely banging off several rolls of film and choosing the best exposure. Instead, one has a single previsualized image in mind, and the only reason to shoot more than one exposure is for insurance (pictures do get spoiled at the lab) or to make carefully controlled and pre-planned changes to exposure and filtration.

When it comes to backgrounds, plain seamless paper backgrounds are commonplace, and quite often there are back-projected or transilluminated backgrounds using translucent materials such as Rosco Tough Lux or even Kodatrace, though the material must be chosen carefully to avoid "hot spots" from the projector lamp. A surprisingly common requirement is for a "starry" background, which is normally achieved in one of two ways. The first is a perforated black paper background, illuminated from behind, through which the lights shine; if coloured stars are required, either the lights or the holes may be filtered. The second way to create "stars" is by sprinkling glitter on a black velvet or black flock background and photographing that by reflected light. Colour may be introduced by using coloured glitter or through filtration on the lens or light sources.

Black velvet or flock is also widely used, as already noted, to create a "dead" background which will not read in the picture.

THE TEAM

The nature of special effects photography means that it is possible for one photographer to work on his or her own, slowly and methodically building a

set, working out the lighting, and then shooting it. It is normally much easier, however, to work with an assistant. This means, for example, that instead of moving a light and then walking back to the camera to see what the effect is, the photographer can simply ask the assistant to move the light. Likewise, the assistant can be sent out to chase props or to telephone suppliers or to load dark slides while the photographer is deeper in the creative side of things.

More than one assistant is a luxury, and may of course be an expensive luxury: quite a number of the photographers in this book habitually work with only one assistant, though others may be hired as necessary – or other people may be pressed into service, such as art directors and anyone else who is hanging around.

There may however be a need for other specialist talents either before or after the shoot. Model-makers, set-builders and painters have already been mentioned, and if there are live models, then the usual hair and make-up people may also be required. When it comes to after-work, there may be a need for specialist retouchers and artists, though with the rise of electronic image manipulation it is becoming more and more usual for the photographer to undertake post-production work either on his own or with only technical assistance from a computer operator. This may be expected to become the norm as more and more powerful computers become increasingly affordable.

THE FUTURE OF SPECIAL EFFECTS

There is a strong temptation, especially among non-photographers, to believe that special effects photography will become less and less important as electronic image manipulation becomes more and more commonplace. This viewpoint holds that all that will be needed is a collection of simple pictures, simply lit, which can then be electronically glued together in whatever combination is required.

This is a very short-sighted view. Certainly, it can be tried; and we have all seen some of the truly appalling consequences. A single image is apparently lit from five different directions, with highlights all over the place, and yet with no crossed shadows. Perspectives are nightmarish, and proportions are wrong. While it is in theory perfectly possible for a sufficiently skilled person to manipulate a collection of basic and essentially unrelated components into a complex picture, in practice it is normally easier for the photographer to do as much as possible using conventional photographic techniques. For a very clear example of this, look at Maurizio Polverelli's *Self Made Pencils* (page 248).

It would have been quite feasible to start out with a single pencil and a pile of white powder. The pencil could have been reproduced in triplicate; the leads could have been coloured; the highlights and shadows could have been added to the bodies of the pencils; the white powder could have been coloured...

But actually, this would have been far more difficult than setting the shot up as it was – though this is not to imply that the set-up was easy. The advantage of shooting a "real" photograph is that the lights and shadows are natural, as are the perspectives. The same theme is repeated throughout Chapter 6, which deals with electronically manipulated images: electronic image manipulation is used only when it can do a particular job better or more easily than traditional photographic techniques.

It seems, therefore, that "traditional" special effects photography will be with us for a very long time yet; and this book should serve as an inspiration and information for anyone who wants to pursue this branch of image-making.

8 lighting
sequences

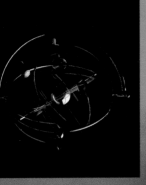

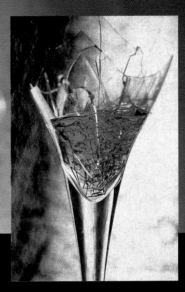

► Only comparatively rarely does a photograph in this book depend on a single technique or trick, but the pictures in this chapter normally depend upon one of three things. The first is mixing flash and continuous lighting. The second is lighting the same object with a sequence of exposures. The third is lighting a sequence of objects with essentially the same lighting set-up, though some lights may be turned on or off for the different exposures.

Mixing flash and continuous lighting may be more or less obligatory, simply because there are light sources in the picture as with Coskun Ipek's radio dial, or it may be a deliberate choice in order to get both movement and "frozen" motion, as illustrated by James DiVitale's ballet dancer.

Lighting the same object with a sequence of exposures allows different intensities of light to be balanced to the desired blend on the subject, and allows soft filters to be introduced for some exposures and not others. This is well illustrated by Roy Genggam's *Nightmare*. It also allows colours to be selectively introduced, as in Francesco Bellesia's *Broken Glass*.

Finally, the technique of lighting a sequence of objects with the same set-up is illustrated by Aik Khoo's beer shot – though he also used the additional technique of masking in camera.

Photographer: **Francesco Bellesia by Wanted**

Client: **Personal research**

Use: **Portfolio**

Camera: **4x5 inch**

Lens: **210mm**

Film: **ISO 64**

Exposure: **Not recorded**

Lighting: **Tungsten**

Props and set: **Glass, paper, opal plastic**

B R O K E N G L A S S

▼

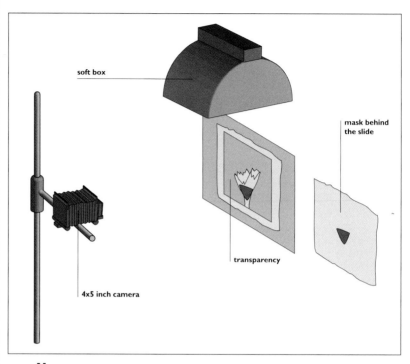

soft box

mask behind
the slide

transparency

4x5 inch camera

First Exposure

Third Exposure

► *Larger formats make mask-cutting (as for the tissue paper mask) easier*

► *Quality losses when rephotographing an existing image are also reduced by using larger formats*

► *The brain sees what it expects to see, not necessarily what is there*

NOT ALL MULTIPLE EXPOSURES ARE MADE IN CAMERA — OR EVEN NECESSARILY ON THE SAME PIECE OF FILM. IN ORDER TO MAKE THIS INTRIGUING SHOT, FRANCESCO BELLESIA REPHOTOGRAPHED HIS FIRST EXPOSURE ONCE THE FILM HAD BEEN DEVELOPED.

The first exposure was a straightforward shot of the broken glass against a translucent background, with masking to create the impression of a large, feather-like shape in the background.

This photograph was then processed and used as the top layer of a sandwich with yellow tissue paper in the middle and, again, a translucent background. The tissue paper had a hole cut in it corresponding to the liquid in the glass.

Finally, the whole sandwich was re-photographed using both a grazing front/side lighting (to bring out the texture in the paper) and transillumination for the "wine" in the glass.

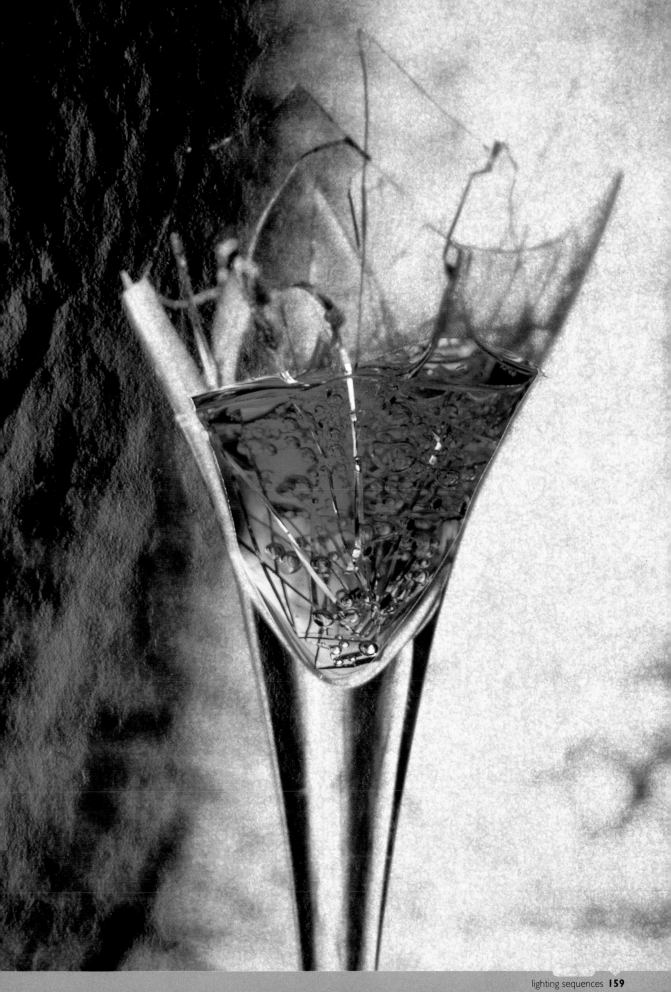

Photographer: **Jim DiVitale**

Client: **Professional Photographers of America**

Use: **Cover of Members' directory**

Model: **Ballet dance student**

Camera: **6x6cm**

Lens: **80mm**

Film: **Kodak Ektachrome 64**

Exposure: **5 seconds at f/16**

Lighting: **Flash: 4x4 foot (120cm square) soft box. Tungsten: 1000W light with gels**

Props and set: **Black seamless paper background**

Plan View

► *Tungsten light on daylight film creates a warm effect*

► *Balancing exposure (between flash and tungsten) requires careful metering and preferably Polaroid testing*

► *Dark backgrounds are often essential for long exposures and multiple exposures; anything else will read through the "ghost" images*

S Y N C H R O N I C I T Y

▼

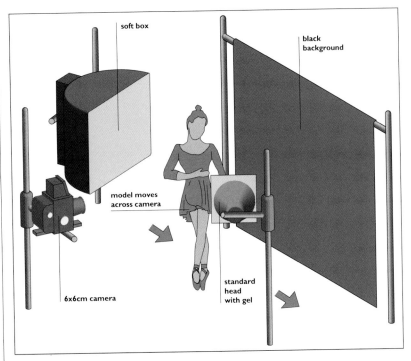

"STROBOSCOPIC" EFFECTS CAN BE OBTAINED IN THE MOST OBVIOUS WAY OF ALL, BY ACTUALLY HAVING THE MODEL STOP PERIODICALLY DURING A LONG EXPOSURE. THE EFFECT WILL INEVITABLY DIFFER FROM A TRUE STROBE SHOT BUT IT CAN STILL BE VERY EFFECTIVE.

The model was a trained ballerina, who simply stopped at one-second intervals as she danced out of the frame. An initial flash exposure from camera left created the essentially sharp image, while the rests created the "stroboscopic" multiple image – surprisingly sharp because of the model's superb control. The continuous 5-second exposure was lit by a gelled tungsten light to camera right, which also created some fill on the dark side of the model's legs in the initial shot.

Photographer's comment:

This shot was originally used as a demonstration for a college photography lighting class for which I was instructor, demonstrating the mix of strobe and tungsten light on daylight-balanced film. It was then picked up by the Professional Photographer's of America as a cover for the Members' directory.

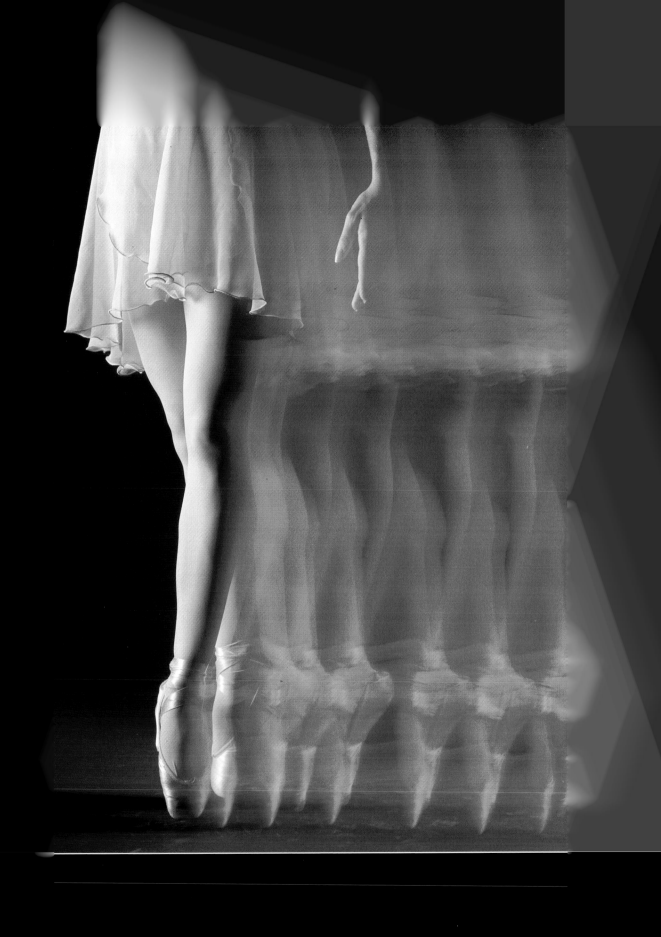

Photographer: **Paul Cromey**

Use: **Portfolio/experimental**

Camera: **4x5 inch**

Lens: **210mm**

Film: **Fuji RDP ISO 100**

Exposure: **f/32-1/2, 3 exposures**

Lighting: **Electronic flash: soft box and strip light with coloured gels**

Props and set: **Executive toy on black velvet**

Plan View

KINETIC TOY

▼

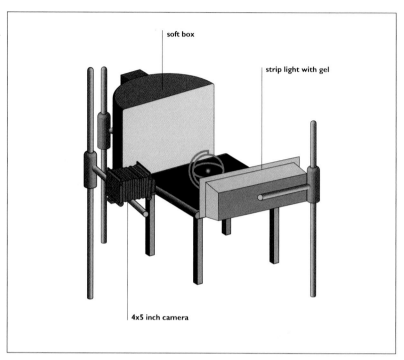

soft box

strip light with gel

4x5 inch camera

THIS IS A CLASSICALLY SIMPLE MULTIPLE EXPOSURE – AND AS WITH MOST CLASSICALLY SIMPLE SHOTS, IT WAS MORE DIFFICULT THAN IT LOOKS. THE BEST APPROACH WAS TO EXPOSE SEVERAL SHEETS OF FILM AND THEN TO PICK THE BEST.

The point is that the toy is in motion in each of the three shots; at rest, it tends to return to the same position, which makes for a rather boring picture.

It is lit with two lights for each exposure. The soft box on the left is unfiltered, while the strip light on the right was fitted with three coloured gels in succession: red, green and blue. Lighting the toy only with the filtered light (or using filters over the lens instead of over one light) would have lost a great deal of the three-dimensionality which is a major part of the attraction of the image. On the other hand, because of the shape of the toy and the fact that it was in motion, lighting from either side was easily the most successful approach. The black velvet background recorded so dark in each of the three exposures that it was not a problem.

► *Although it was not done here, it is worth knowing that if you make three exposures using tri-cut filters (red, green and blue) and balance them correctly, only those parts of the subject which move will show any colour: immobile subjects will record as white, because of the additive effect of the three exposures*

Photographer's comment:

This executive toy caught my eye one day and I wanted to try and express the movements that it made.

NOSTALGIA

▼

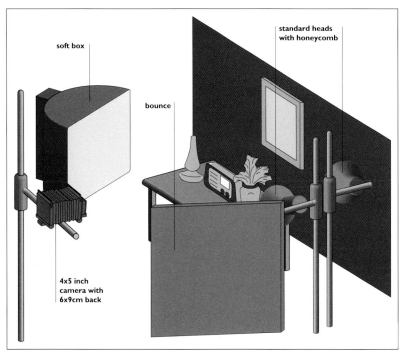

soft box

standard heads
with honeycomb

bounce

4x5 inch
camera with
6x9cm back

Photographer: **Coskun Ipek**

Client: **Personal work**

Use: **Greetings card**

Assistant: **Zeynel Ipek**

Camera: **4x5 inch with 6x9cm back**

Lens: **100mm**

Film: **Kodak Ektachrome EPT ISO 160**

Exposure: **2 seconds at f/22**

Lighting: **Electronic flash: 3 heads, one in
50x50cm soft box, two standard reflectors,
plus radio panel light and oil light**

Props and set: **Tablecloth, brass vase with dried
grasses, framed portrait and oil lamp**

WHEN YOU MIX FLASH AND CONTINUOUS LIGHT SOURCES FOR A NON-MOVING SUBJECT, THE
APERTURE IS DETERMINED BY THE FLASH (BECAUSE FLASH EXPOSURE IS INDEPENDENT OF
SHUTTER SPEED) AND THEN THE EXPOSURE TIME IS SET TO SUIT THE OTHER LIGHT SOURCES.

The flash exposure of f/22 was determined by the need to keep a relatively deep set in sharp focus from front to back. A soft box to camera left illuminates the ancient wireless, and is effectively the fill (look at the shadows). One honeycombed standard reflector provides the highlight on the top of the radio, and another illuminates the wall and the portrait, creating the illusion of windowlight. An exposure time of two seconds allows the radio dial to read and very slightly overexposes the oil lamp.

Photographer's comment:

*The creative use of a fog filter adds to the feeling of days gone by; the accessories are chosen
to complement the old-time look.*

► The oil lamp is a light source and therefore benefits from slight overexposure

► If it had not been possible to balance the oil lamp and the wireless dial, the answer would have been a double exposure: one for the oil lamp and the flash, and one for the dial

Plan View

Photographer: **Aik Khoo**

Client: **East Asiatic Company**

Use: **Annual report**

Camera: **4x5 inch**

Lens: **240mm with soft-focus screen**

Film: **Kodak Ektachrome EPP**

Exposure: **Not recorded, but see text**

Lighting: **Electronic flash: 3 100x100cm soft boxes plus gold reflector boards**

Props and set: **4 bottles; one beer pump on black background**

Plan View

B E E R

▼

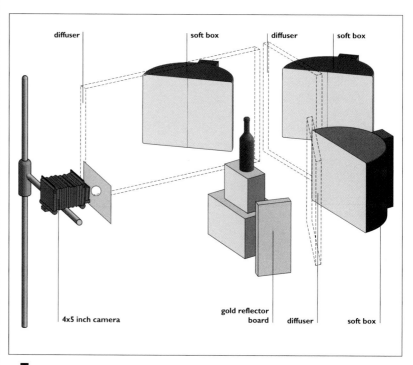

THIS WELL ILLUSTRATES THE TECHNIQUE OF USING A CUT-OUT MASK (OR A SEQUENCE OF CUT-OUT MASKS) IN FRONT OF THE CAMERA; BECAUSE THE MASK IS SO CLOSE TO THE LENS, IT ALWAYS PROVIDES A VIGNETTED EFFECT RATHER THAN A HARD EDGE.

The same set, as illustrated, was used to photograph all four bottles, working to a tracing on the ground glass. The set-up for the beer pump was similar, except that the rear diffusion sheet was replaced with a plain black background.

Transillumination of the beer provided a warm feeling, complemented by the gold reflector board. To show the edges of the bottles clearly, Aik Khoo used a main light on the left, a rim light to the right rear, and a back light. The three modestly-sized soft boxes (100cm/ 18 inches square) were further softened by the use of large diffusion screens.

► Many photographers improvise diffusion screens from Kodatrace, a tough plastic tracing film

► "Holding" the edges of bottles (rendering them sharply) can be difficult

Photographer: **Roy Genggam**

Client: **Personal work**

Use: **Exhibition**

Camera: **4x5 inch with 6x9cm back**

Lens: **210mm, with soft focus for second
exposure**

Film: **Fuji Velvia 50 push one to EI 100**

Exposure: **f/22**

Lighting: **Electronic flash: 6 heads**

Props and set: **Toy elephant, gear wheel, palm
leaf. 2 pieces stone, glass, grey background**

Side View

► *Working around a self-imposed theme
is often a spur to creativity*

► *With highly directional lighting, the
contrast between a sharp first exposure
and a diffused second exposure can be
very marked*

► *Film selection and processing variations
can greatly affect colour saturation.
Pushed Velvia is very saturated*

N I G H T M A R E

▼

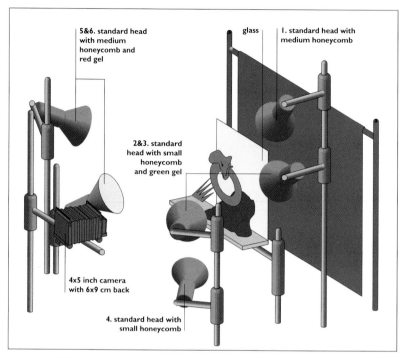

5&6. standard head
with medium
honeycomb and
red gel

glass

1. standard head with
medium honeycomb

2&3. standard
head with small
honeycomb
and green gel

4x5 inch camera
with 6x9 cm back

4. standard head with
small honeycomb

THIS IS FROM A SERIES OF PICTURES BY ROY GENGGAM ON THE THEME
"ELEPHANT," USING A WIDE VARIETY OF DIFFERENT TECHNIQUES, EQUIPMENT AND IDEAS.
THE PICTURES FORMED THE MATERIAL FOR AN EXHIBITION.

All six heads were fitted with standard reflectors and honeycombs for increased directionality. Two had red gels, two green, and two were unfiltered. The first exposure used lights 1, 2 and 5; the second, with a soft-focus screen over the lens, used 3, 4 and 6.

Opposing red and green gels create considerable tension, while the white light from the other two lights creates a disturbingly natural-looking light – precisely the way things are in a nightmare, where it is impossible to distinguish what is "normal" from what is not.

Photographer's comment:

I wanted a horror effect in this shot.

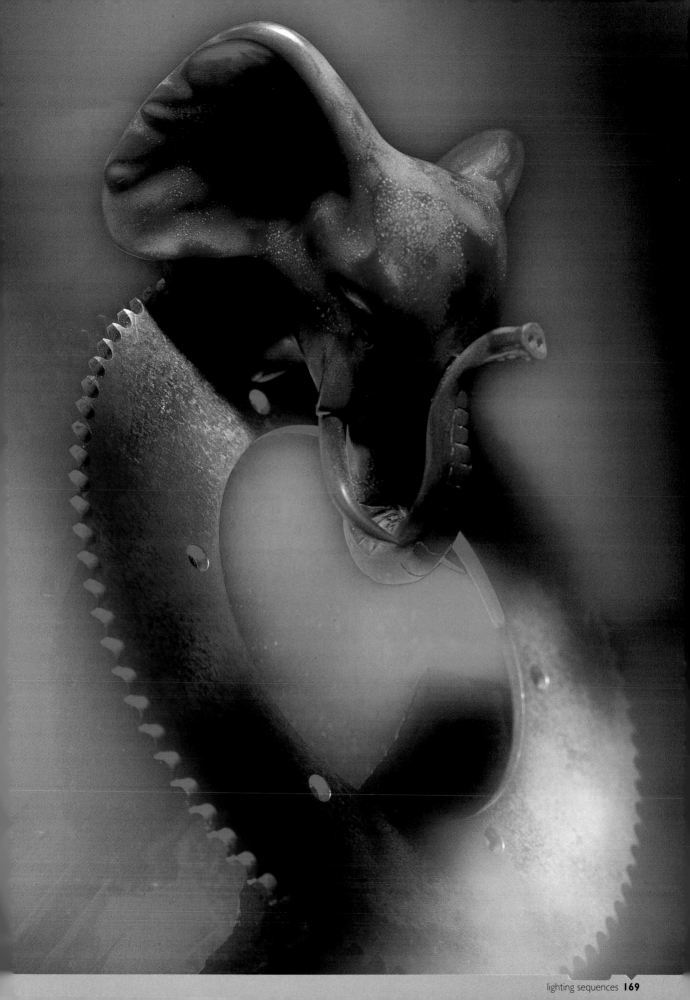

9 photographic superimposition

The differences in technique between this chapter and the last are often not great; indeed, there are pictures in both which could have gone in either chapter. Here, however, there is more emphasis on the multiple exposure – one of the oldest and simplest techniques for "trick" photography – which may be done in a number of ways. The same subject can be photographed a number of times, moving it between exposures, as in Francesco Bellesia's *Esposizioni Multiple* or Maurizio Polverelli's *A Strange Hit*. Different subjects may be combined on the same sheet of film, either as originals, as in Tim Hawkins' *Olympia Concert Centre*, or in the darkroom from two separate exposures, as with Jim DiVitale's *How the Hoover got its Stripes*.

The underlying problems with any multiple exposure picture are exposure and registration: one exposure incorrectly exposed, or too close to or too far from another, and all the exposures are rendered worthless. This is why Polaroid tests are all but essential – indeed, it is quite usual for a picture to be tried out on Polaroid, in its entirety with all multiple exposures, before it is committed to conventional film – and why 4x5 inch cameras are regarded as the minimum size which can conveniently be used for multiple exposures. The relative positions of the different picture elements can be sketched either directly on the ground glass, or on a sheet of acetate taped to the ground glass; the latter has clear advantages when it comes to cleaning the marks off.

Photographer: **Francesco Bellesia by Wanted**

Client: **Francoli**

Use: **Magazine**

Camera: **4x5 inch**

Lens: **210mm**

Film: **Kodak Ektachrome ISO 100**

Exposure: **Not recorded**

Lighting: **Electronic flash: one soft box**

Slide projector

Props and set: **Backgrounds: translucent plastic and black paper**

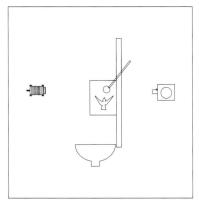

Plan View

First Exposure

► *A slide projector can be adapted to multiple uses, including (if necessary) a high-intensity spotlight*

► *Working with live animals is always difficult, but it is almost always the way to get the most natural picture*

W H I T E B I R D

▼

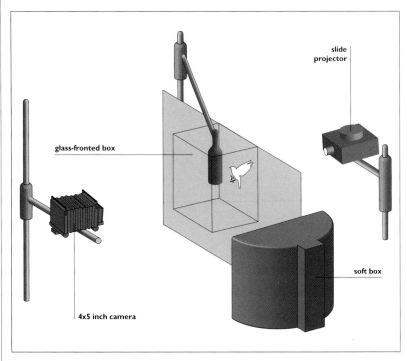

slide projector

glass-fronted box

4x5 inch camera

soft box

THE MAIN INTEREST IN THIS PICTURE LIES IN THE FACT THAT THE SKY WAS BACK PROJECTED ONTO A TRANSLUCENT SHEET USING A SLIDE PROJECTOR. THE OTHER THING TO NOTE IS THAT THIS IS A LIVE CAGE BIRD; IT IS NOT STUFFED.

The first exposure was the bottle and the background; the lighting of the bottle with a soft box from the left is clear. As with any shot where flash and continuous lighting are mixed, the aperture was chosen to suit the electronic flash (and depth of field requirements) and the shutter speed was adjusted to suit the continuous source. The bottle is clamped in front of the translucent sheet.

For the second exposure, the bird was in a glass-fronted box with polystyrene sides; the back of the cage was black paper. The photographer does not record how many exposures were needed to get a suitable pose!

ORIGINAL

NETIAN CREAM

ALIAN CREAM LIQUEUR

PRODUCT OF ITALY

Photographer: **Maurizio Polverelli**

Client: **Personal work**

Use: **Portfolio**

Camera: **8x10 inch**

Lens: **300mm**

Film: **Ektachrome 6117**

Exposure: **Ten exposures!**

Lighting: **Tungsten: two soft boxes**

Props and set: **Baseball bat, model planet, masks, film of "explosion" – black velvet backgrounds**

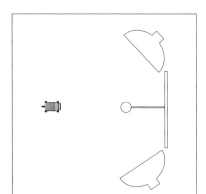

Plan View

Exposure Sequence

► *Working out the concept and the correct shooting sequence is often half the battle*

► *Perforated card can usefully stand in for a star-studded sky*

► *Very large formats make it easier to plan complex multiple-exposure sequences on the ground glass*

A S T R A N G E H I T

▼

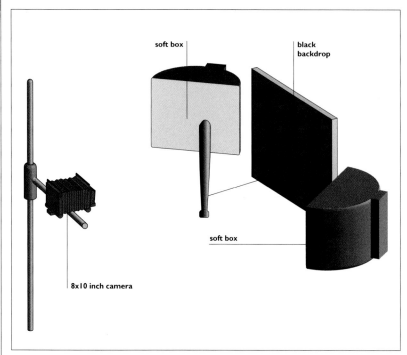

soft box

black backdrop

8x10 inch camera

soft box

COMPLEX IN-CAMERA MULTIPLE EXPOSURES ARE MOST EASILY CARRIED OUT WITH THE LARGEST FORMAT PRACTICABLE, AS THE GROUND GLASS CAN BE MARKED UP TO SHOW THE POSITION OF EACH PICTURE ELEMENT – HENCE MAURIZIO POLVERELLI'S CHOICE OF AN 8X10 INCH CAMERA.

The bat is held on a long rod coming forward from a black velvet background, and the first five exposures were made by moving the camera slightly. The first shot (1/2 second at f/16- 1/3) was made with two soft boxes, as shown in the diagram; then the next four shots (1/2 second at f/22-1/3) were made with the right-hand light only.

The "explosions" were added by photographing a transilluminated film twice, at different scales. Next, the planet was added: 3 seconds at f/22 for the planet, plus 2 seconds at f/22 for the trail, shooting through a triangular mask in front of the camera for the trail. Finally, the star-studded sky is perforated, transilluminated black card.

Photographer: **Jim DiVitale**

Client: **Self-promotion**

Use: **Company advertisement for a source book**

Art directors: **Sandy & Jim DiVitale, DiVitale Photography**

Camera: **4x5 inch**

Lens: **150mm**

Film: **Kodak Ektachrome Professional Plus**

Exposure: **1/60 second + 15 minutes at f/32 (sheet 1)**

10 seconds at f/32 (sheet 2)

Lighting: **Electronic flash: soft box Hosemaster light brush**

Props and set: **Vacuum cleaner painted by Jerry Silvestrini, Dog Eat Dog Productions. Painted backdrop by Rear Window Backgrounds**

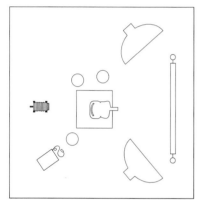

Plan View

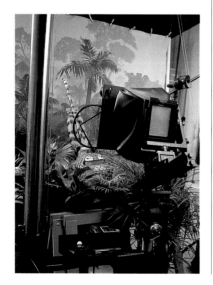

► *Diffusing a background exposure can make a sharp foreground all the more dramatic*

HOW THE HOOVER GOT ITS STRIPES

▼

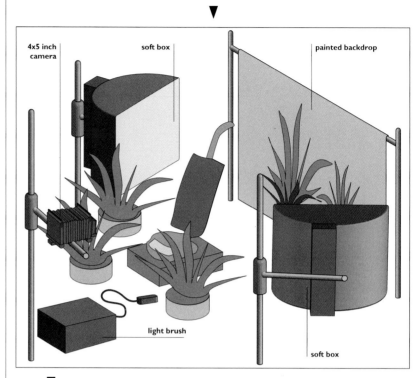

THE FEROCIOUS VACUUM CLEANER WAS SIMPLY PAINTED BY JERRY SILVESTRINI OF DOG EAT DOG PRODUCTIONS AND PHOTOGRAPHED IN A SET MADE OF TROPICAL-LOOKING PLANTS WITH A PAINTED BACKDROP. THE "SPEED STREAKS" TO CREATE THE ILLUSION OF MOVEMENT WERE SHOT ON A SEPARATE SHEET OF FILM.

The first exposure was made in two stages. Two 90x120cm soft boxes, set two stops down from the metered exposure (1/60 at f/32), took care of the background. A mild diffusion screen over the lens further added to the sense of a gloomy jungle. The hoover itself was then light brushed with a Hosemaster during a period of 15 minutes at f/32, this time with no diffusion.

The second exposure of the "speed streaks" was made with a 10 second exposure at f/32, moving the camera to create the illusion of the "tiger" jumping. The two sheets of film were then copied sequentially to superimpose one on the other. The advantage of this is that they can be aligned precisely without worrying about spoiling an initial shot which took just a quarter of an hour to light brush.

► *Model-makers and artists can provide subjects (like the vacuum cleaner) which could take forever to fake photographically*

► *Consider shooting two exposures separately and then combining them in the darkroom/workroom*

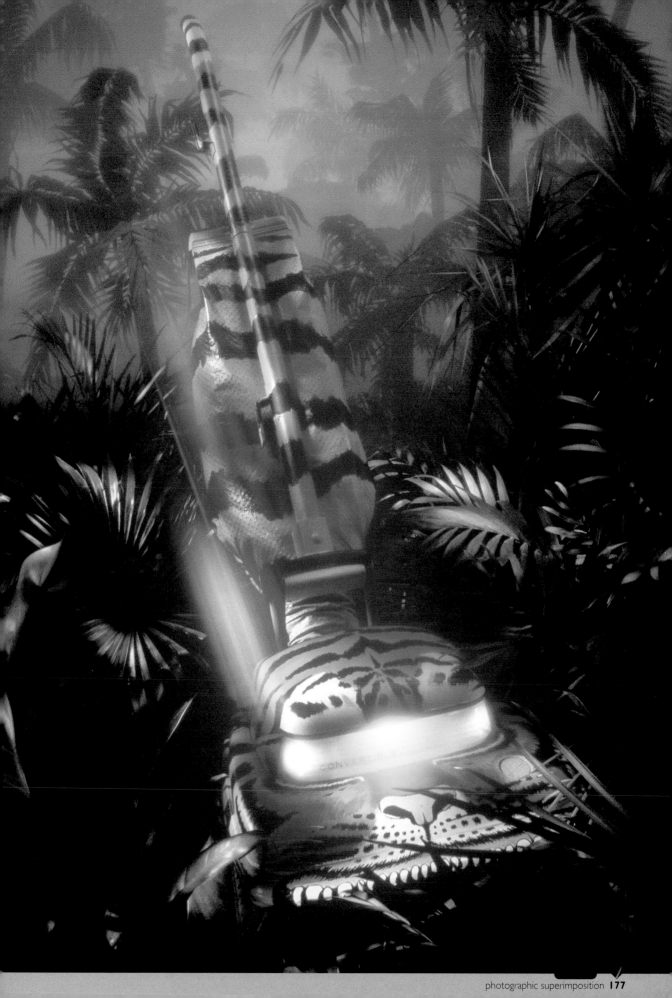

Photographer: **Maurizio Polverelli**

Client: **General Music**

Use: **Brochure**

Stylist: **Emanuela Mazzotti**

Camera: **4x5 inch**

Lens: **210mm**

Film: **Kodak Ektachrome 64 EPR 6117**

Exposure: **f/16-2/3 – see text**

Lighting: **Electronic flash: 3 heads**

Props and set: **Slate tile background**

Plan View

► *A studio with a solid (preferably concrete) floor makes multiple exposures and long exposures much safer*

► *Switch off slaves for lights which you do not want to fire during a long exposure if other flashes are fired during the exposure*

► *"Press" (self-cocking) shutters provide an easy way to make multiple-flash exposures without having to leave the shutter open while the flash recycles*

MULTIMEDIA

▼

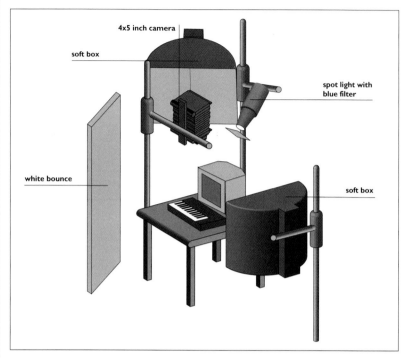

THIS IS EFFECTIVELY A TRIPLE EXPOSURE: ONE FOR THE "BLACK BOX" AND THE KEYBOARD; ONE FOR THE DISPLAYS AND LIGHTS ON THE KEYBOARD; AND ONE FOR THE SUBTLY LIGHT-PROJECTED "WE ARE THE CHAMPIONS".

The first exposure was made using the two soft boxes, one above the set and to the left and the other more of a side and back light to camera right. This was a straight picture at f/16- 2/3, with a single flash. The lights on the keyboard needed a 4-minute exposure at the same aperture in order to record properly. Finally, with the other lights switched off, four flashes with the projection spot sufficed to record the words on the keyboard; a piece of film formed the "gobo" in the projection spot.

In practice, such an exposure can be made by opening and closing the shutter just once. First, the shutter sync fires the soft boxes (with their modelling lights switched off). Next, during the 4-minute exposure needed for the keyboard, the projection spot is fired four times.

Photographer's comment:

The client requested an original image reproducing the multimedia effect of the new keyboard. In order to realize the concept we used the blue light from the computer screen, with the title of a song you can play with the keyboard while watching the screen.

Photographer: **Maurizio Polverelli**

Client: **Portfolio work**

Stylist: **Emanuela Mazzotti**

Camera: **4x5 inch**

Lens: **300mm**

Film: **Kodak Ektachrome EPR ISO 64**

Exposure: **Various – see text**

Lighting: **Tungsten – see text**

Props and set: **Fake snow, fake mountains**

Plan View

► *Extremely careful planning and marking of the ground glass is necessary to ensure that each picture element falls on pure black in the other two exposures*

► *Once you have each picture element on film, you can experiment in the darkroom to match them as well as possible*

F L Y I N G

▼

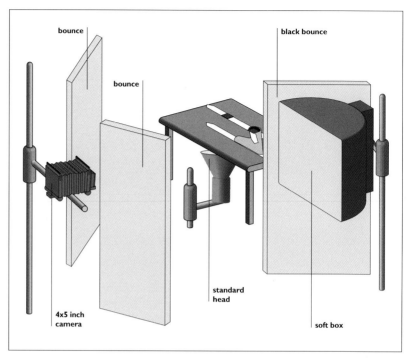

THREE SEPARATE FILMS WERE SUPERIMPOSED IN THE LABORATORY TO CREATE THIS PICTURE. ONE IS THE STAR-STREWN SKY AND THE PLASTER MOUNTAINS; ONE IS THE UPPER SKI BOOT AND ITS TRAIL; AND THE THIRD IS THE TWO LUMINOUS TRAILS WITH THE SKI BOOT AND FASTENER.

The starry sky is perforated paper, lit from behind with four lights and shot at f/45 to get the "starburst" effect; the plaster mountains, back lit and side lit in deep blue, are then double exposed onto this.

The second exposure is a straight shot of the big ski boot against black velvet. The third is of an opal acrylic sheet with the ski boot and fastener on it, and fake snow. This is lit indirectly, with the light from a big soft box bounced back into the set by two large white bounces. Under the sheet is a piece of cardboard with slots cut in it to transilluminate the "skis"; these are cleared of fake snow, and two standard heads underneath provide the light.

All exposures were copied sequentially onto one sheet of film in the darkroom, moving the ski boot picture during the exposure to create the trail.

Photographer: **Tim Hawkins**

Client: **Olympia Conference Centre**

Use: **Brochure cover**

Camera: **2x 4x5 inch**

Lens: **90mm and 210mm**

Film: **Kodak Ektachrome daylight type**

Exposure: **(1) f/22 (2) 10 seconds at f/45**

Lighting: **Flash (plus ambient fill in second exposure)**

Props and set: **Photographs on wooden scaffold**

Plan View

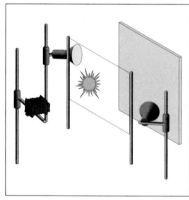

First Exposure

► *It is sometimes quicker and easier to set up two cameras for a complex double exposure, rather than moving one camera*

► *The "flying" prints are very reflective, and have to be angled very carefully in order to avoid reflections — look at Picture 2 overleaf*

OLYMPIA CONFERENCE CENTRE

▼

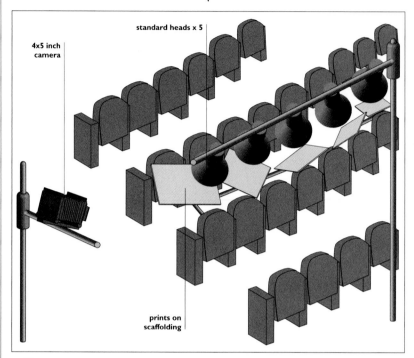

standard heads x 5

4x5 inch camera

prints on scaffolding

THE REMARKABLE THING ABOUT THIS PICTURE IS THAT IT IS A STRAIGHTFORWARD DOUBLE EXPOSURE IN CAMERA — OR RATHER, IN TWO CAMERAS, A FIVE MINUTES' WALK APART. WHAT IS MORE, THE PHOTOGRAPHER HAD ONLY HALF A DAY IN WHICH TO SET IT UP AND SHOOT IT.

The first exposure, shown overleaf, was a copy of a large display transparency. This was transilluminated as shown in the second small drawing on this page: a straightforward exposure at f/16 using bounce flash. It was shot up in the projection room of the conference centre on one camera.

The lighting and set-up for the second exposure, as illustrated in the principal lighting diagrams on this page, was rather more complex. The fifteen or so photographs which "fly" out of the apparent explosion at the back of the hall were all real pictures, mounted on a wooden support or scaffold. They were illuminated by five flash heads pointing downwards and carefully masked to illuminate only the pictures. The other picture overleaf shows a preliminary test shot for this part of the picture.

Photographer's comment:

Having to think this out, set it up and shoot it in half a day was a considerable challenge.

As with all double exposures in camera, exposure determination is critical. In addition to using Polaroids, Tim Hawkins also ran actual E-6 tests during the set-up and had them processed while he was completing the shot. This is why the picture of the auditorium on these pages has fewer prints than the final shot on the preceding pages. As well as the wooden frame being visible, there is significant reflection off the third picture and an awkward corner of light on the first picture: it was essential to juggle the lights and the precise angles of the prints in order to eliminate all reflections.

Although the use of a 90mm lens gave fairly steep perspective in the shot of the auditorium, the effect was enhanced by having the prints made in diminishing sizes with the largest at the front; this also tied the perspective of the prints to the perspective of the "explosion". A wider lens such as a 75mm or even 65mm would have created too steep a perspective in the auditorium.

Matching the centre of the "explosion" to the vanishing point of the prints was also a difficult exercise. The precise angle of each camera had to be carefully adjusted, and the easiest way to do this is again by making actual E6 tests and placing the transparency of the "explosion" on the ground glass to match it up with the prints. The other way to do it is with Polaroids. This involves less elapsed time (in that there is no need to wait for the E-6 processing) but rather more effort, as the two set-ups are a good five minutes' walk apart.

Although only one of the pictures on this page – the "explosion" – is masked,

both pictures were masked for the final double exposure, using a piece of matte black card a few inches from the camera lens. The angle of the camera in the auditorium was slightly changed between taking the original test shot (on these pages) and the final picture (on the previous spread): the rake of the seats is much less exaggerated in the final picture.

This shot would have been all but impossible with any format other than 4x5 inch. Anything smaller would have been very hard to set up with the necessary precision, simply because of the small size of the focusing screen: a pair of roll-film cameras with one interchangeable back might conceivably

have been used, but why make life more difficult for yourself than you have to? Going in the other direction, using even 5x7 inch would have led to considerable depth of field problems. Of course, Tim used the Scheimpflug rule for maximum depth of field, but this works only in one plane (the pictures): in the vertical plane, the depth of the seats could have been a problem.

Finally, the cut-out layout with the pictures coming out of the frame required a certain degree of mental gymnastics and of marking up the ground glass; it is all too easy to assume that something will show when it won't, or to assume that it won't show when it will.

10 materials and techniques

It often seems that there are two kinds of photographers: those for whom materials are a tiresome necessity, and those for whom they represent a playground. The former category dismisses them as irrelevant, and indeed may become rather irritated at being asked what they use; their argument is that the materials are quite secondary to what they do with them.

The latter category, on the other hand, points out that every different film has its own particular characteristics of contrast, tonality, colour rendition, grain, sharpness, latitude and so forth, and that certain effects are possible with some films which are either difficult or impossible with others. The only way to find out what they can do is to experiment with them; the results of those experiments can then be applied to commercial work.

Both attitudes are defensible, in that both may be carried too far. The "playground" group may end up shooting mere empty experiments, with negligible aesthetic content; but equally, those who believe that materials are irrelevant can fall into a rut which grows ever deeper when they do not even try to emerge from it. In this chapter, one school will find that their work has to some extent been done for them – any photographer who refuses even to consider anything new is in deep trouble – while the other school will find a number of departure points for their own experiments.

B E E H I V E

▼

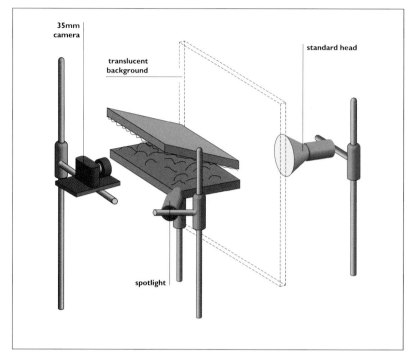

Photographer: **Mario Di Benedetto**

Client: **Personal work**

Use: **Research**

Camera: **35mm**

Lens: **55mm Macro**

Film: **Kodak Ektachrome 64**

Exposure: **f/32, 1/125 and 15 seconds**

Lighting: **Electronic flash: 3 heads, but the modelling light was used with one of them**

Props and set: **Plastic sheeting and water**

Labels in the diagram:
- 35mm camera
- translucent background
- standard head
- spotlight

MANY OF THE PHOTOGRAPHS IN THIS BOOK WERE NOT SHOT COMMERCIALLY; RATHER, THEY WERE MADE IN A SPIRIT OF "WHAT WOULD HAPPEN IF...?" THIS IS BECAUSE CLIENTS CONSTANTLY DEMAND NOVELTIES AND EVEN IMPOSSIBILITIES, AND THE BEST TIME TO EXPERIMENT IS WHEN YOU ARE NOT UNDER PRESSURE.

This is actually a very simple shot: two sheets of plastic, arranged as shown in the drawing, with the camera peeking between them. A spray of water added to the "organic" mood of the image. In order to get the necessary depth of field, the only possible choice was a 35mm camera and a lens working at a very small aperture (f/32): camera movements cannot be used to hold two receding planes arranged like this. The principal light is a big 1500 watt-second unit, used both as flash and as a tungsten light; the second light, behind an opal acrylic diffuser, creates the impression of daylight outside the "honeycomb."

- All formats have their own strengths and weaknesses

- Experiments with no immediate commercial application often give insights which are useful in later, commercial jobs

- The modelling light of a flash head can be used as a light in its own right

Side View

Photographer: **Frances Schultz**

Client: **Personal work**

Use: **Research**

Camera: **35mm**

Lens: **17mm**

Film: **Polaroid Polablue**

Exposure: **1/60 at f/5.6**

Lighting: **Daylight (high sun)**

Props and set: **Boat on concrete slab paving;
sea in background**

Plan View

H A R B O U R

▼

sun

35mm camera

catamaran

OFTEN, CREATIVITY INVOLVES EXPLORING THE LIMITATIONS OF MATERIALS AND EQUIPMENT, RATHER THAN STAYING INSIDE THE DESIGN PARAMETERS. POLAROID POLABLUE IS A VERY SLOW (EI 8) MATERIAL DESIGNED FOR COPYING TEXT TO MAKE SLIDES FOR AUDIO-VISUAL PRESENTATIONS: IT IS MARKED "NOT SUITABLE FOR GENERAL PHOTOGRAPHY."

Naturally, therefore, any photographer who had the chance would try it for general photography. Even in bright sun, a relatively wide aperture was necessary in order to get a short enough shutter speed to stop subject movement.

The overall effect is very reminiscent of one of the early Victorian processes, but the unexpected bonus was that because the latitude of the film is so slight – half-stop brackets are the order of the day – the extreme wide-angle lens actually vignetted the image. Once the possibilities of Polablue are known to exist, however, the same technique can be tried in the studio.

► *EI 8 at f/5.6 is equivalent to EI 64 at f/16 – a common combination in studio photography*

► *Never neglect an opportunity to experiment with unfamiliar materials*

► *Duplicate originals onto conventional film; Polaroid instant-picture emulsions are fragile*

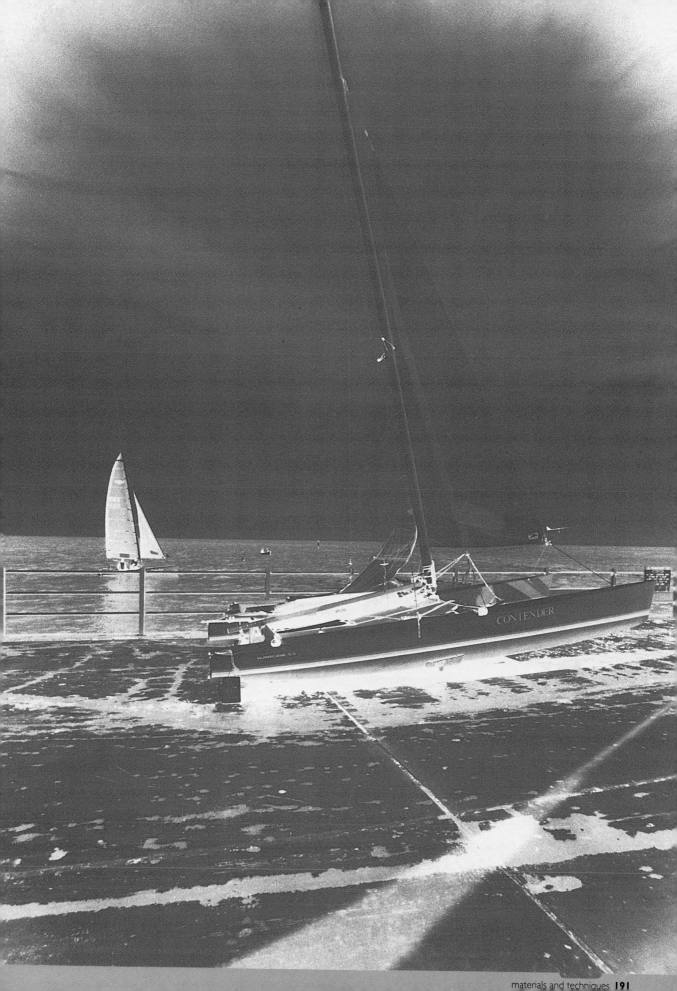

VORTICE D'ARGENTO

▼

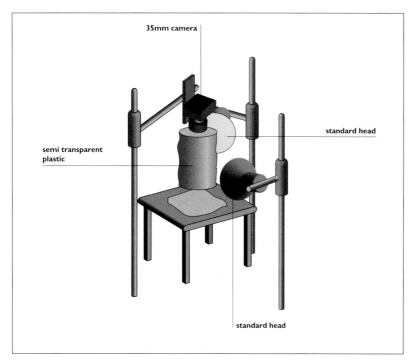

35mm camera

standard head

semi transparent
plastic

standard head

Photographer: **Mario Di Benedetto**

Client: **Personal work**

Use: **Research**

Camera: **35mm**

Lens: **35mm**

Film: **Kodak Ektachrome EPY**

Exposure: **1/60 second at f/22**

Lighting: **Tungsten: 2 quartz heads**

Props and set: **Metallized
semi-transparent plastic**

Most of us have seen the distorted reflections in a tube of silvered plastic film such as Mylar. From there it is a short step to setting up a camera to see how such a thing would photograph.

The semi-transparency of the plastic film confuses matters, and there is the question of what to use as the subject at the end of the tube: here, another piece of silvered plastic, to carry through the "melting metal" look. Even at minimum aperture, a 35mm lens cannot hold the tube in focus – and where it might start to be in sharp focus, it is cut off.

There is often a considerable gap between the original idea and the execution: you may need a different focal length from what you expect, the dimensions of the component parts of the set may need modification, and the lighting may be different too.

- ► *Time spent experimenting is seldom wasted; it is often as important to know what will not work as to know what will work*

- ► *Once a technique is semi-standardized, try it with different subjects*

Side View

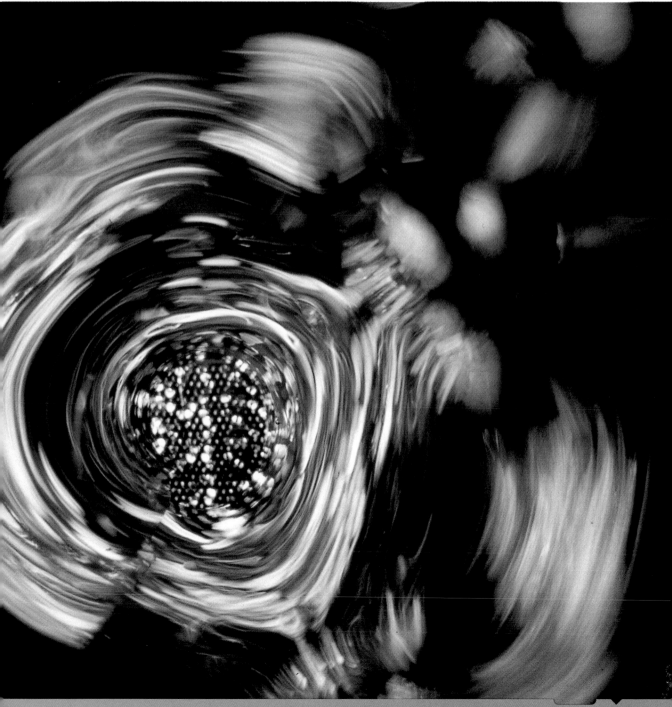

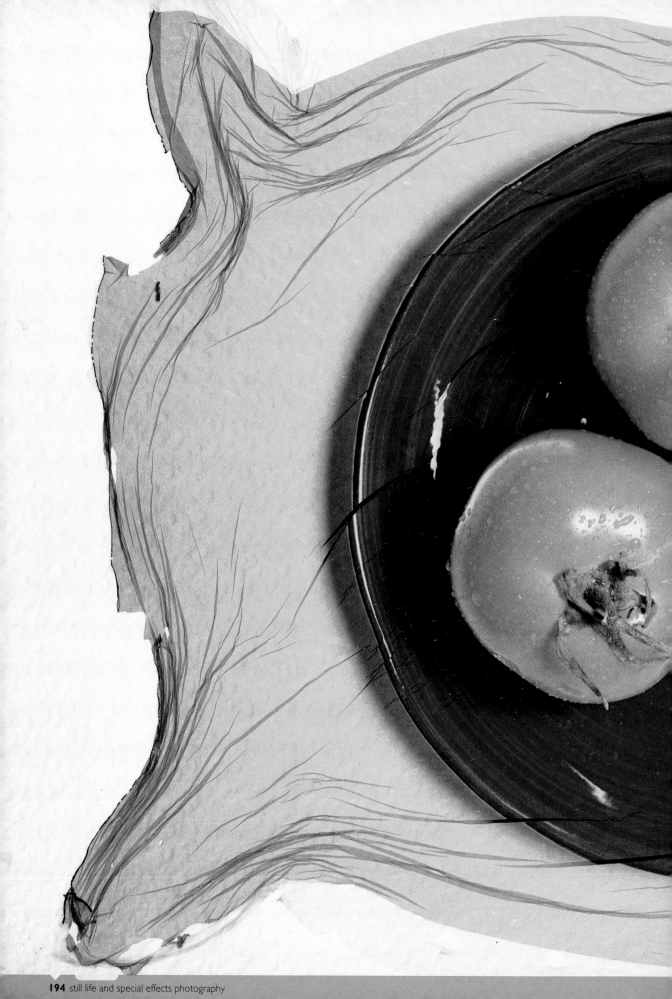

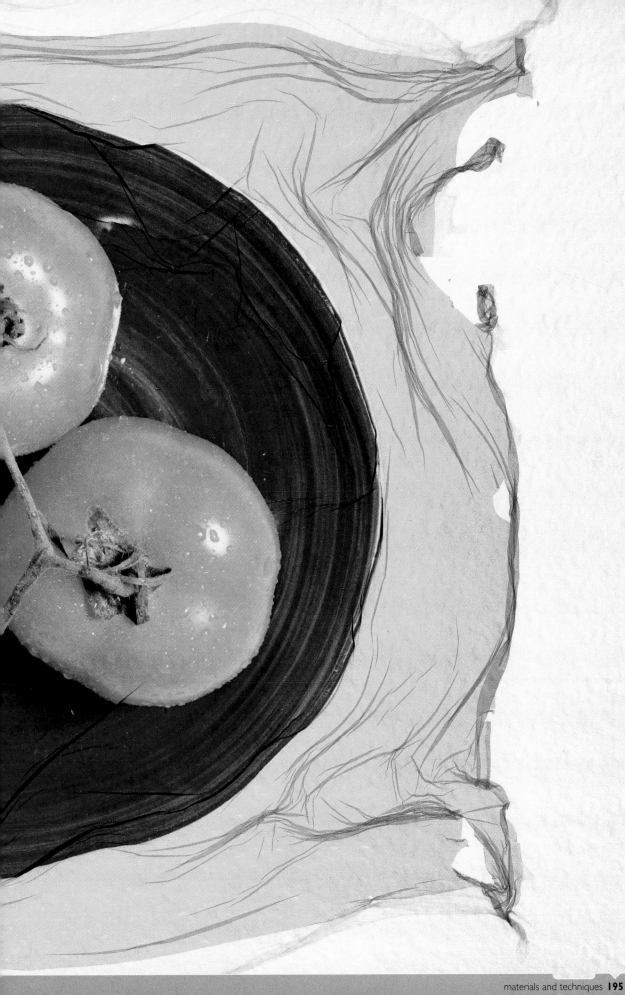

Photographer: **Stefano Zappalà, Green & Ever Green**

Use: **Personal work**

Camera: **8x10 inch**

Lens: **360mm**

Film: **Polaroid 809**

Exposure: **f/45**

Lighting: **Electronic flash: one head**

Props and set: **Yellow-orange paper background; blue-painted plate with 3 tomatoes**

Plan View

T O M A T O E S

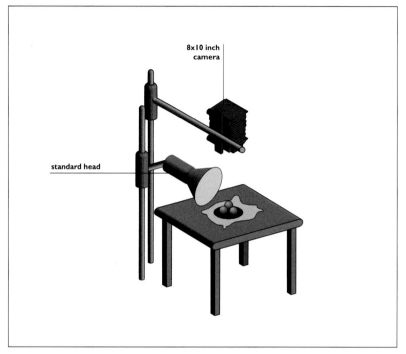

BY CAREFUL CHOICE OF FOCAL LENGTH AND LIGHTING, THE PHOTOGRAPHER HAS GIVEN THIS A UNIQUELY THREE-DIMENSIONAL EFFECT: IT LOOKS AS IF REAL TOMATOES HAVE BEEN PLACED ON AN EMULSION-LIFT PICTURE OF A PLATE.

The single standard head is very close to the tomatoes, just a few inches away, and the camera is directly overhead: the 360mm focal length is "standard" on 8x10 inches (that is, it equates closely to the image diagonal) so there is a marked three-dimensional feel to the picture.

Polaroid emulsion lift is exactly what its name suggests. The freshly developed print is soaked in boiling water to which ammonia has been added until the emulsion floats off; it is then "captured"

on another substrate, typically heavy watercolour paper. The inevitable distortions of the emulsion are a part of the charm of the picture.

Emulsion lift should not be confused with emulsion transfer, of which there are examples on page 65. It is an even trickier and more difficult technique: it is by no means unusual to lose two out of three images, or more, while you are trying to float them off and transfer them to a different support.

► *You may find it easier to shoot original images on 'chrome film and copy them onto Polaroid material for emulsion-lift and image transfer*

► *Some photographers prefer to work with originals, as it adds to the uncertainty and excitement of the process*

► *Be prepared to use up a lot of material while you are learning emulsion transfer techniques*

Photographer: **Rod Ashford**

Client: **Personal; subsequent editorial usage**

Model: **Coral**

Stylist: **Sandra Ashford**

Camera: **35mm**

Lens: **70-210mm zoom**

Film: **Ilford FP4; Ilford Multigrade paper hand-coloured with Fotospeed dyes**

Exposure: f/16

Lighting: **Electronic flash: one head in standard reflector**

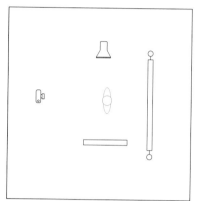

Plan View

T A T T O O

▼

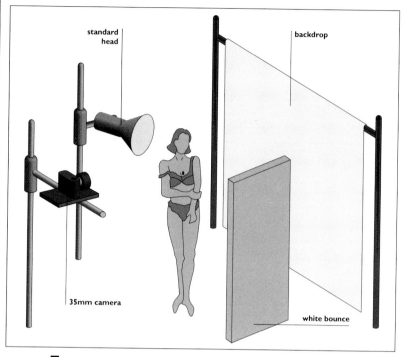

standard
head

backdrop

35mm camera

white bounce

THERE IS SURPRISINGLY LITTLE HAND-COLOURING IN THIS BOOK, GIVEN ITS
POPULARITY AT THE TIME OF WRITING, BUT IT IS AS MUCH A MATTER OF CHOOSING
THE RIGHT MATERIALS AS ANYTHING ELSE: THE RIGHT FILM, THE RIGHT PAPER FOR
COLOURING, AND THE RIGHT MATERIALS TO COLOUR IT WITH.

The lighting is no more than a single flash head at the model's shoulder level or just below (look at the shadows), with a white bounce to camera right to provide a very modest degree of fill. The picture shows (as ever) how it is the photographer's eye which makes any picture. It also shows more attention to detail than one might think possible in a photograph which superficially appears so simple. The way in which the left bra strap is loose suggests considerable intimacy, and the tattoo carries its own freight: girls with tattoos, the popular wisdom goes, are interesting. Of course, it has to be a black bra; there is something "naughty" about that too, which matches the image of the tattoo. The lighting is on the edge of harshness, but once again, this is totally in character – and it helps to emphasize the contrasts of textures.

► *Match all the components of a simple picture with more than usual care: props, textures, lights*

► *Look carefully at the model's skin before you take a picture like this: bruises, bites, spots, etc., can ruin the mood*

► *Afterwork such as hand-colouring often reflects a very personal style*

Photographer's comment:

The tattoo is not real. The outline was applied as an alcohol-based transfer, and left uncoloured.

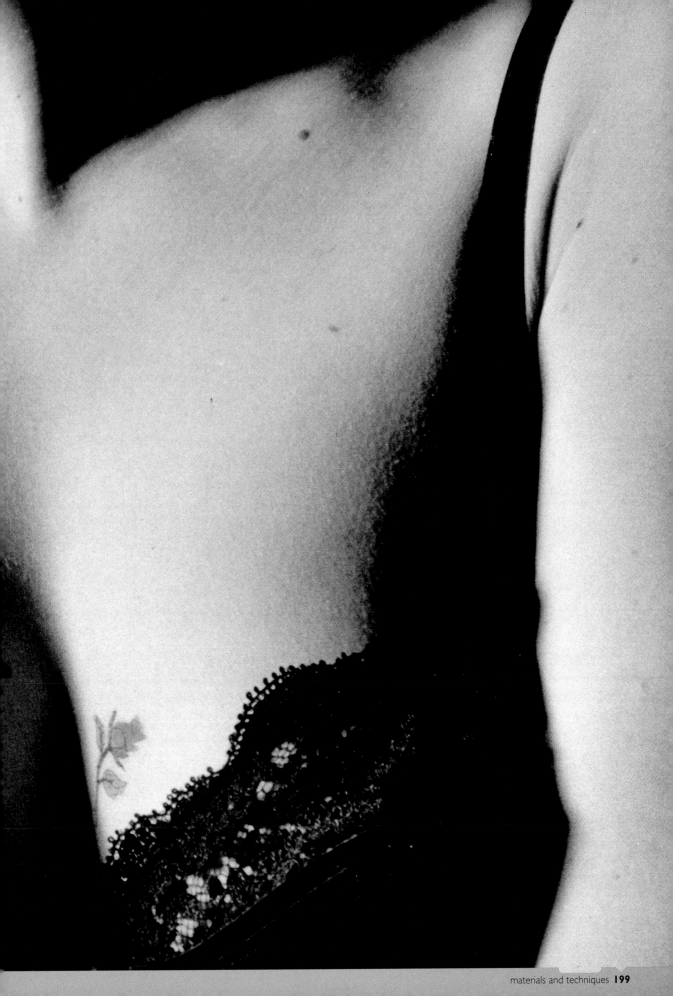

Photographer: **K**

Client: **Personal work**

Use: **Exhibition**

Models: **Mandy & Rebecca**

Assistant: **Katy Niker**

Camera: **645**

Lens: **70mm**

Film: **Ilford FP4 Plus (initially)**

Exposure: **f/11**

Lighting: **Electronic flash: 2 heads**

Plan View

► *There is a "photographic" quality which transcends such questions as sharpness and grain*

► *As mentioned elsewhere in the book, the Victorians used simple lighting, and simple lighting must be used if you want to re-create a Victorian mood*

► *Compare this with a portrait by Julia Margaret Cameron from the mid-1800s*

M O T H E R A N D C H I L D

▼

soft box

645 camera

standard head

THIS IMAGE IS, IN THE STRICTEST SENSE, TIMELESS: IT COULD HAVE BEEN TAKEN AT ANY TIME SINCE WILLIAM HENRY FOX TALBOT PRODUCED STABLE IMAGES ON PAPER. THE TECHNOLOGY USED HAS SUPPRESSED DETAIL, WHILE STILL RETAINING A CLEARLY PHOTOGRAPHIC LOOK.

The initial exposure was made on Ilford FP4 Plus monochrome film. This was printed onto Kentmere Art Classic, an unusual paper which allows the texture of the paper to show through because it has no baryta coating. This image was then sepia toned, and finally an image transfer was made using Polaroid 669 onto heavy watercolour paper. The "faults" in the image – wobbly emulsion at the edges, variable density and texture – are rather like weathering in a building:

they have their own charm and their own timelessness.

The lighting is simple, but still more complex than a true Victorian photograph would have been in that the background is lit separately using a standard head. The key light is however a close approximation to the "northlight" so beloved of our ancestors: a large soft box somewhat above the subject and distinctly to one side (camera left).

Photographer's comment:

There is no doubt that the pain of motherhood exists, yet the inner strength of women is greater.

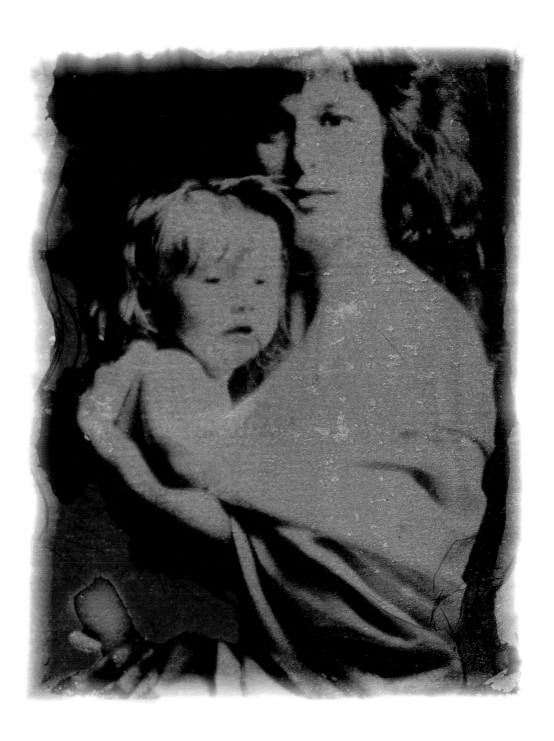

Photographer: **K**

Client: **Personal work**

Use: **Exhibition**

Model: **Amanda Flatt**

Assistant: **Katy Niker**

Camera: **4x5 inch**

Lens: **360mm**

Film: **Polaroid Type 55 P/N rated EI 25**

Exposure: **f/8**

Lighting: **Electronic flash: 2 heads**

Props and set: **Distressed tarpaulin background**

Plan View

► *A 360mm lens, even at f/8, has very shallow depth of field – a classic technique for large-format portraiture*

► *There is a considerable difference between a large reflector used with a honeycomb and one used without*

► *Unusual paper surfaces such as the non-baryta-coated Kentmere materials may be attractive in their own right*

A M A N D A

▼

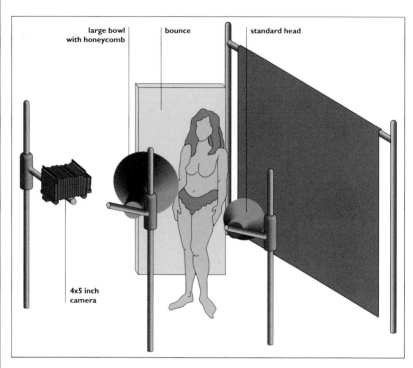

THERE IS A VICTORIAN QUALITY TO THIS PORTRAIT – IT IS A DEFINITE "LIKENESS" –
YET THERE IS ALSO A CONSIDERABLE ARTISTIC DIMENSION, A DIRECTNESS WHICH IS WELL
SUMMED UP IN THE PHOTOGRAPHER'S COMMENT BELOW.

The simplicity and directness of the pose are complemented by the lighting, which is soft yet strongly directional. This is achieved by using as a key light a large bowl reflector plus a honeycomb on a standard flash head. A large gold reflector behind the model and to camera left provides some fill from the key light and also kicks back some light into the hair from the background light – an unusual economy of lighting.

The print was made on Kentmere Art Classic paper and split-toned. The photograph is particularly interesting as it turns on its head the famous saying of John F. Kennedy. He said, "Those who do not study history are condemned to repeat it." K shows clearly that those who do not study history are unlikely to be able to repeat it.

Photographer's comment:

This image was inspired by Julia Margaret Cameron's poem, On a portrait:
And yet the head is borne so proudly high, / The soft round cheek, so splendid in its
bloom, / True courage rises thro' the brilliant eye, / And great resolve comes flashing
through the gloom

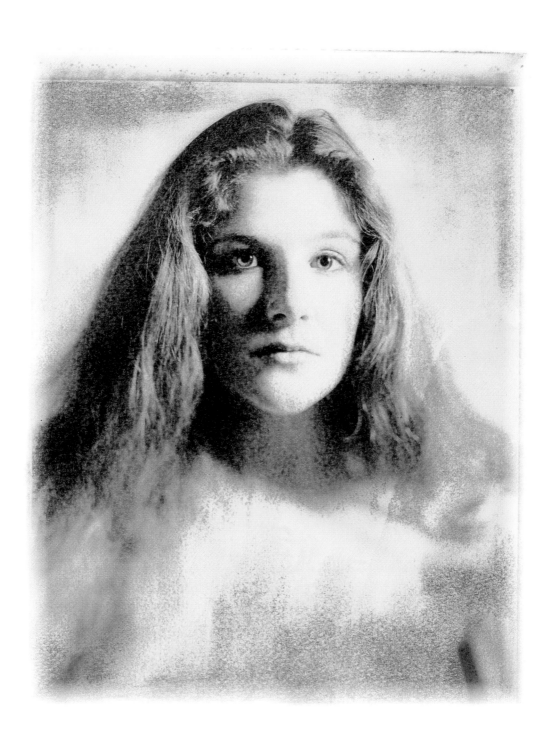

11 sets and models

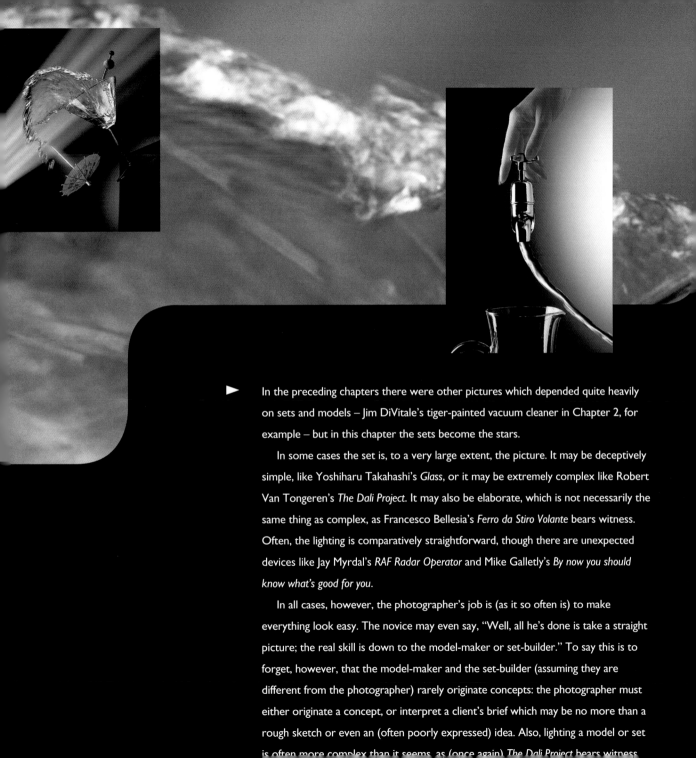

In the preceding chapters there were other pictures which depended quite heavily on sets and models – Jim DiVitale's tiger-painted vacuum cleaner in Chapter 2, for example – but in this chapter the sets become the stars.

In some cases the set is, to a very large extent, the picture. It may be deceptively simple, like Yoshiharu Takahashi's *Glass*, or it may be extremely complex like Robert Van Tongeren's *The Dali Project*. It may also be elaborate, which is not necessarily the same thing as complex, as Francesco Bellesia's *Ferro da Stiro Volante* bears witness. Often, the lighting is comparatively straightforward, though there are unexpected devices like Jay Myrdal's *RAF Radar Operator* and Mike Galletly's *By now you should know what's good for you*.

In all cases, however, the photographer's job is (as it so often is) to make everything look easy. The novice may even say, "Well, all he's done is take a straight picture; the real skill is down to the model-maker or set-builder." To say this is to forget, however, that the model-maker and the set-builder (assuming they are different from the photographer) rarely originate concepts: the photographer must either originate a concept, or interpret a client's brief which may be no more than a rough sketch or even an (often poorly expressed) idea. Also, lighting a model or set is often more complex than it seems, as (once again) *The Dali Project* bears witness.

Photographer: **Mike Galletly**

Client: **Computer Weekly**

Use: **Leaflet**

Art director: **Mike Gornall, Black Sheep Design**

Camera: **4x5 inch**

Lens: **240mm**

Film: **Kodak Ektachrome EPR 6117 ISO 64**

Exposure: **f/32**

Lighting: **Electronic flash: soft box, standard head with deep honeycomb, standard head with mini-spot/ snoot**

Props and set: **6x7 cm transparency of magazine cover; coloured glycerine for medicine; mottled blue background**

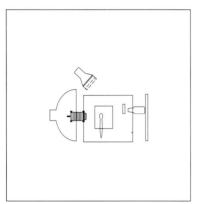

Plan View

► *Often, a simple shot is only simple once you know how it was done*

► *With liquids, the most natural viscosity and appearance may best be achieved by using a different liquid from the one being portrayed*

► *Fill spoons with an eye-dropper for precise control*

BY NOW YOU SHOULD KNOW WHAT'S GOOD FOR YOU

▼

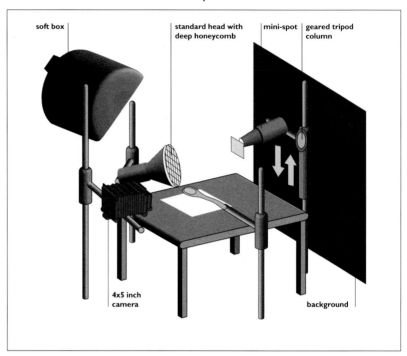

soft box standard head with deep honeycomb mini-spot geared tripod column

4x5 inch camera background

THE KEY TO THIS PICTURE IS THE TRANSPARENCY OF THE MAGAZINE COVER, TAPED IN FRONT OF A MINI-SPOT AND MASKED TO PREVENT SPILL. THE FIRST EXPOSURE WAS FOR THE SPOON AND "MEDICINE"; THE SECOND FOR THE REFLECTION OF THE TRANSPARENCY.

A standard head with a deep honeycomb on a shallow, round reflector illuminated the background; a soft box, masked down to a 100x20cm strip (about 40x8 inches) was the key light. A matte silver reflector under the spoon provided the edge definition and illuminated the drop of "medicine" on the bottom. This was the first exposure.

Next, with all other lights off, the snooted head with the transparency was lowered into position so that it reflected from the "medicine." For repeatability and precision, the snooted head was mounted on a geared camera stand.

Photographer's comment:

The copy line was, "By now you should know what is good for you." The brief was to link the magazine Computer Weekly *and a spoonful of medicine.*

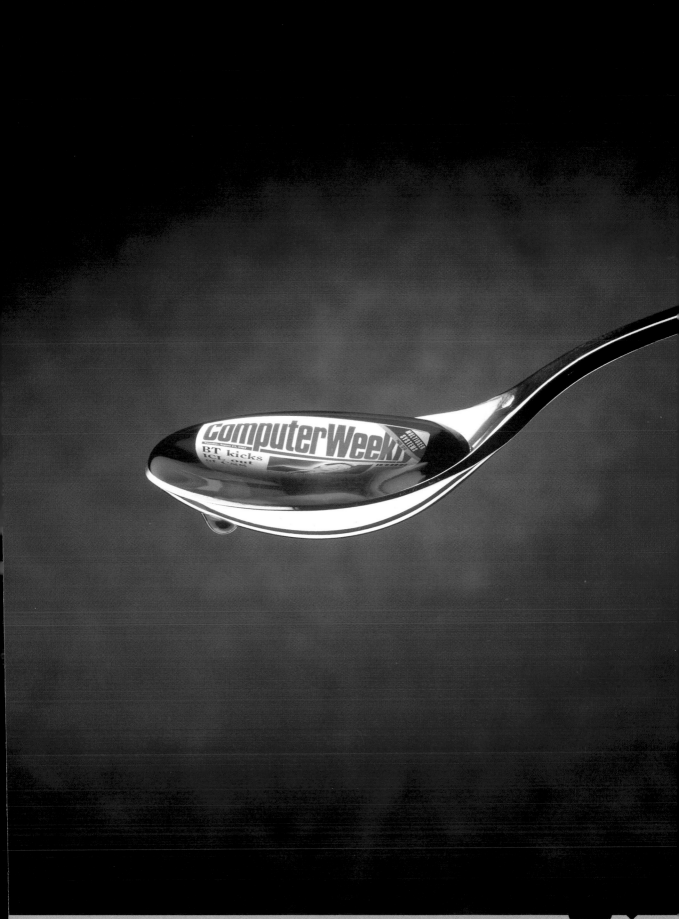

PEPSI COLA

▼

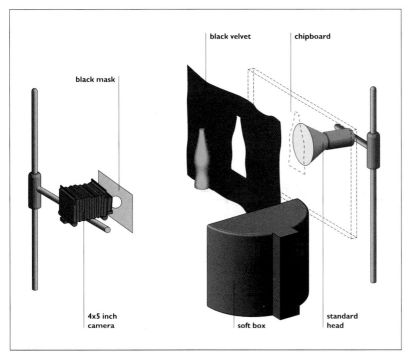

Photographer: **Matthew Leighton**

Client: **Pepsi Cola**

Use: **Poster**

Camera: **4x5 inch**

Lens: **240mm (3 exposures) and 75mm (one exposure)**

Film: **Fuji RDP 100**

Exposure: **f/64 - f/32 - f/8 - f/16**

Lighting: **Electronic flash: 2 large soft boxes, 1 small soft box, and plain reflector**

Props and set: **Background of black velvet**

MOST PEOPLE ASSUME THAT A SHOT LIKE THIS CAN ONLY BE CREATED WITH A COMPUTER, BUT MATTHEW LEIGHTON DID IT ALL IN CAMERA WITH TWO LENSES — A 75MM AND A HIGH CAMERA POSITION CREATED THE CORRECT PERSPECTIVE FOR THE "ASTRONAUTS" — AND A TOTAL OF FOUR EXPOSURES.

The first shot with a 240mm lens was of the Pepsi bottle resting over a hole in a piece of board covered in black velvet, and with a black mask in front of the camera. The bottle was both transilluminated and lit from the front. The second was of the "astronauts" standing on black velvet, lit with two overhead soft boxes and an angled reflector head. The third was of an illustration of the earth, on a black velvet background, and the last was of black velvet sprinkled with glitter and chalk. Both were lit with single reflector heads.

Photographer's comment:

The models had problems holding poses because they could not breathe. Eventually an air hose was run up the leg of each spacesuit and we were able to complete the shot.

- ▶ Precise registration is important: the impact would disappear if the hand overlapped with the bottle

- ▶ Switching lenses between exposures can create different perspective effects

Second Exposure

Third Exposure

Photographer: **Jay Myrdal**

Client: **JWT/COI/RAF**

Use: **Recruiting advertisements**

Assistant: **Peter Day**

Art director: **Chris Pay**

Camera: **8x10 inch**

Lens: **300mm**

Film: **Kodak Ektachrome ISO 100**

Exposure: **f/32**

Lighting: **Electronic flash: 4 heads**

Props and set: **See text**

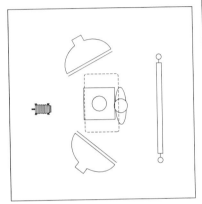

Plan View

RAF RADAR OPERATOR

▼

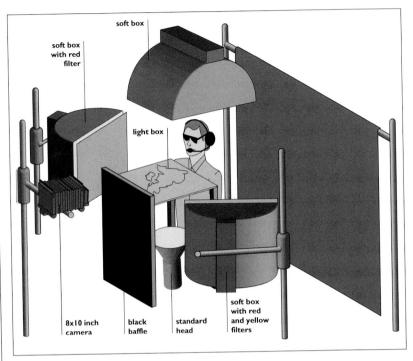

THE REFLECTED MAP IS MADE BY COPYING A LINE MAP ONTO LITH FILM AND ADDING COLOURS WITH CUT-UP FILTERS — IN PRE-COMPUTER DAYS A COMMON WAY OF MAKING COLOURED TEXT SLIDES FOR PROJECTION, BUT HERE INGENIOUSLY ADAPTED FOR ANOTHER PURPOSE.

The key light is in effect the light which comes through this map and from the "light box" on which it rests; no ordinary light box, but one with 3,000 watt-seconds of flash underneath it. Even then, the box is placed as close to the face as possible to give the most dramatic effect. A black baffle shields the light box itself from the camera.

The remaining lights are very much fills: one soft box on each side, and one above. The soft box above is stronger than the other two, and is unfiltered, but the other two are filtered and on low power: red and yellow filters on the right, red on the left.

The choice of an 8x10 inch camera is unusual, but Jay Myrdal prefers whenever possible to work with this format, both for the image quality it delivers and for the size of the image on the ground glass.

► *Larger formats than 4x5 inch can deliver wonderful quality but also demand very powerful lighting because of the small apertures which are normal*

► *Lighting from below is often called "horror film" lighting, but with the rise of computer screens it could equally be called "techno" lighting*

Photographer: **Francesco Bellesia by Wanted**

Client: **Termozeta**

Use: **Advertising**

Camera: **4x5 inch**

Lens: **210mm**

Film: **Kodak Ektachrome 64**

Exposure: **Triple exposure, details not recorded**

Lighting: **Tungsten, 2 heads, plus slide projector**

Props and set: **Built set, modified iron**

Plan View

Side View

► *Protect light backgrounds with black velvet which can be removed as necessary*

► *Experiment with model-making or find a model-maker who also wants to experiment*

F E R R O D A S T I R O V O L A N T E

▼

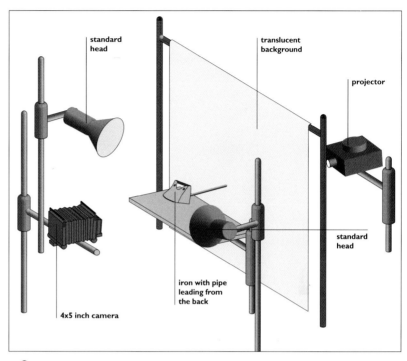

SET-BUILDING CAN BE EVEN MORE COMPLEX THAN ONE MIGHT THINK. THIS IS A REAL IRON, WHICH HAS BEEN MODIFIED BOTH TO ALLOW SMOKE TO BE BLOWN THROUGH THE STEAM HOLES AND FOR INTERNAL ILLUMINATION USING A BATTERY.

The sky and planet are back projected; the landing ground is a model; and the iron is suspended using a rod which is behind the iron from the camera's point of view. The rod also carries the pipe for feeding smoke through the iron.

There were three exposures. The first, with the two key lights switched on and the smoke blowing, was the main picture. The second exposure was made with all lights off except the internal light in the iron. For both the first and the second exposures, the translucent acrylic background was covered with a sheet of black velvet. The third exposure was for the sky, back projected as described.

Photographer's comment:

No computer!

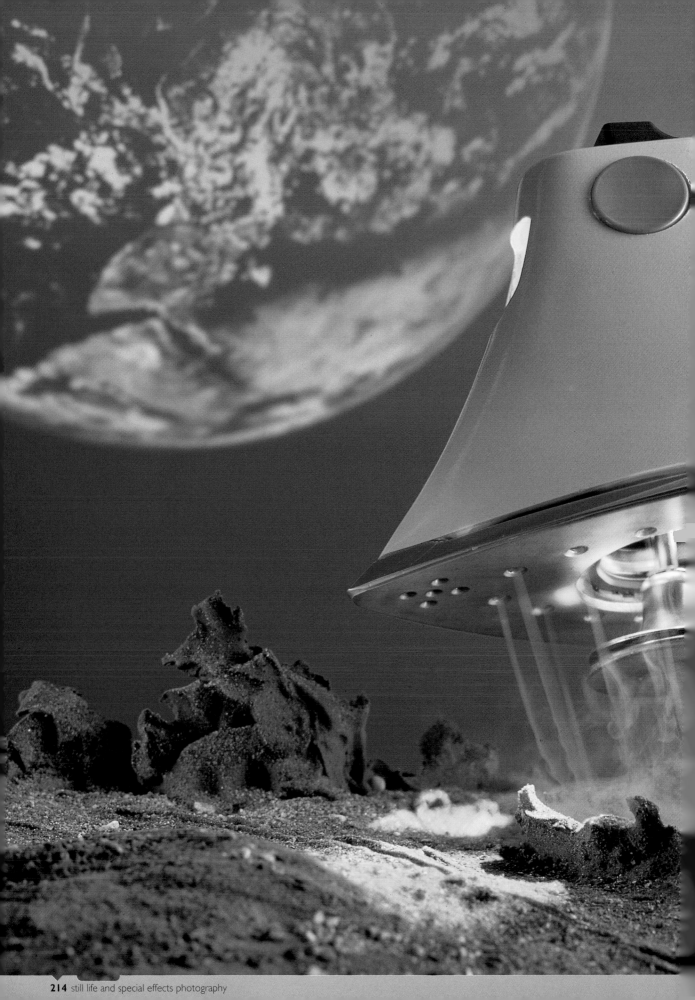

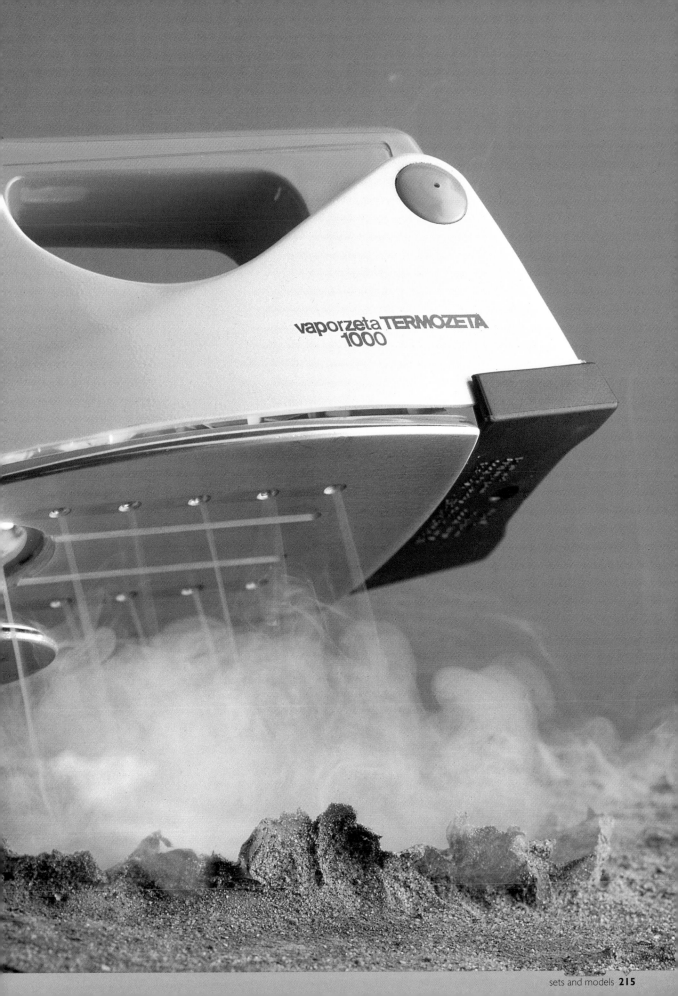

Photographer: **Yoshiharu Takahashi**

Client: **Personal work**

Camera: **4x5 inch**

Lens: **300mm**

Film: **Fuji Velvia**

Exposure: **f/22**

Lighting: **Electronic flash: I head**

Props and set: **2 glasses glued to a glass sheet**

Plan View

G L A S S

▼

black cloth

glass

standard head
with honeycomb

acrylic board

4x5 inch
camera

T HIS IS A GOOD EXAMPLE OF A "DOUBLE-TAKE." MOST PEOPLE DO NOT IMMEDIATELY NOTICE
THAT THE LOWER GLASS, WHICH THEY ASSUME TO BE A REFLECTION OF THE UPPER GLASS, HAS
NO WATER IN IT. THEN THEY REALIZE THAT THE WIRE IS NOT REFLECTED EITHER.

The glasses are glued to a sheet of glass; the single light, a standard head with a honeycomb grid, is diffused through an acrylic panel some distance behind that. The positioning of the pool of illumination is critical: the way the lower glass is less well illuminated automatically makes us see it as a reflection.

Once the set had been built, it was a question of pouring or squirting water into the glass and shooting when the shape of the water was precisely right – which normally involves a certain amount of trial and error, and a time-consuming clean-up between shots.

► *Having a long lens reduces the likelihood of splashing water on it*

► *The camera looks through a hole in a piece of black cloth, to obviate reflections on the background*

► *Short-duration flash "freezes" the movement of the water*

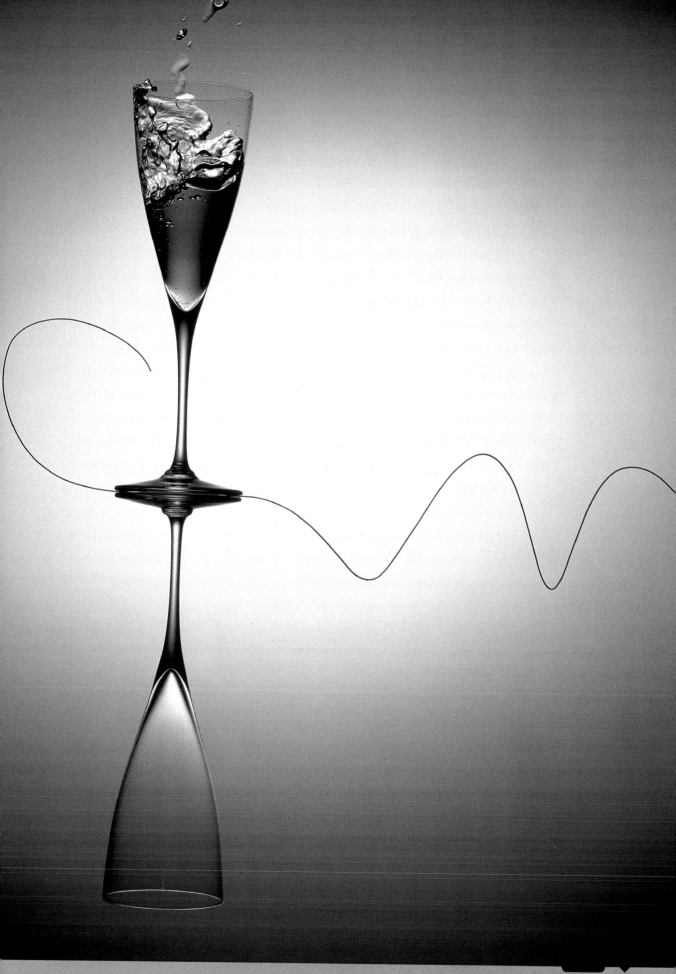

LA STANZA

▼

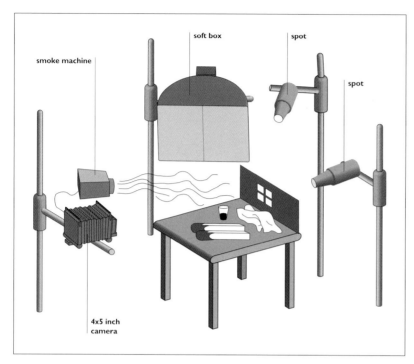

Photographer: **Mario Di Benedetto by Wanted**

Client: **Imagic**

Use: **Calendar**

Assistant: Francesco Bellesia

Camera: **4x5 inch**

Lens: **90mm**

Film: **Kodak Ektachrome EPP**

Exposure: **f/45**

Lighting: **Electronic flash: 2 spots, 1 soft box**

Props and set: **Built set, smoke machine; models by Francesco Bellesia**

EVERYTHING HERE IS SCALED FROM THE GLASS, WHICH IS LARGE AT 25CM (ABOUT 10 INCHES) BUT NOT IMPOSSIBLE. THE "MATCHES" ARE 50 CM LONG (JUST UNDER 20 INCHES), BUT THE WINDOW IS ONLY 13x18CM (ABOUT 5x7 INCHES).

The whole set is back lit, as befits the theme with the window – though close examination of the light through the window, and the shadow cast by the glass, reveals that it is not the same light in both cases, which adds to the unreality or dream-nature of the scene. A big soft box provides the fill, while spotlights provide the directional lighting. A smoke machine helps with the "sunbeams".

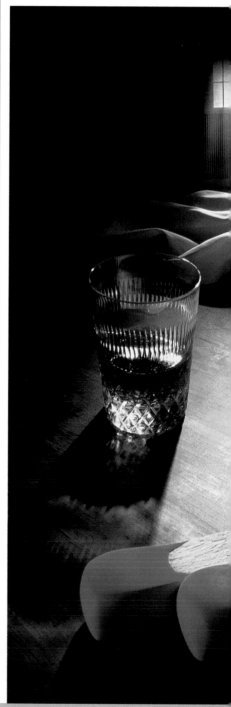

Plan View

► Strongly directional lighting often adds to the realism of a scene as well as the mood

► Texture is an important point in model-making; a pill photographically enlarged to full-page size has a surface cratered like the moon

Photographer: **Mike Galletly**

Client: **Self and model (see Photographer's Comment)**

Use: **Self promotion and model card**

Model: **Joanna Aitkens**

Camera: **5x7 inch**

Lens: **300mm**

Film: **Kodak Ektachrome 6117 ISO 64**

Exposure: **f/45**

Lighting: **Electronic flash: one soft box, one with square reflector**

Props and set: **Tap, jug**

Plan View

► *It can be difficult to define the edges of glass and chrome against a dark background*

► *Careful positioning of lights and reflectors helps to define edges clearly*

► *Polished chrome surfaces need to be checked carefully and repeatedly for fingermarks*

H A N D A N D T A P

▼

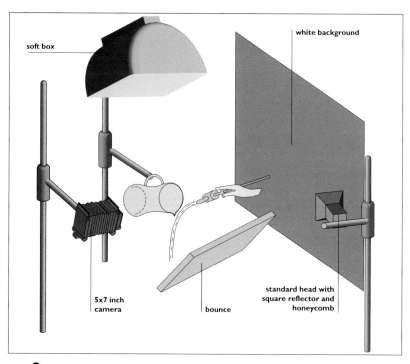

white background

soft box

5x7 inch camera

bounce

standard head with square reflector and honeycomb

ONCE YOU HAVE SEEN THE DRAWING OF THE SET, THE ESSENTIAL SIMPLICITY OF THIS PHOTOGRAPH BECOMES APPARENT. BUT WITHOUT THE LIGHTING — ESPECIALLY THE WAY THE HAND, TAP AND WATER ECHO THE CURVE OF THE LIGHT — IT WOULD BE MUCH LESS ATTRACTIVE.

The modelling of the hand, and the clear, sharp definition of both the jug and the tap, are taken care of by the 100x70cm soft box to camera left and the large white reflector to camera right; but the brilliance of the water owes a good deal to light and dark refracted from the background. The large patch of light on the right is thrown by a head with a square reflector and a medium honeycomb: the "curve" is actually a corner of the light patch.

Photographer's comment:

I wanted to create an intriguing shot which could be used both in my portfolio and in the model's.

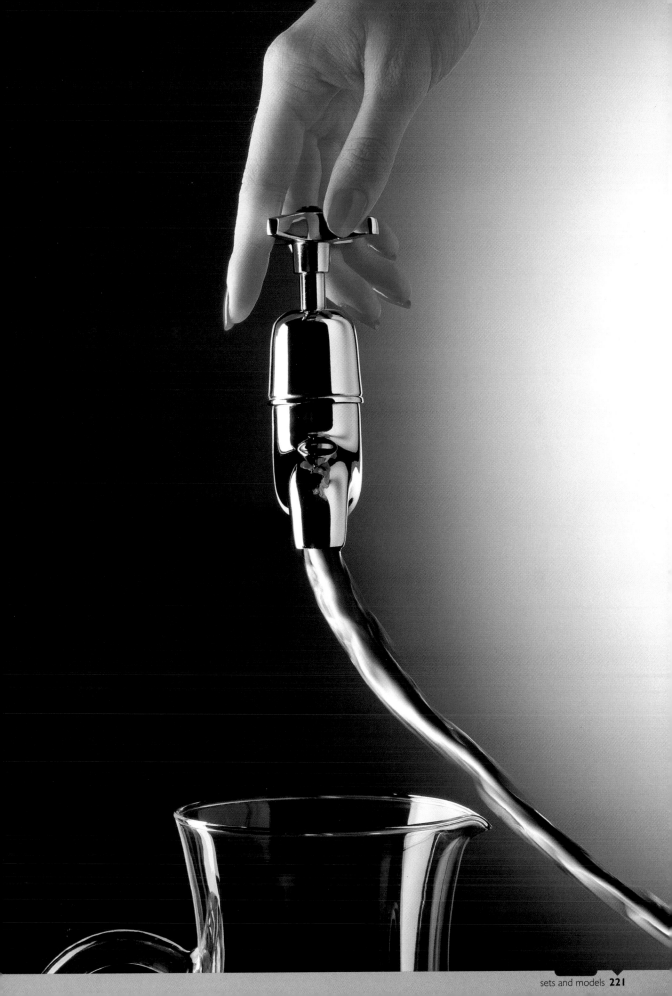

Photographer: **Mike Galletly**

Client: **Self promotion**

Camera: **5x7 inch**

Lens: **300mm**

Film: **Kodak Ektachrome EPR 6117 ISO 64**

Exposure: **f/45**

Lighting: **Electronic flash: soft box, 2 standard heads, plus bounce reflectors**

Props and set: **White Formica background; black table top; cocktail glass with hole drilled in side**

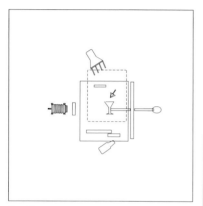

Plan View

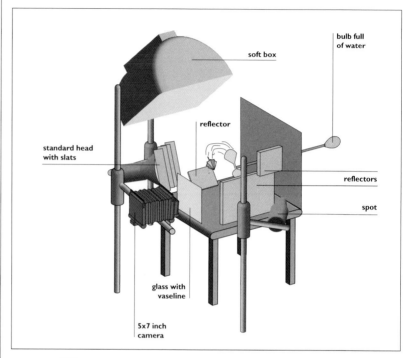

C O C K T A I L G L A S S

▼

WITH THIS SORT OF SHOT THERE IS ALWAYS A DEGREE OF CHANCE IN EXACTLY WHERE THE WATER WILL ARC UP, SO THE NORMAL APPROACH IS TO SHOOT A NUMBER OF PICTURES AND CHOOSE THE BEST.

The diagram is self-explanatory. The glass was filled to the brim, then more water was squirted in via an aluminium tube attached to a rubber bulb; the cocktail stick is glued in.

Although the key light is a soft box, it is the other lighting which "makes" the shot: the streaks from a gobo'd light to camera left and below, the light behind the table to give the halo on the corner, the shiny silver reflector below the glass to improve edge definition of the water and the glass. A little petroleum jelly on a glass in front of the lens adds movement to the umbrella.

► *The duration of a powerful studio flash can be as long as 1/300 second, so the water is not fully "frozen"*

► *The contrast between the movement of the water and the absolutely sharp glass is useful*

Photographer's comment:

I lost count of the number of umbrellas I used. They had to be replaced after each shot as they were soaked.

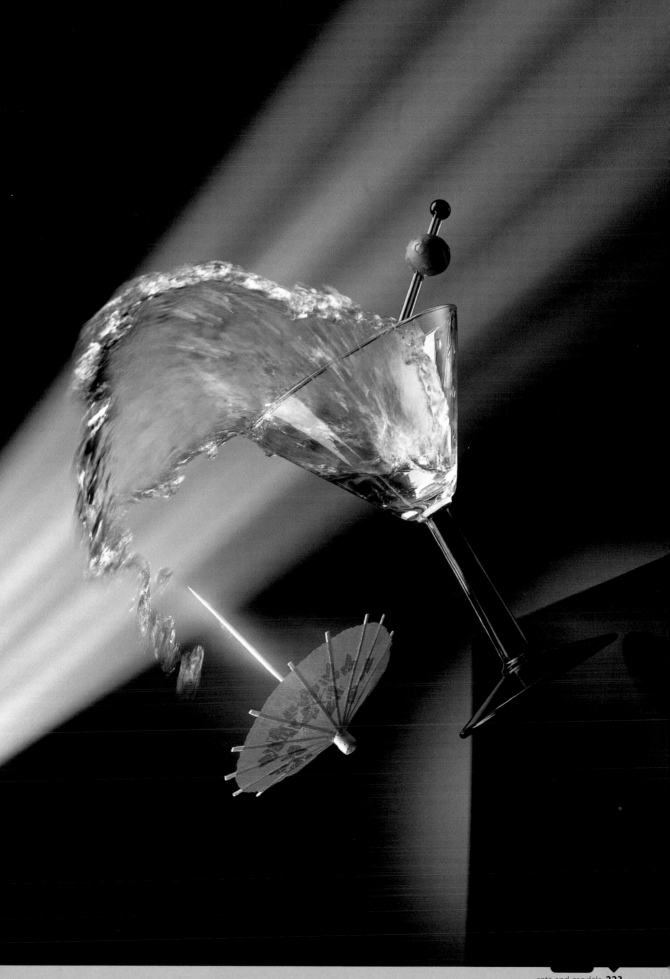

Photographer: **Robert Van Tongeren**

Client: **Self-promotional work**

Use: **Christmas card**

Assistant: **Fernando Vicente**

Camera: **4x5 inch**

Lens: **360mm**

Film: **Kodak Ektachrome 100**

Exposure: **1/2 second at f/45**

Lighting: **Flash and tungsten; see text**

Props and set: **Built set, plus painting by
Fernando Vicente**

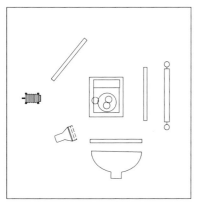

Plan View

► *Some sets are built in such a way that
they can only be photographed from a
single viewpoint*

► *Reproducing in a photograph the style
of lighting which appears in a painting
can be extremely difficult, as the painter
can add and remove highlights and
shadows at will*

THE DALI PROJECT

▼

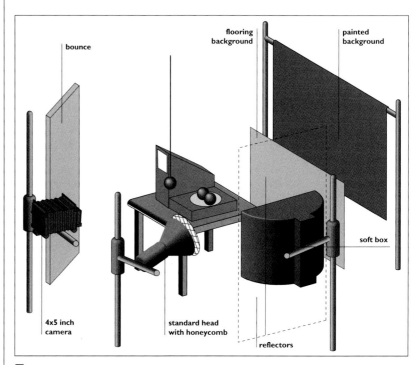

T HIS IS AN EXTRAORDINARY MIXTURE OF THE ORIGINAL DALI PAINTING (IN THE "BOX" ON THE
LEFT), THE MELTING WATCH (BUILT BY A MODEL-MAKER), A SET BUILT WITH FALSE PERSPECTIVE,
AND A PAINTED BACKGROUND, ALSO WITH STRANGE PERSPECTIVE.

Each picture component was
independently mounted on tripods,
stands and trestles so that it could be
moved independently until it looked right
on the ground glass. Overleaf, the actual
set is shown as a series of black and
white pictures which clearly show how
everything was set up and how it was lit.
These were taken as reference shots
rather than for publication; they need to

be examined carefully if one is to
understand how everything was done.

It was important to have the original
picture in shot; this was copied from a
book, but in order to get an extra three-
dimensional effect the transparency was
sunk into the main built set. It was
transilluminated by its own light box, as
can be seen in picture 2 overleaf.

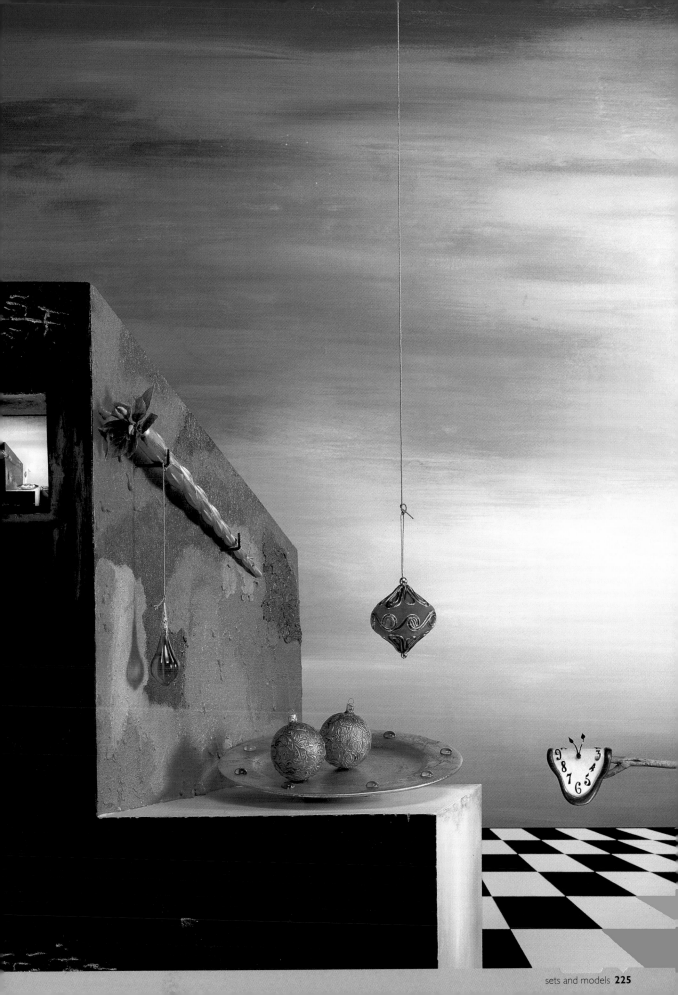

The key light is a big flood to camera right, diffused through a large sheet of tracing paper. A hanging Christmas bauble replaces the fried egg in the original, as this was intended as a Christmas card. To remain faithful to the painting, the melting watch hanging from the hook which supports the carrot had to cast a shadow on the wall; but if the main bauble had been in the obvious place, it would have cast a second shadow, which was obviously undesirable. It was therefore hung in front of the set where it would cast no shadow.

A honeycombed spot to camera right illuminates the two painted backgrounds (the sky and the perspective squares). Because of the angle of the light, and because there is a gap between the two backgrounds, it casts no shadow, not even of the melting watch.

► *Beside the camera. This gives the clearest approximation to how the shot appears on the ground glass and in the final picture, while also showing the considerable stand-off afforded by shooting a large set (around a metre square) with a 360mm lens on 4x5 inch.*

► *From above. The considerable depth of the set is apparent here – just under a metre from front to back, which explains why f/45 was essential for depth of field. The large bauble can be seen in the upper centre of the image, at the foot of the lighting stand, and the backdrops are well illustrated. You can also see the light box which transilluminates the image of the original painting.*

To camera left, a large flat provided general fill, but as can be seen from Reference 3, several small mirrors (not shown in the lighting diagram) were used to throw extra light on specific areas of the set. A very long focal length – over twice the 150mm standard for 4x5 inch – was chosen to give plenty of stand-off and working room as well compressing the perspective so that the whole set would "work" from the camera viewpoint. In addition, shooting from this distance means that the two backdrop paintings can be fairly small: they would need to be a lot larger if a shorter focal length had been used with such a deep set. It might have been possible to shoot on a still larger format, but a very long lens indeed would have been necessary to achieve it.

▶ *From camera right. It is clear from this picture how everything is supported at the appropriate level and can be moved independently. The small mirrors to the left of the set are also clear; they add highlights such as those on the left-hand side of the large hanging bauble.*

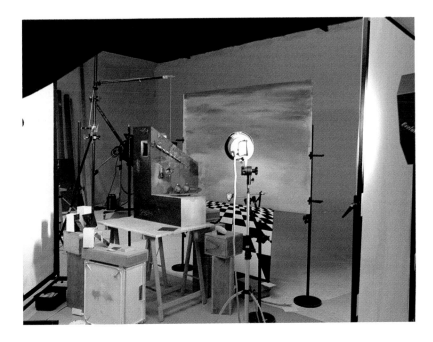

▶ *From behind the set, camera right. The considerable distance of the large hanging bauble from the back of the set is readily apparent here, though the backdrop has been moved back to allow a clearer view of the set. For the picture, the backdrop would be pushed up against the boxes at the back of the set as seen from above (left).*

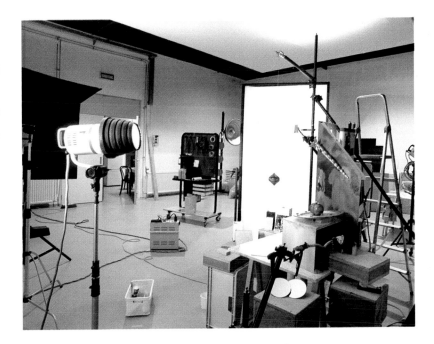

12
artwork

There are many ways of mixing artwork and the photographic image. To begin with, the artwork can be in the form of make-up applied to the subject itself, as in Peter Barry's *Clay Torso* or Marc Joye's *Finger*. Or again, the artwork may be double exposed onto a photographic image, like Marc Joye's *Fur Coat*. Yet another possibility is to use a photographic print essentially as a canvas for painting on: Peter Barry's *Marionette* is a good example of this. Then there is collage, which can be done with prints or with transparencies – though if you are going to cut up transparencies, you would be well advised to start with very large ones, or to have camera originals "duped up" to 8x10 inch or (preferably) 11x14 inch.

With "comped-up" (composite) pictures, it is often necessary to add some artwork to complement the purely photographic components of the work: shadows, in particular, of which Peter Barry's *On the Buses* or *Girl on a Neck Chain* is evidence. The traditional way of doing this was with an airbrush, though increasingly it can be done electronically as illustrated in the next chapter. Traditional retouching and comping does however have the advantage that it forces the person doing the work to have some artistic awareness: electronic work, on the other hand, is so easy to get into (once you have spent the money on the electronics) that too many people plunge in and are so impressed by the speed and ease with which they can get a result that they never make the effort to learn the craft that they need.

Photographer: **Peter Barry**

Client: **Arborite**

Use: **Calendar**

Assistant: **Stewart Harden**

Camera: **6x6cm**

Lens: **110mm + Softar 1**

Film: **Kodak Ektachrome EPR**

Exposure: **f/16**

Lighting: **Electronic flash: 3 heads**

Props and set: **Clay, wig, board**

Plan View

► *Clay dries the skin badly, so a layer of barrier cream is very useful if the model is to remain in contact with it for long*

► *A shower in the model room is all but essential if you are going to use whole-body make-up*

► *Professional make-up and styling are essential for shots like this. The girl cannot do it, nor (usually) can the photographer*

C L A Y T O R S O

▼

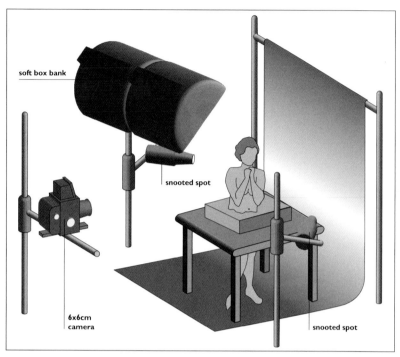

soft box bank

snooted spot

6x6cm camera

snooted spot

THIS IS A STRAIGHT SHOT OF A REAL GIRL. THE BOARD WAS IN TWO PIECES, TO FIT AROUND THE GIRL; THERE IS A HOLE IN THE TABLE; AND THE REST WAS ACHIEVED WITH CLAY AND MAKE-UP.

The clay around her waist was pushed into place; her skin was covered with clay-coloured make-up; and the clay hair is a wig that was filled with clay and modelled to shape. While all the clay and make-up and so forth was being applied, she had to hold her pose for almost three hours: anything more than the slightest move marred the make-up.

After this, the lighting was fairly simple: a standard head with a large soft box directly above the camera, and two snooted spots trained on the seamless paper background to create the "hot spot" behind the model. A "Softar" soft-focus attachment on the lens blurred the textural distinctions between made-up skin, and real clay.

Photographer's comment:

She was an incredibly patient girl.

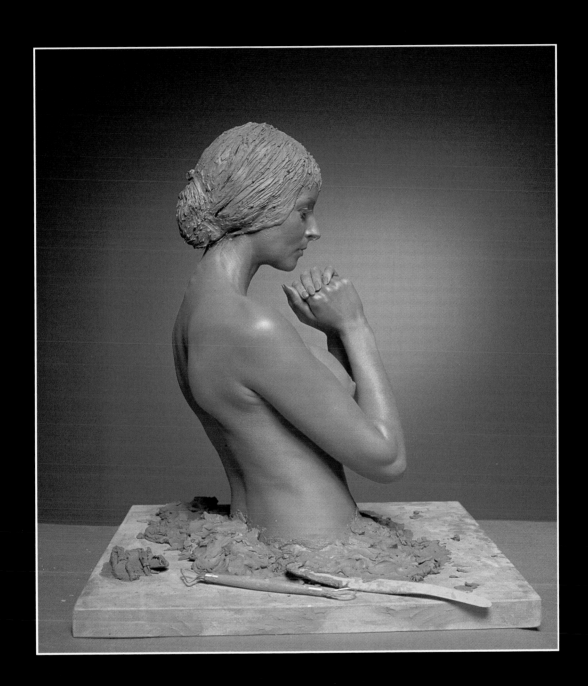

Photographer: **Peter Barry**

Use: **Portfolio**

Model: **Rowena**

Assistant: **Stewart Harden**

Artist: **Alan Gray**

Camera: **6x6cm**

Lens: **80mm**

Film: **Kodak Ektachrome EPR**

Exposure: **f/8**

Lighting: **Electronic flash: single large soft box**

Props and Set: **White seamless background**

Plan View

PUPPET

▼

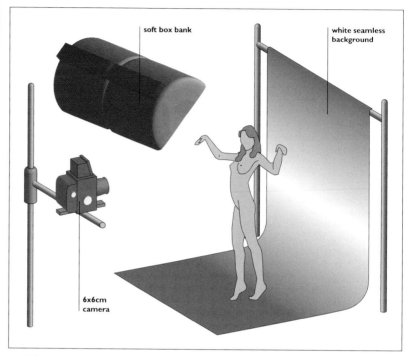

soft box bank

white seamless background

6x6cm camera

THIS IS CLEARLY THE WORK OF A TALENTED AIRBRUSH RETOUCHER, WORKING TO THE PHOTOGRAPHER'S CONCEPT. IT IS SUPERBLY EXECUTED, BUT IT IS ON A CURIOUS BORDERLINE BETWEEN HUMOUR, FANTASY AND SOMETHING RATHER DARKER.

► *Although electronic retouching is now more fashionable, there is still room for traditional airbrushing skills.*

► *Electronic retouching has removed a great deal of the craft from the retoucher's skills, meaning that people who could never master an airbrush may try to use computers*

► *Whatever method is used for retouching, the retoucher must have considerable artistic skills*

The original picture is very simply lit, with a single very large bank above the model. This also lit the seamless paper background, which would in any case be blown over white with the airbrush when it was retouched.

A 16x20 inch (40x50cm) C-type was made from the original transparency, and all those parts of the girl's body which were not to be retouched were masked out. The artist then blew in the background, including the paint splotches. Next, the "sections" through the body were masked and sprayed. The pubic hair was sprayed out, and the joints and wires were drawn in.

The difficult things with a picture like this are getting the original pose right, and then finding a retoucher who understands the masking sequences necessary to create the picture.

Photographer's comment:

Like most children, I had puppets when I was a boy. This picture grew out of a dream: what would it be like to have a real girl whom you could control like that?

Photographer: **Peter Barry**

Use: **Portfolio**

Model: **Amanda**

Assistant: **Stewart Harden**

Camera: **6x6cm (both pictures)**

Lens: **80mm (all pictures)**

Film: **Kodak Ektachrome EPR**

Exposure: **(Girl) f/11 (bus) 1/125 @ f/11**

Lighting: **(Girl) Electronic flash: 3 heads**

(Bus) Available light

Props and set: **Silver bus, seamless paper background in studio**

Plan View

► *There is still scope for cut and paste, though learning to use an airbrush as well will greatly increase the scope of what you can do*

► *Shadows are not the only important thing to add when retouching: reflections are also important. How often have you seen a "sunset" which looked totally unnatural because it was not reflected in anything in the foreground?*

O N T H E B U S E S

▼

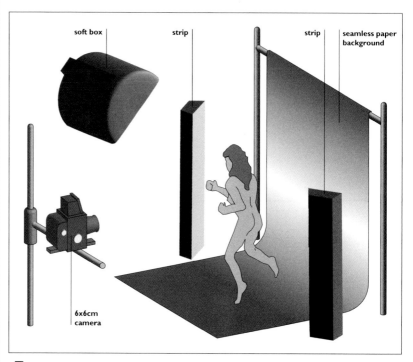

THERE ARE FOUR PHOTOGRAPHS HERE, CUT AND PASTED TOGETHER AND THEN RETOUCHED WITH AN AIRBRUSH TO ADD THE GIRL'S SHADOWS, THE SHADOW OF THE RAIL ON THE BUS, AND SO FORTH. ADDING THE SHADOWS MAKES ALL THE DIFFERENCE TO REALISM.

The pictures of the girl – it is of course all the same girl – were shot in the studio with a single 4x4 foot (120x120cm) soft box above the camera. Two strips lit the seamless white paper background, about half a stop brighter than the girl herself, to make it easy to cut them out. She adopted a wide range of poses: the most appropriate were selected to drop onto the picture of the bus.

Working with a 20x16 inch (40x50cm) enlargement of the bus, the pictures of the girl were enlarged to size, then physically cut out and put onto the picture. Finally, the shadows were added with an airbrush.

Photographer's comment:

I shot the silver bus just because I love silver. The rest of the shot came later.

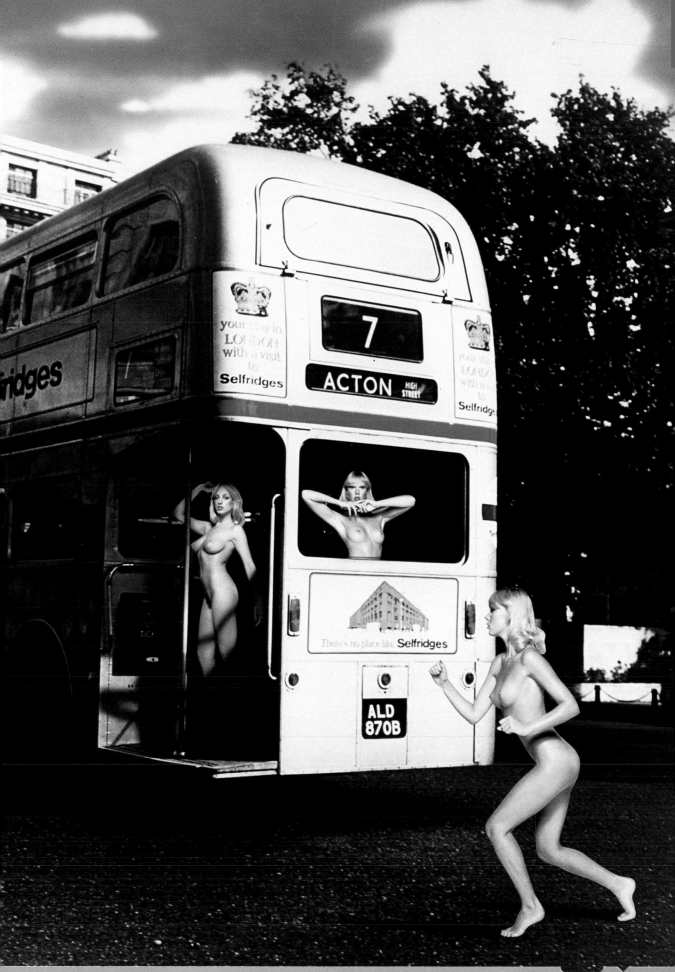

Photographer: **Peter Barry**

Client: **Arborite**

Use: **Calendar**

Assistant: **Stewart Harden**

Camera: **8x10 inch**

Lens: **420mm**

Film: **Kodak Ektachrome**

Exposure: **f/32 (panel) f/22 (girl)**

Lighting: **Electronic flash: see text**

Props and set: **Carved gilt panel, gold painted background**

Plan View

▼

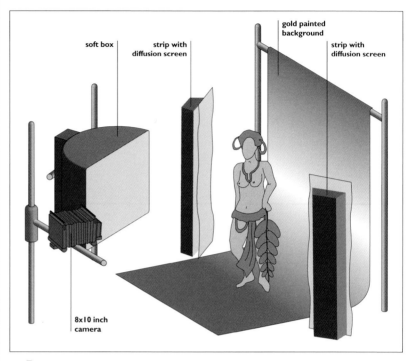

BOTH THE GIRL AND THE PANEL WERE PHOTOGRAPHED ON 8×10 INCH TRANSPARENCY FILM. THE PANEL WAS THEN DUPED TO 11×14 INCH AND THE GIRL (PLUS BACKGROUND) WAS CUT OUT AND DROPPED INTO THE ENLARGED TRANSPARENCY.

► *The two shots are similarly lit, except for scale, so that the lighting appears to be coming from the same source in both*

► *James Bond movies notwithstanding, being covered in gold make-up is not dangerous*

► *A major problem when working with gold, gilt, etc is reflections: heavily diffused light sources are normally essential*

The lighting for both was similar: a large soft box on the left-hand side, though the panel was filled from the right with a large bounce but the girl wasn't. The panel was shot against a black background (not shown) and the girl (covered in gold make-up) was shot against a gold-painted background (shown) which was lit with two heavily diffused strips; the diffusion was necessary to avoid glare from the background.

The main reason for shooting on 8x10 inch was the need for subsequent manipulation: today, it would probably be easier to shoot both pictures on 4x5 inch and combine them electronically.

Photographer's comment:

I can't think why I didn't use a fill panel to the right when photographing the model; an oversight, I think. But the picture works anyway.

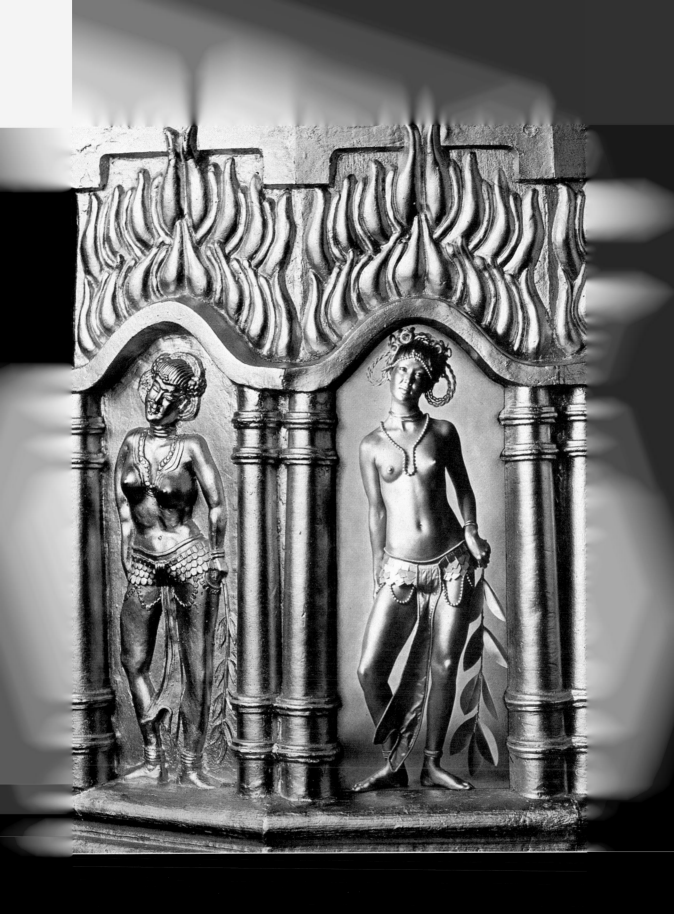

THE MOTORBIKE

▼

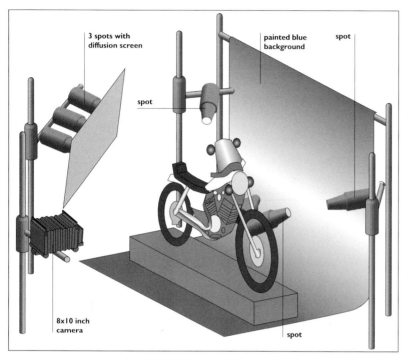

3 spots with diffusion screen

painted blue background

spot

spot

8x10 inch camera

spot

THE INITIAL 6-SECOND EXPOSURE OF THE MOTORCYCLE WAS MADE WITH THREE SPOTLIGHTS TO CAMERA LEFT, DIFFUSED THROUGH A SCREEN OF TRACING PAPER. NEXT, WITH A HEAVY DIFFUSER ON THE CAMERA, THE BACKGROUND WAS LIT FOR 10 SECONDS WITH FOUR SPOTS. THEN THE FUN STARTED...

The large-format 'chrome was printed as a dye transfer – a very stable colour medium, which lends itself well to afterwork, but expensive and difficult. Only a few labs are equipped to make dye-transfer prints. The dye-transfer print itself was then reworked with pastels, and the final image was rephotographed. This was done partly to disguise the amount of hand-work; partly because of the risk of damaging a picture reworked with pastels; and partly because it is

always better to retain irreplaceable originals and send out duplicates.

It might seem that if you were going to do this much work on a print, you might as well start with a cheaper, easier-to-use format than 8x10 inch. And yet, the choice of the large format adds its own special quality to the image: a strange combination of the photographic clarity we associate with 8x10 inch and the very non-photographic qualities of hand-worked pictures.

Photographer: **Stefano Zappalà**

Client: **Personal work**

Camera: **8x10 inch**

Lens: **450mm, with and without diffuser**

Film: **Kodak Ektachrome 64T**

Exposure: **Double exposure at f/45: see text**

Lighting: **Electronic flash: 3 heads for first exposure, 4 for second exposure**

Props and set: **Motorcycle; painted blue background with some texture**

- ► *Spotlights behind a diffusing screen create a different effect from either big soft boxes or light bounced off white flats*

- ► *Lighting the background as a separate exposure allows more control*

- ► *Dye-transfer prints are particularly suitable for additional work with pastels and other unconventional media*

Side View

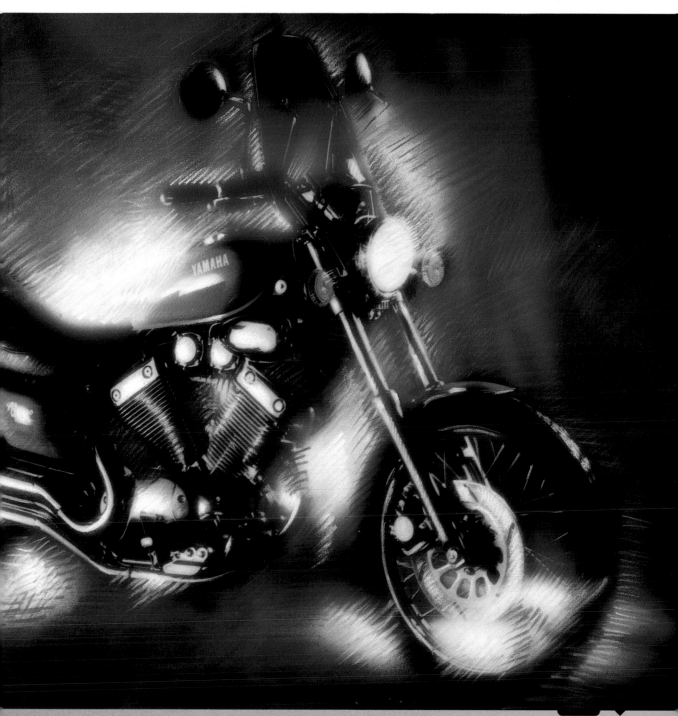

Photographer: **Marc Joye**

Client: **Printing Office Demuyter**

Use: **One page calendar**

Model: **"My left arm!"**

Assistant: **Margareth**

Camera: **4x5 inch**

Lens: **150mm**

Film: **Kodak Ektachrome 100**

Exposure: **Multiple: see text**

Lighting: **Electronic flash: candle**

Props and set: **Torn paper; make-up**

Plan View

First Exposure

► *Multiple superimposed exposures can be surprisingly effective*

► *"Artwork" can be applied as make-up as well as on a print*

► *"Artwork" can also be double exposed onto an existing picture*

F I N G E R

▼

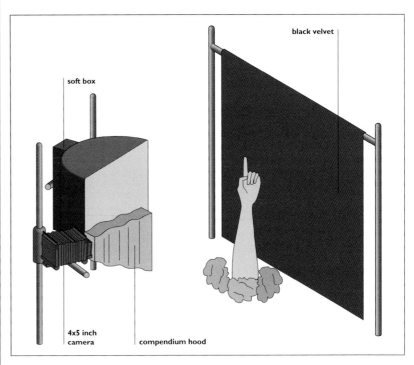

black velvet

soft box

4x5 inch camera

compendium hood

THERE ARE ACTUALLY FIVE EXPOSURES ON THIS SINGLE SHEET OF FILM: THE ARM, THE FLAME, THE STREAKED MASK (EXPOSED TWICE) AND A SHEET OF WHITE PAPER. AS SO OFTEN, THE WHOLE SEQUENCE IS QUITE SIMPLE AND OBVIOUS — ONCE IT HAS BEEN EXPLAINED.

The first exposure, lit with a soft box above the camera, is of the arm. Marc Joye painted the brickwork, the sky, the clouds and the birds on his own left arm, using make-up, and photographed it with torn paper "rocks" at its base. This was shot at f/22; the position of the arm was marked on the ground glass.

Next, the candle flame was added, using the reference marking on the ground glass; it was shot through a small hole in a sheet of black card, 1/10 second at f/11.

The third and fourth exposures were both of the streaked "clouds" at different magnifications and exposures; a compendium hood held the "cloud" mask, transilluminated by a strobe head. Finally, the internal "frame" was added: this is a sheet of white paper lying on a piece of black velvet, heavily underexposed.

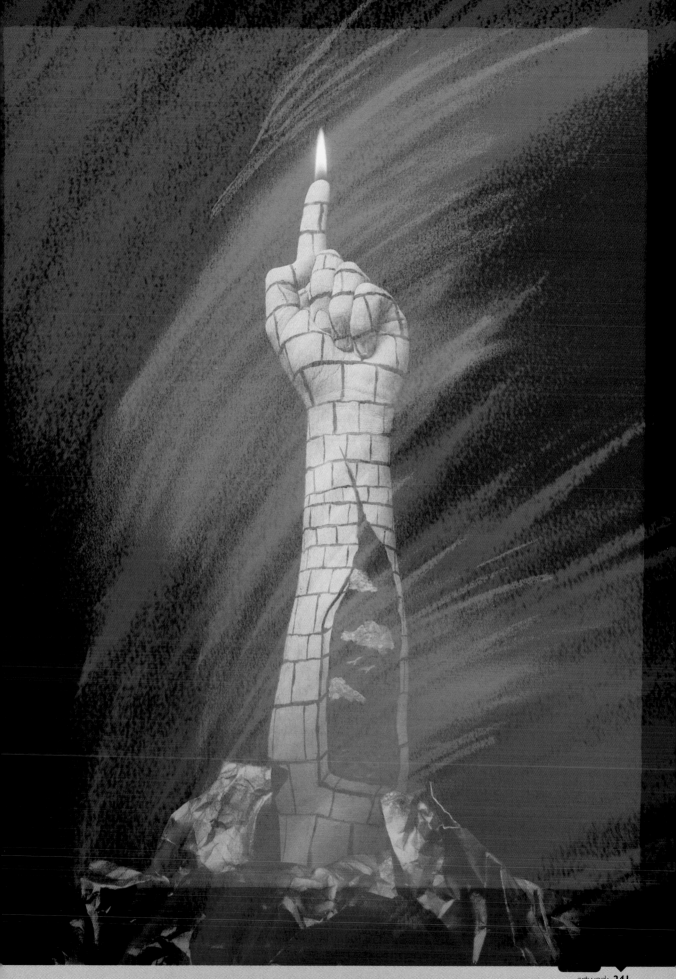

Photographer: **Marc Joye**

Client: **Fourrure Snauwaert**

Use: **Advertising poster**

Model: **Edith by Models Office**

Camera: **4x5 inch**

Lens: **150mm**

Film: **Kodak T-Max 100/Kodak Ektachrome**

Exposure: **f/22**

Lighting: **Flash**

Props and set: **Self-made masks**

Plan View

COAT

▼

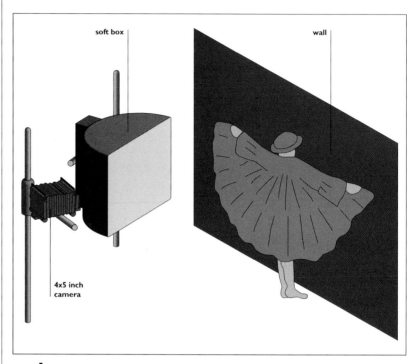

ALTHOUGH THERE ARE SOME SIMILARITIES BETWEEN THIS PICTURE AND THE ONE ON PAGE 107, SEVERAL OF THE TECHNIQUES INVOLVED ARE SIGNIFICANTLY DIFFERENT. THIS IS AN AIRBRUSHED BLACK AND WHITE PRINT REPHOTOGRAPHED ONTO COLOUR FILM THROUGH A SEPIA FILTER AND WITH EXTRA PICTURE ELEMENTS DOUBLE EXPOSED IN.

The first shot, made with a big soft box, was a black and white picture of the model. The soft box was to camera left; exposure was generous in order to capture detail in the fur. This was printed to 40x50cm (approximately 16x20 inches), and masked to just outside the edge of the coat. When the background was airbrushed black and the mask removed, the effect was of a thin line around the coat.

This was then copied onto slide film through a sepia filter, with a simple copying set-up. The streaks, from a mask made by the photographer, were then superimposed using a compendium hood; this was photographed twice, each time at a different magnification and exposure. Finally, the inner "frame" was added by photographing a sheet of white paper on black velvet, underexposing by 2-1/2 stops.

► *Masking is one of the fundamental skills of airbrushing. A hard mask at the edge of the fur would not have worked, but by going outside the edge of the fur, the edge texture was preserved*

► *The actual resolution of this picture is not high – but the mood is what makes the image*

Photographer's comment:

The fur coat was a semicircle five metres in circumference, and very soft; Edith made as if to fly away.

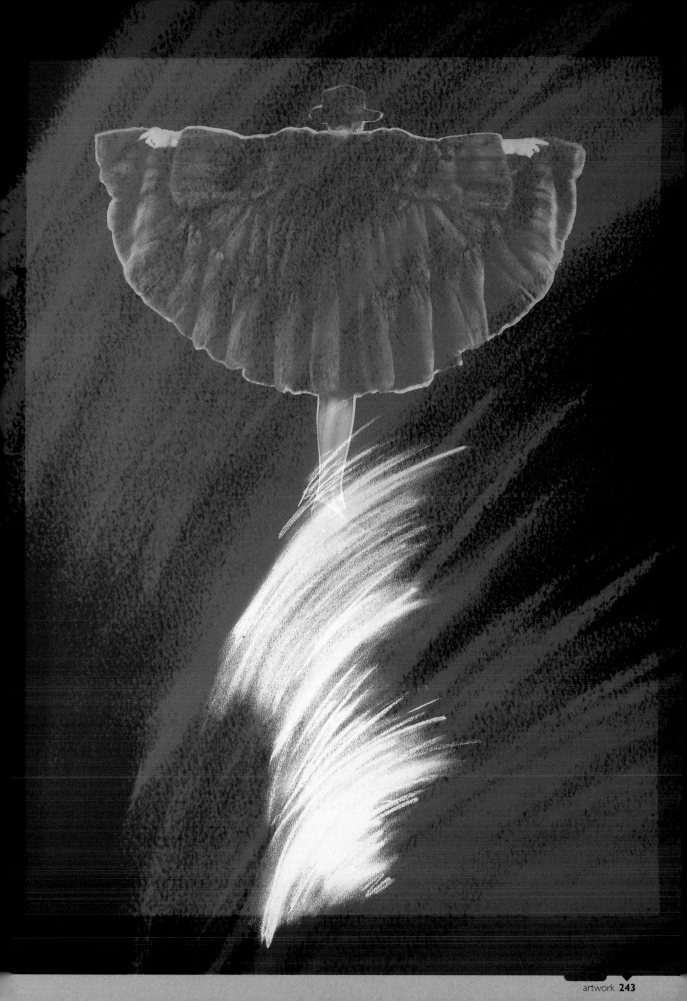

13
electronic
image
manipulation

A famous couturier once said, "If someone walks into a room wearing one of my dresses, and people say, 'What a beautiful dress,' then I have failed. But if they say, 'What a beautiful woman,' then I have succeeded."

Much the same can be said of electronically manipulated images: people should say, "What a great image," not "What a great piece of electronic manipulation."

The most successful images are often the subtlest, and indeed, there are some images in this chapter where it is by no means obvious that electronic manipulation has been used, such as Fabio Meazzi's *Wanted Since 1894* or *Lights on the Sea*, also from the Wanted stable. In Maurizio Polverelli's *Self-Made Pencils*, on the other hand, the manipulation is detectable and indeed essential; but it is subsidiary to the overall concept. Then there are pictures like Jim DiVitale's *Door on Sky* which are archetypally manipulated, and (from the same photographer) *Born Antagonists* where the immediate humour of the situation is far more important than the technique used to achieve it.

At present, electronic image manipulation is rather like low-light photography without flash in the 1930s: people are so fascinated by it that they sometimes lose sight of pictorial merit. But as the pictures in this chapter show, technique must be as much taken for granted as in any other branch of photography: it is the picture that is of greatest importance.

Photographer: **Wanted**

Client: **Tronconi**

Use: **Poster**

Camera: **6x7cm with Leaf digital back**

Lens: **110mm**

Film: **Digital**

Exposure: **f/22**

Lighting: **Electronic flash: strip light and standard reflector**

Props and set: **Monochrome print; lights inserted electronically**

Plan View

▼

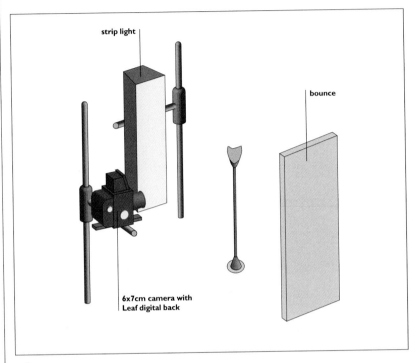

strip light

bounce

6x7cm camera with Leaf digital back

INSTEAD OF LIGHTING TWO (OR MORE) SETS IN SUCH A WAY THAT THEY CAN BE COMPED TOGETHER DIGITALLY, YOU CAN START OUT WITH AN EXISTING IMAGE AND LIGHT THE SECOND IMAGE TO MATCH IT. THIS IS WHAT WAS DONE HERE.

The seascape was a location shot, taken in the normal manner and made into a toned monochrome print; it is clearly back lit. The lamp was photographed with a strip light on one side (for a narrow highlight) and a bounce on the other (for a broad highlight), in order to represent the upright as clearly as possible. The two images – the seascape and the lamp – were then comped together electronically, and the "shadow" of the lamp was added to match the direction of the lighting in the original print. Mixing colour and monochrome is an old and effective technique, and digital imaging broadens the scope for using it.

► *Sources for background pictures can include one's own archives, and commercial picture libraries*

► *The handling of shadows and reflections is often what distinguishes a good electronic composite from a bad one*

► *In colour pictures (though not here) it is important to match the colours of reflections; for example, make sure that an added pink sky is properly reflected in the foreground*

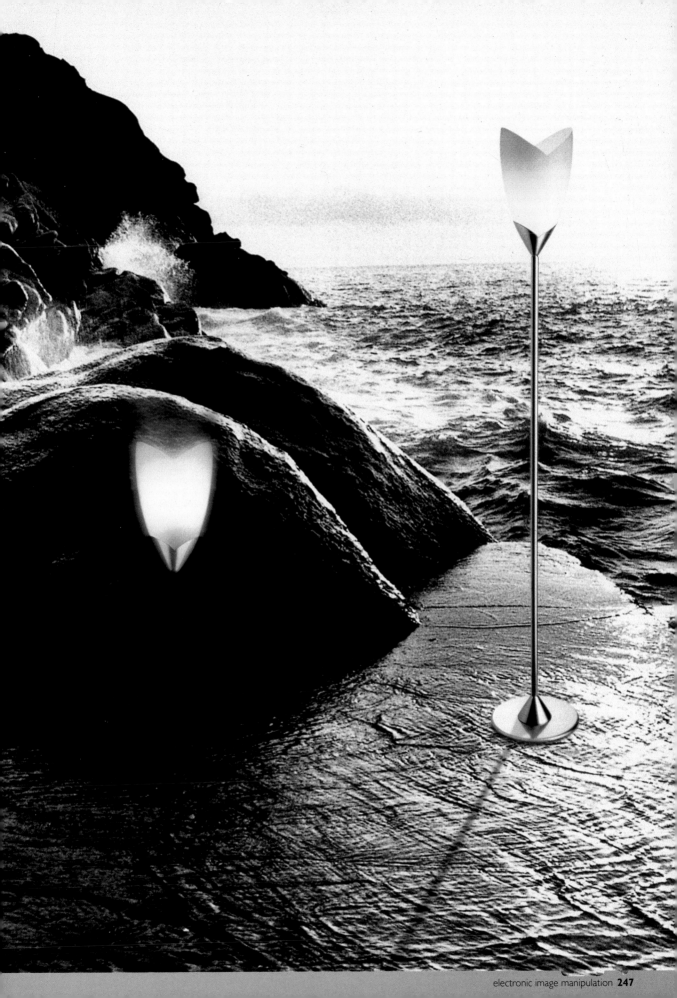

Photographer: **Maurizio Polverelli**

Client: **Personal work/portfolio**

Stylist: **Emanuela Mazzotti**

Image processing: **Millenium, Rimini**

Camera: **8x10 inch**

Lens: **480mm**

Film: **Kodak Ektachrome EPR 6117**

Exposure: **f/45-2/3, 8 flashes**

Lighting: **Electronic flash: 2 soft boxes**

Props and set: **Slate tile base; graded paper background**

Plan View

► *The most successful electronically-comped shots draw on the strengths of both conventional photography and digital retouching*

► *For the modest amount of retouching in a shot like this, traditional hand-work on an 11x14 inch duplicate would have been adequate*

S E L F - M A D E P E N C I L S

▼

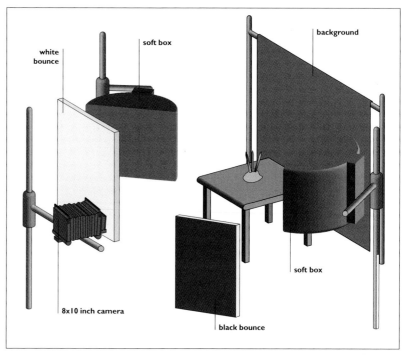

LIKE SOME OF THE OTHER PICTURES IN THIS CHAPTER, THIS IS ONE WHICH COULD QUITE EASILY HAVE BEEN RETOUCHED USING TRADITIONAL TECHNIQUES – BUT WHICH WAS MORE EASILY ACCOMPLISHED USING DIGITAL RETOUCHING. THE ONLY ELECTRONIC TECHNIQUE WAS THE BLENDING OF THE PIGMENTS AND THE PENCILS.

The lighting set-up is surprisingly complex, with two soft boxes, a black bounce and a white bounce. This was principally necessary to get the right pattern of highlights on the pencils, but it also helped to balance the relative intensities of the three pigments and to create a three-dimensional feel to the mound of pigment, which might otherwise have looked very flat. Cover the pencils with your hand, and suddenly the red and yellow pigments lose much of their three-dimensionality: only the light on the blue pigment gives a real clue to roundness.

The background is graded paper lit by spill from the main lights, though it would have been quite feasible to add that in the computer as well.

Photographer's comment:

This image represents the creation of three pencils which come out of the raw material of the same pencils, but also from the three main subtractive colours.

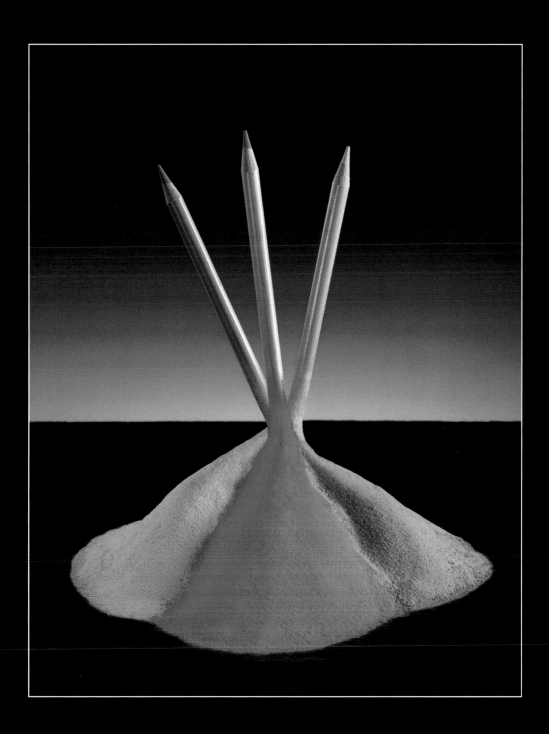

Photographer: **James DiVitale**

Client: **Original: S.P. Richards Company**

Use: **Promotional folder**

Art director: **David Stone (first shot)**

Camera: **4x5 inch**

Lens: **120mm**

Film: **Kodak Ektachrome 64T**

Exposure: **First shot: f/32, 1 second + 45 seconds for sky**

Lighting: **Tungsten**

Props and set: **The door is a doll's house miniature; the sky is back projected onto a sheet of Rosco Tough Lux**

Plan View

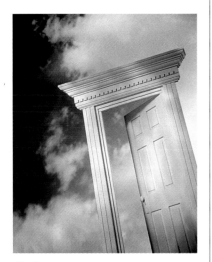

First Exposure

► *Digital image manipulation means that it is now possible to work with 4x5 inch originals without serious loss of quality. Formerly, 8x10 inch originals would have been preferred*

D O O R O N S K Y

▼

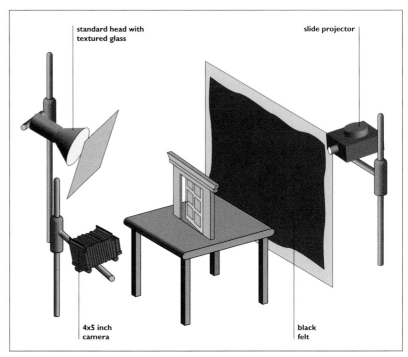

standard head with textured glass

slide projector

4x5 inch camera

black felt

IN ELECTRONIC IMAGE MANIPULATION, AS IN ANY OTHER BRANCH OF PHOTOGRAPHY, THERE IS NO SUBSTITUTE FOR THE PHOTOGRAPHER'S EYE. TOO MANY MANIPULATED IMAGES (THOUGH NOT IN THIS BOOK) ARE OVER-MANIPULATED: MERELY BECAUSE SOMETHING IS POSSIBLE, THIS DOES NOT MEAN THAT IT SHOULD BE DONE.

This picture begins with a double exposure. The door is a miniature from a doll's house. For the first exposure, it was photographed with a black felt background; a tungsten light illuminated the door frame. Then the felt was removed, the light on the door was turned off, and the back projected sky (projected onto Rosco Tough Lux) was exposed for 45 seconds.

Unexpectedly, everything in the final shot derives from this first picture – and indeed, the final shot *is* the first picture. The yellow sky is a reversed version of the blue, while the square and circle are the blue as initially recorded. The original image was input using a Leaf scanner and manipulated on a 486DX2-66 PC in Adobe Photoshop 2.5; output was to a Kodak LVT film recorder.

Photographer's comment:

The original client was the S.P. Richards company, but we altered the image on our computer for our own purposes.

Photographer: **James DiVitale**

Client: **S.P. Richards Company**

Use: **Promotional folder**

Stylist: **Sandy DiVitale, DiVitale Photography**

Art director: **Allayne Brackbill, S.P. Richards Company; also designed and assisted with computer work**

Camera: **4x5 inch**

Lens: **210mm**

Film: **Kodak Ektachrome EPP 100**

Exposure: **First exposure: 1/60 at f/22.5**

Second exposure: **30 seconds at f/22**

Lighting: **First exposure: flash, 1 soft box, 2 standard reflectors. Second exposure: tungsten soft box**

Props and set: **Lock and "Old Man North" key**

Plan View

First Exposure

► *With a matted or comped shot, consistency of lighting is very important*

► *Consistency of lighting includes both shadows and colours — colours in both highlights and "reflections"*

UNLOCKING THE HEAVENS

▼

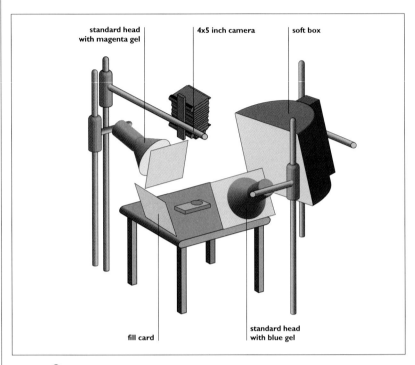

standard head with magenta gel | 4x5 inch camera | soft box

fill card | standard head with blue gel

OVERLEAF, THE ORIGINAL RENDERED BRIEF IS PRINTED FOR COMPARISON WITH THE FINAL, PHOTOGRAPHIC VERSION SHOWN OPPOSITE — A CLEAR (AND CLASSIC) ILLUSTRATION OF THE WAY IN WHICH A GOOD BRIEF IS INTERPRETED, RATHER THAN DUPLICATED, BY A GOOD PHOTOGRAPHER.

The problem (as ever) was that it was not possible to find exactly the right lock and key. Even if they could have been found, the picture was clearly going to fall into the category of "special effects." As it was, digital manipulation provided two solutions simultaneously: matting the lock and key onto the sky and making the key closer to the designer's heart's desire.

The first shot was of the lock and key on a piece of white seamless paper background. The camera was looking straight down, and the lock is lit on three sides with a fill card opposite the key light on the fourth side. The key light (a 90x120cm soft box) comes from above the lock and there is a 60x60cm fill card opposite that. To the left of the lock there is a standard head with a magenta gel, and to the right there is another with a blue gel.

Photographer's comment:

This image won first place in the first annual electronic imaging competition run by Industrial Photography *and subsequently appeared as the June 1994 cover for the awards annual.*

The second shot, the "starry sky", uses a familiar technique with an extra twist. The "stars" are the old standby of holes punched in black seamless background paper, and the colours come from gels projected against the black background. The twist comes from the use of quite heavy diffusion, which still further blends the "starlight" and the coloured "galaxies", which of course echo the colours on the lock.

Once both pictures were processed, the digital manipulation began. Scanning was via a Leaf and image manipulation was on a 486DX2-66 PC.

In the original picture, the key had only a single tongue (as indeed it did in the brief). The designer wanted a more complex key, and the tongue was therefore duplicated to provide a more ornate appearance. Perhaps needless to say, the art director had combed the country for the lock itself, which is a modern reproduction of a Victorian design called "Old Man North." The TIF files for the key manipulation are shown in the screen dump (opposite, top).

Next, the two images were matted together. In the screen dump, you can see the partially completed composite (LOCK-4.TIF); the lower part of the lock under manipulation (STAR-1.TIF RGB 1:2); and a completed stage (STAR-1.TIF, RGB 1:6).

This sequence is proof, if any were needed, that the downfall of a great deal of digitally manipulated imagery is a lack of attention to detail – something of which the DiVitales could never be accused. All too often, though, photographers who are trying digital image manipulation for the first time are

too hurried: because a great deal can be accomplished astonishingly quickly and easily, and because the effects are so dramatic, they neglect to add the finishing touches which conceal the way in which a photograph was manipulated. They may also neglect to make sure that the different picture components are compatible.

The artist's eye is even more important in digital manipulation than in conventional photography, because a single photograph must exhibit consistent perspective and lighting; a picture that has been comped from two or more sources has no such necessary consistency.

▲ *The original brief. Note the totally different treatment of colour on the lock (blue on brass instead of blue and magenta); the way in which the second key is attached to the key in the lock instead of being separated; the different design of the second key; and the way that the sky "bites into" the lock to a very considerable extent on the lower right-hand side.*

▶ *Copying the key tongue. The way in which this was done is abundantly clear from the files shown on screen.*

▼ *Comping the lock and the sky together. In LOCK-4.TIF (RGB, 1:2) the lock is plainly sitting on top of the sky image, and the screw-hole in the face plate looking rather obvious. In the other two images, the lower part of the lock has been partially "erased" so that the stars now shine though it — especially in the keyhole and in the screw-hole.*

Photographer: **Manuel Fernández Vilar**

Client: **Personal work**

Camera: **4x5 inch**

Lens: **300mm**

Film: **Kodak Ektachrome 64**

Exposure: **f/22**

Lighting: **Electronic flash: one head**

Plan View

▼

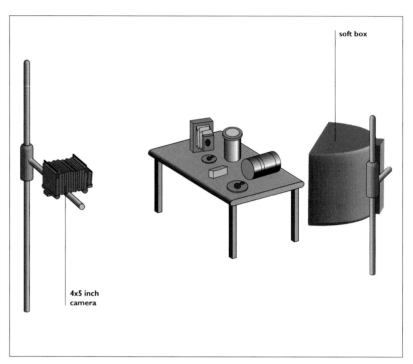

soft box

4x5 inch
camera

AT FIRST SIGHT, THIS LOOKS LIKE AN UNUSUALLY SUCCESSFUL VERSION OF THE SORT OF COLOUR SOLARIZATION WHICH WAS POPULAR IN THE 1970S; BUT IN FACT, IT IS AN INTERESTING EXAMPLE OF HOW COMPUTER MANIPULATION CAN MIMIC AND INDEED IMPROVE UPON TRADITIONAL TECHNIQUES.

The basic picture is simply lit, with a medium-sized soft box above the subject and to camera right. The shadows make this clear. Then, everything was manipulated in the computer, making particular use of the ability of the computer to re-colour an area of constant tone. What distinguishes it from a traditional colour solarization, however, is the naturalistic colour of the old roll of Kodak Autographic 120 film – though even this has been manipulated in the computer, presumably to enhance ancient and faded colours.

In the days before digital image manipulation, it would have been very difficult and very time-consuming to achieve this effect, as it would almost certainly have involved two separate pictures – the Kodak box and everything else – which would then have had to be comped together. This is not to say that the computer is quick or easy; just that it is quicker, and easier, and that it gives the operator more than one chance at changing any given image.

► *Selective manipulation of parts of the image is the great strength of the computer, as compared with chemical manipulation or solarization*

► *For equal-tone manipulation, directional light and reflective surfaces will give very different effects from flat light and non-reflective surfaces*

Photographer: **James DiVitale**

Client: **Professional Photographer magazine**

Use: **Editorial**

Models: **Mack Norman and Michael Leidel**
(both art directors with S.P. Richards
Company)

Art director: **Sandy DiVitale**

Camera: **4x5 inch**

Lens: **90mm**

Film: **Kodak Ektachrome EPP ISO 100**

Exposure: **3 shots, each 1/60 second at f/22-1/2**

Lighting: **Electronic flash: 4 heads, 2 soft boxes**
and 2 standard reflectors, plus prop soft box

Props and set: **Gumball machine, soft box,**
camera and stand

Plan View

► *Light sources in shot must cast some*
shadows in order to be believable –
Hollywood movies often forget this

► *The blur in the art director's arms is*
digitally added

► *The task of merging the different*
pictures of the art director's arms is
eased by not having a graded, toned
background behind him

B O R N A N T A G O N I S T S

▼

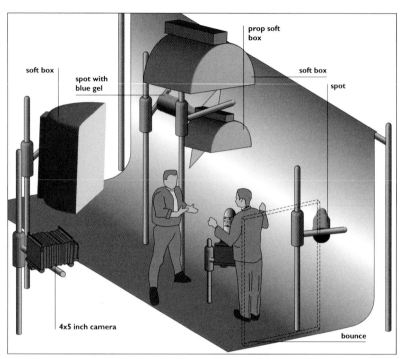

soft box

spot with
blue gel

prop soft
box

soft box

spot

4x5 inch camera

bounce

Few PHOTOGRAPHERS WILL BE ABLE TO LOOK AT THIS PICTURE WITHOUT SMILING;
WE HAVE ALL DEALT WITH ART DIRECTORS LIKE THIS. FURTHERMORE, THIS IS AN EXCELLENT
EXAMPLE OF A PICTURE WHICH CAN (RELATIVELY) EASILY BE DONE DIGITALLY BUT
WHICH WOULD TAX MOST RETOUCHERS.

The basic shot is as illustrated in the lighting diagram; the other two were close-ups of the art director in the same position, with the same lighting, but with his arms in different positions and holding different things.

The key light is the large (120x180cm) soft box to camera left, with another the same size overhead for fill. The overhead soft box in shot also contributes some light (if it did not, it would look most unnatural) and there is a very large (240cm square) bounce to camera right as a fill. The background is independently lit, using a standard head to camera right and a standard head plus blue gel to camera left; this is what creates the blue light behind the photographer.

Opposite, the different arm shots are shown together with the stages in merging them. There is also a discussion of the props and other factors in the shot – something for which there is not normally room in the *Pro Lighting* series.

Photographer's comment:

We shot this to illustrate an article which we wrote for the May 1994 issue of Professional
Photographer *(circulation 33,000), published by Professional Photographers of America.*

It is worth reproducing in full the comments which Jim and Sandy DiVitale wrote to accompany this picture and its accompanying step-by-step photographs, as they provide an extremely valuable insight into the creative process:

"Because this shot was done as an article illustration, all of the contents were "props". This includes the gumball machine, chosen for its wonderful, diverse colour and its compactness, which it needs in order to nestle comfortably in such a cluttered set. It represents the product being shot.

Other props include those being used by the art director. We chose a megaphone to represent the control the art director takes on the set, in analogy with a movie director. The telephone represents the many things art directors often do while on the set, things which can pull them in different directions. The triangle is updated with modern colors but represents the design element in a photo shoot, with

▲ *The initial shot was taken with the megaphone and "How To Art Direct"; a second shot with the telephone and stopwatch is also shown inset on the computer screen. Using a conventional (corded) phone instead of a cordless phone emphasizes the forces which drag the art director away from the photographer.*

▼ *This screen dump shows the process of adding in the arm with the triangle and also shows how the 60-foot cyc was not quite long enough, which necessitated cloning more white background in behind the many-armed shot.*

which the art director must also deal. The stopwatch represents how the art director often worries about how much time is ticking away while the art director himself is not always doing everything he can to contribute to the shot; his multiple roles often work against time and against the photographer's patience. And finally, the book in his hand represents the fact that many art directors are not formally trained in the United States.

Even the clothing worn by our models was planned. Mack, near the gumball machine, is wearing the typical photographer's uniform, while Michael, our art director, is sporting the business suit which demonstrates how an art director must float between the art and business worlds.

The main shot was created to provide the overall appearance of a photo shoot in progress. The criterion for this shot was to capture the best expression of annoyance on the photographer's face, supplemented by his body language. Two other shots were done with the art director staying in the same position as the first shot, while moving his arms to new, predetermined positions. We then traded out props in each of these shots.

The shot was set against a 60 foot (18 metre) cyclorama wall – a "cyc" or "cove" – painted white. At that, the wall was still not long enough when we added the extra arms, so we had to clone the wall to create additional length."

14 the
unexpected

Most of the remaining pictures in this book could easily have been put in one of the other chapters. They depend on set-building, and double exposures, and other tricks we have already seen. They have however been segregated because they are just not what one expects. For example, who would think of photographing stationary cars while the track and the background moved? David Watts did in *Power and the Glory*. For that matter, Peter Barry's picture of a live model between two idols, all distinguished by the grain of the wood from which they are apparently carved, is striking enough; but when you know that the two "wooden" models are white fibreglass, and that the texture is as much projected on them as on the girl, it takes on a new dimension. The philosophically inclined can have a field day speculating on the nature of reality, as they can too with Jay Myrdal's *Dog on the Wall*.

Some of the techniques are very simple: Ray Kirby's *Broken Mirror*, for example, could hardly be simpler. Others – *Dog on the Wall* again – are astonishingly complex. Yet others, such as Stefano Zappalà's *Horses and Riders against the Sun* are downright impudent. But all of them should serve as a reminder that the whole of photography is to some extent a special effect, and that the photographers who pursue this fascinating and often elusive craft are those who make it even more special.

DOG ON THE WALL

▼

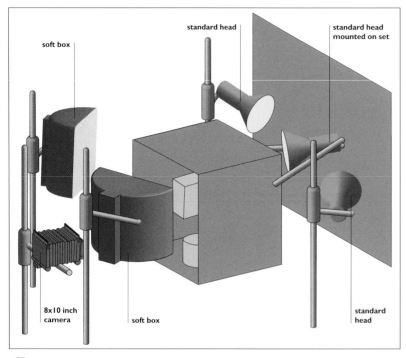

soft box

standard head

standard head mounted on set

8x10 inch camera

soft box

standard head

T HE SECRET HERE IS A ROTATING SET, A BOX SET ON TRESTLES. WITH EACH 90° ROTATION, THE LOWEST SET WAS FULLY BUILT AND FILLED WITH WATER FROM THE RIGHT-HAND TANK.

The key light is mounted on, and rotates with the set. Two soft boxes act as fill lights: both of these were moved independently of the set for each exposure, to retain the same relative lighting direction. Finally, there were two more lights which light the background obliquely for a fifth exposure. The five shots were comped together on a Crossfield Mamba by Peter Holmes.

Side View

Photographer: **Jay Myrdal** Client: **Personal work: AFAEP awards etc.** Use: **Poster**
Model: **Dog "Rosie" from Heather Smith** Assistant: **John Midgley** Model-maker: **Parallax Models**
Camera: **8x10 inch** Lens: **155mm + 82 filter** Film: **Fuji Velvia rated EI 32** Exposure: **f/22-1/4**
Lighting: **Electronic flash** Props and set: **Built set – see text. Background by Marguerite Horner.**

► *The clear, strong and above all directional lighting is what makes this picture so believable*

► *Moving lights in step with moving sets is something which can require a degree of mental gymnastics*

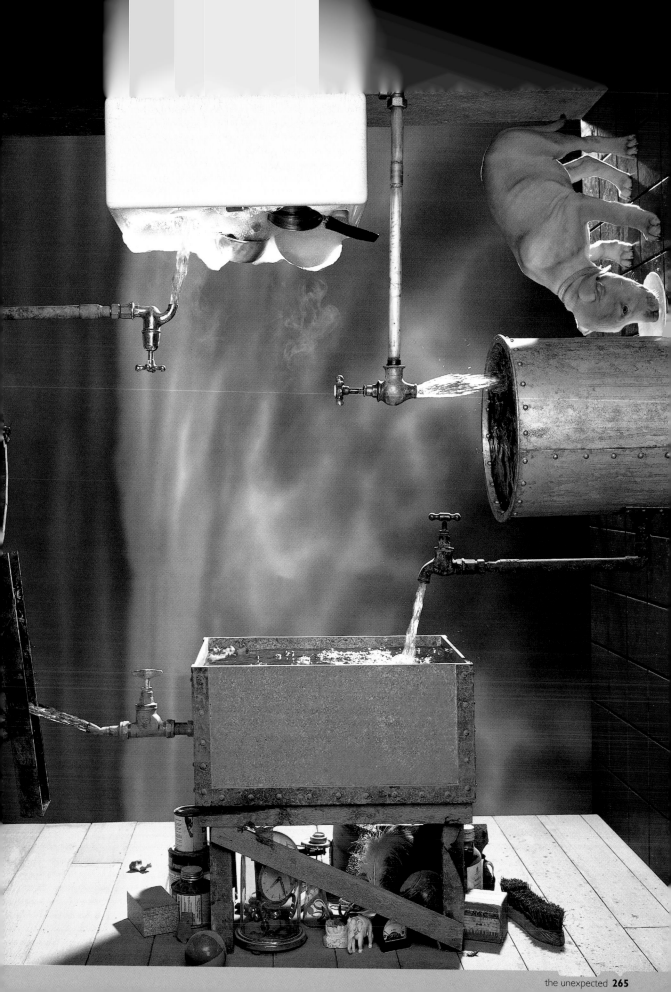

Photographer: **Peter Barry**

Client: **Arborite**

Use: **Calendar**

Assistant: **Stewart Harden**

Camera: **6x6cm**

Lens: **80mm**

Film: **Kodak Ektachrome EPR**

Exposure: **1/15 second at f/8**

Lighting: **3 slide projectors**

Props and set: **Slides of wood grain; black paper background**

Plan View

W O O D E N M O D E L

▼

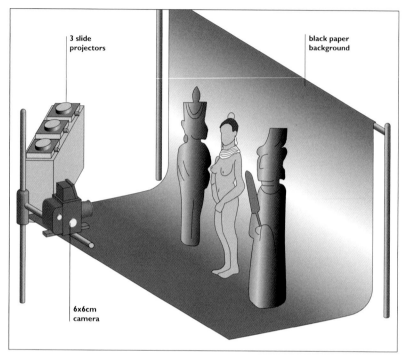

3 slide projectors

black paper background

6x6cm camera

THIS IS NOT COMPED UP FROM A COUPLE OF SMALL FIGURINES AND A GIRL IN MAKE-UP: IT IS A STRAIGHT PICTURE OF ONE REAL GIRL AND TWO LIFE-SIZE FIBREGLASS FIGURES, ILLUMINATED WITH SLIDE PROJECTORS.

Once you know this, it is merely a matter of detail. The subjects had to be far enough from the background that it would go completely dark; the light had to come from the same direction, or the picture would not look natural; and there had to be a certain amount of juggling with lamp intensity and projector distance to allow for the different reflectivities of the two pale-coloured figures (which were made specially for the shot) and the girl. Shooting the original wood-grain slides also involved a certain amount of searching around.

Projector lamps burn at about 3400°K, so when they are used as a light source with daylight-balance film, the effect is warm – which is exactly what you want in a shot like this.

► As illustrated elsewhere in the book, projectors can be pressed into service for all kinds of purposes

► If you buy second-hand projectors, remember to buy spare bulbs – or alternatively, just hire reliable, modern projectors

► Use warming filters when photographing wood to emphasize the grain

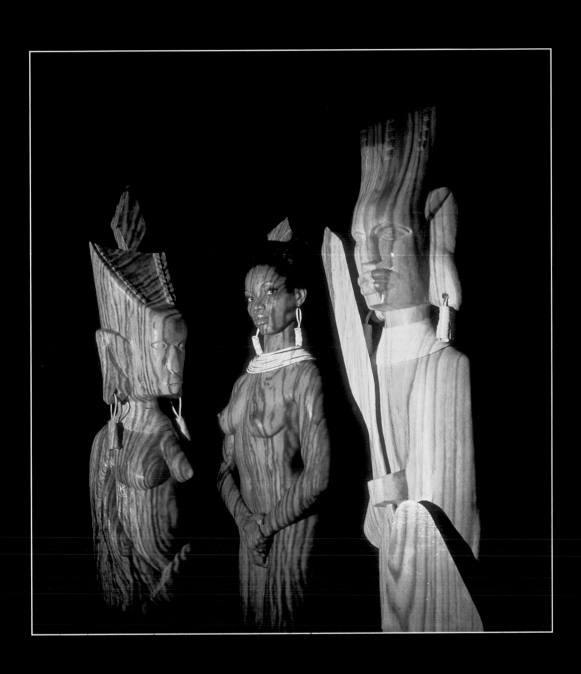

Photographer: **Massimo Robecchi**

Client: **Grupo Hodara SPA**

Use: **Advertising campaign**

Model: **Gabriele Sala**

Assistant: **Gianni Maspero (who also built the set)**

Art director: **Enrico Porro from Made in L&A Diagonale, Milano**

Camera: **4x5 inch**

Lens: **240mm**

Film: **Kodak 6105**

Exposure: **f/22**

Lighting: **Electronic flash: 4 heads**

Props and set: **Metallic structure to support model is entirely self-supporting**

Plan View

▶ *The way that the ropes disappear into darkness is particularly effective*

▶ *Matching four spots to create even lighting can be very time-consuming*

▶ *Before you ask a model to go on a set like this, ask yourself if you would be willing to do it*

ATHLETIC GAME

▼

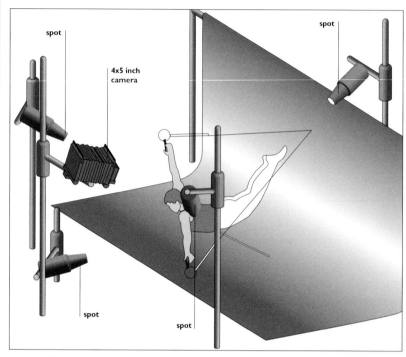

THIS LOOKS LIKE A LOT OF TROUBLE TO GO TO – UNTIL YOU LOOK CLOSELY AND SEE THAT THE MODEL IS ACTUALLY HOLDING ONTO THE RINGS WITH TWO PAIRS OF PLIERS, WHICH ARE THE PRODUCT TO BE ADVERTISED.

One focusing spot lights the model's face. A pair of Fresnel spots illuminate the two rings, and another Fresnel spot back lights the hair and body – insofar as a picture taken with this very high camera angle can be said to be "back lit".

The lighting is carefully faded to nothing on the ropes leading back from the rings; the ropes are in fact attached to metal rods. A massive metal cantilever, bolted to the floor, supports the model and is concealed by his body. To balance on something like this requires iron will as well as an iron constitution.

This well represents the difficulty of realizing an art director's conception, but it is doubtful whether the panacea of electronic retouching could improve upon, or even equal, this effect.

Photographer's comment:

The model is an Olympic athlete in the Italian national team and now trains the Italian youth team. This was the only way we found to capture the "mood" of the layout in which the athlete grips the rings with pliers.

Photographer: **Rayment Kirby**

Use: **Picture library**

Model: **Fred**

Camera: **35mm and 6x7cm**

Lens: **50mm on 35mm/180mm on 6x7cm**

Film: **Kodak Plus X and Fuji RDP 100**

Exposure: **Not recorded**

Lighting: **Electronic flash: see text**

Props and set: **Shot 1: white seamless**

Shot 2: ribbed black glass, barbed wire

Plan View

► *Properly used, symbols can be enormously potent – but poorly used, the effect is one of bathos*

► *Bouncing the light off ribbed black glass mixes flare and sharpness in just the right quantities*

► *Without the red gel, the picture would lose a great deal of its impact*

B A R B E D W I R E

▼

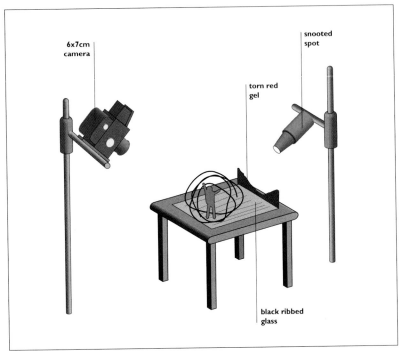

ONE SHOT, ON 35MM IN BLACK AND WHITE, IS OF THE MODEL SILHOUETTED AGAINST A WHITE BACKGROUND. THE OTHER USES A CUT-OUT OF THE FIGURE, A PIECE OF RIBBED BLACK GLASS AND A COIL OF BARBED WIRE.

The cut-out is from an enlargement made to size and glued to card; highlights were removed with a black felt-tipped pen. The table-top set (illustrated) is made up of a piece of black ribbed glass with a jaggedly-cut red gel at the back: a single 400 watt-second head with a tight snoot casts the band of light which back lights the set. Reflections from the glass are picked up by the barbed wire.

This picture is a semioticist's delight: everything in it is a symbol, far more than it is itself. The flare from the glass background creates some of the qualities of a clandestine photograph: the pose is one of both challenge and (because of the placing of the barbed wire) captivity; and a material designed to keep cattle in fields becomes a symbol of oppression. Then there is the red of blood...

Photographer's comment:

The picture symbolizes loss of human rights.

Photographer: **Stefano Zappalà**

Client: **Personal work**

Camera: **13x18cm**

Lens: **360mm**

Film: **Kodak Ektachrome 64 tungsten-balance**

Exposure: **8 seconds at f/64**

Lighting: **Tungsten: 3 spotlights**

Props and set: **Tennis ball; tracing of cowboys; orange gel**

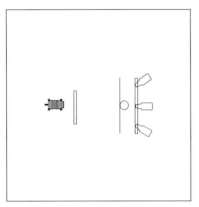

Plan View

H O R S E S A N D R I D E R S
A G A I N S T T H E S U N

▼

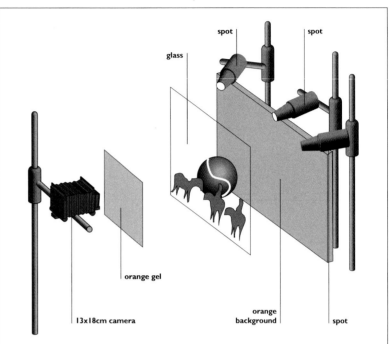

ALMOST NOTHING IN THIS PICTURE IS WHAT IT SEEMS. THE SUN IS A YELLOW TENNIS BALL, THE HORSES AND RIDERS ARE TRACED ONTO CLEAR ACETATE SHEET FROM A BOOK AND THE LANDSCAPE COMES COURTESY OF AN ORANGE GEL; THE BACKGROUND IS AN ORANGE CARD.

The diagram makes the set-up clear. Two spots back light the tennis ball partially, while a third is completely behind the ball to provide the corona – which is also projected onto the acetate, accounting for the halo. The drawing of the cowboys is actually touching the tennis ball, but is thrown slightly out of focus; an interesting example of how cinema, in particular, has conditioned the way we see. We expect cowboys in front of a giant sun to be unclear, because of dust and heat-haze. An out-of-focus orange gel obscures part of the bottom of the picture to create the foreground.

Until you know that the crack in the sun is just the seam in a tennis ball, the picture is somewhat disturbing: the effect is of sunspots and flares, with the sun apparently coming apart. Once you know how it is done, this aspect of the picture is lost completely.

► *Just "playing" can make for dramatic pictures*

► *Ask yourself how you might shoot a similar picture. Would you still use a tennis ball, for instance?*

► *Pieces of old gel (acetate) filter can be used out-of-focus as picture elements in their own right*

Photographer: **David Watts ABIPP**

Client: **Hornby Hobbies plc**

Use: **Catalogue and posters**

Art director: **Jon Case (of Appleby Case)**

Camera: **4x5 inch**

Lens: **90mm**

Film: **Fuji RTP 64**

Exposure: **15 sec at f/45**

Lighting: **Tungsten**

Props and set: **Built set – see text**

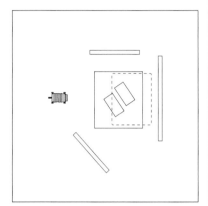

Plan View

POWER AND THE
GLORY SCALEXTRIC

▼

THE IMMEDIATE IMPACT OF THIS PICTURE IS CONSIDERABLE, EVOKING THE GLORY DAYS OF THE LATE 1920S AND THE EARLY 1930S: THE THUNDERING BENTLEYS AGAINST THE MUCH SMALLER, LIGHTER ALFA ROMEOS, BOTH INSTANTLY RECOGNIZABLE IN A WAY THAT ELUDES MODERN CARS.

Only at a second glance does it become obvious that these are only toy cars; and even then, it would take a while to work out how the picture was taken.

The cars are actually stationary, locked in place; the track and background is what moves. This allows the cars to be held perfectly sharp, even with a 4x5 inch camera with the lens stopped down to f/45 in the interests of depth of field. Because the wheels are in contact with the track, they revolve slowly, but more than enough to blur during a 15-second exposure. The 90-mm lens also accentuates the perspective and the impression of the cars bearing down upon the viewer.

The lighting is simple enough: a 120-cm square soft box above the set, acting very slightly as a back light, supplemented by two reflectors as drawn. Only the modelling light of the soft box was used for the exposure. The blue "sky" is a part of the set: the lighting perfectly replicates a hot but hazy summer's day.

► *One of the secrets of special effects photography is to pander to expectations: everyone knows that cars move and backgrounds stay still*

► *Another secret is to escape your own preconceptions*

► *Sinar Bron actually call their soft box a "hazy light" – never more true than in this picture*

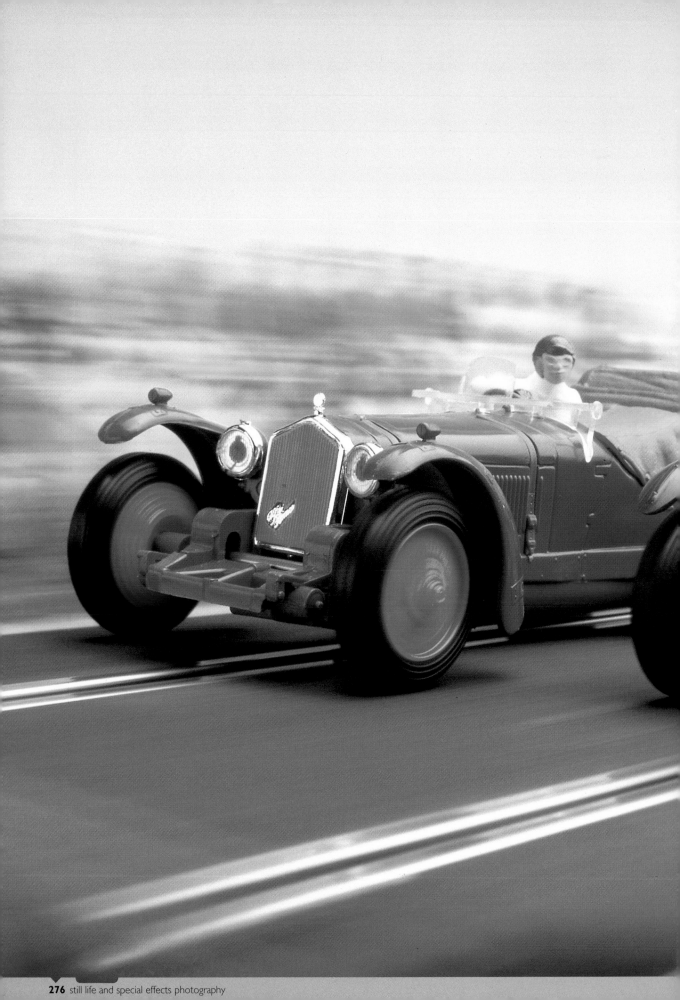

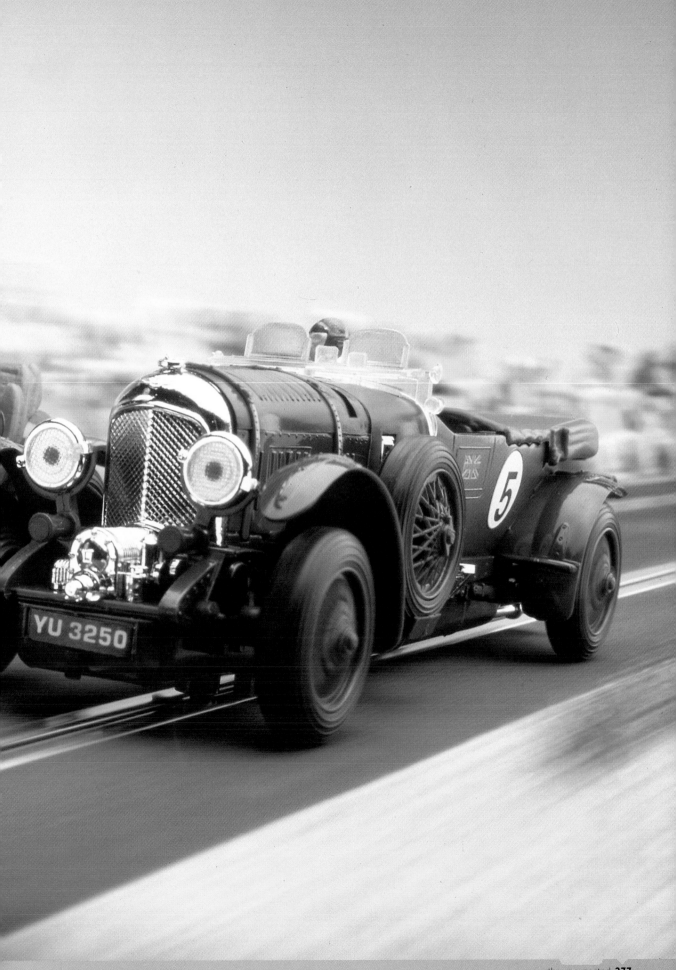

15

directory of
photographers

Photographer: **ROD ASHFORD**
Address: UNIT 10, ARUNDEL MEWS
ARUNDEL PLACE
KEMPTOWN
BRIGHTON BN2 1GD
ENGLAND
Telephone: + 44 (01 273) 670 076
Fax: + 44 (01 273) 688 177
Biography: *Rod runs a commercial photographic studio and busy stock library. His personal work consists mainly of black and white and hand-coloured images which have been widely published as fine art posters and postcards. His work is in great demand for both hardback and paperback book covers in the UK, Europe and the United States.*
Commercial clients have included American Express, Elizabeth Arden, Revlon, Lloyds, South Eastern Electricity Board and Iceland Frozen Foods.

Photographer: **PETER BARRY**
Address: 57 FARRINGDON ROAD
LONDON EC1M 3JB
ENGLAND
Telephone: + 44 (01 71) 430 0966
Fax: + 44 (01 71) 430 0903
Biography: *Peter Barry's work is so varied – fashion, advertising, girls, still life and food – and so every day is exciting and stimulating. Constantly learning and experimenting with new techniques, his two main passions are people and food. Photography has taken him all over the world and allowed him to meet fascinating people. He feels it is not so much work as a way of life.*

Photographer: **FRANCESCO BELLESIA**
Studio: WANTED
Address: VIA PEROSI 5
20146 MILANO
ITALY
Telephone: + 39 (02) 48 95 26 50
Fax: + 39 (02) 42 34 898
Biography: I have been a photographer for over 20 years. I have experienced many diverse situations and experimented with a variety of specialist fields. Today, my comany uses a number of advanced systems for both digital imaging and post-production work.

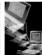
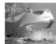

Photographer: **MARIO DI BENEDETTO**
Studio: WANTED
Address: VIA PEROSI 5
20146 MILANO
ITALY
Telephone: + 39 (02) 48 95 26 50
Fax: + 39 (02) 42 34 898
Biography: *Advertising photographer since 1982; in 1994 created "Wanted" studio, working in advertising, still life, digital photography, fashion, beauty, industry, special projects.*

Photographer: **JOHNNY BOYLAND**
Address: THE SOAP FACTORY
9 PARK HILL
LONDON SW4 9NS
ENGLAND
Telephone: + 44 (0) 171 622 1214
Mobile Phone: + 44 (0) 831 838 829
Fax: + 44 (0) 171 498 6445
Biography: *Photography becomes a way of life, an obsession. Luckily for me it also provides a good living. Every new commission, whatever it is, is a challenge. That challenge need not necessarily be photographic. The sourcing of a location; a model; finding an unusual artefact; getting over the logistical problems of travelling to some backwater in another continent. Photography can be make-believe and fantasy, but most of all it is an art form of supplying your client. There is no room for error and there is no forgiving in supplying something that is unusable, whatever the reason. Enjoy!*

Photographer: **MARIA CRISTINA CASSINELLI**
Address: VENEZUELA 1421
(1095) BUENOS AIRES
ARGENTINA
Telephone: + 58 541 381 8805
Fax: + 58 541 383 9323
Agent
New York: BLACK STAR
116 EAST 27TH STREET
NEW YORK, NY 10016
Fax: + 1 (0) 212 889 2052
Biography: *Endowed with a unique creative style, Cristina represents with a clear identity and without spoiling the essence of the subjects, a still life, a portrait or an architectural oeuvre immersed in a landscape. One can recognize a directing thread, magical, in its diversity: innate sensitivity and a mature technique to combine in an image, aesthetics, light, design and subtle details ...*

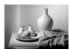

Photographer: **GUIDO PATERNÒ CASTELLO**
Address: Av. Henrique Dodsworth 83/1005
Rio de Janeiro 22061–030
Telephone: + 55 (0) 21 5218064
Fax: + 55 (0) 21 2870789
Biography: *Born in New York City March 19,
1958. Associate Arts degree at the
American College in Paris: June 1979.
Bachelor of Arts degree in Industrial
and Scientific Photographic Technology
at Brooks Institute of Photographic Arts
and Science: June 1984. Presently
working in Brazil as a commercial
photographer. His clients are all major
agencies based in Rio de Janeiro. He
has won various awards including silver
medal in 1992 and gold medal in
1993 at the Prêmio Produçao from
ABRACOMP (Brazilian Association of
Marketing and Advertising).*

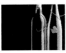

Photographer: **PAUL CROMEY**
Studio: McMillan Studios
Address: Black Robins Farm
Grant's Lane
Edenbridge, Kent
England
Telephone: + 44 (01 732) 866 111
Fax: + 44 (01 732) 867 223
Biography: *Born 1971. Started working in
photography at the age of 15, first for a
photography lab and then as an
assistant. Now (1995) works for a
studio just outside London specializing
in advertising and food.*

Photographer: **BENNY DE GROVE**
Address: Fotostudio De Grove
Zwijnaardse Steenweg 28A
9820 Merelbeke
Belgium
Telephone: + 32 (0) 231 96 16
Fax: + 32 (0) 9 231 95 94
Biography: *Born 1957, he has been a
photographer since 1984. Most of
the time he works in publicity and
illustration for magazines. For some
time now he has been fascinated by
triptychs. He likes to make his pictures
somehow symbolic: they must be a
starting point for discussion, for
thinking about.*

Photographer: **JAMES DIVITALE**
Studio: DiVitale Photography
Address: 420 Armour Circle NE
Atlanta
GA 30324
USA
Agent: Sandy DiVitale, at the same address
Telephone: + 1 (404) 892 7973
Biography: *Jim has been a commercial
photographer since the late 1970s. His
work has been recognized in such
awards annuals as* Advertising
Photographers of America Annuals
One *and* Two, Graphis Photo 93 *and*
94, Print's Computer Art and Design
Manual 3, *and* Print's Regional Design
Annual *(1995) and he advertises in*
Creative Black Book 1992–1995,
Workbook Photography 17–18,
Workbook's Single Image #15–18,
Workbook's "Portfolio CD-Rom", Klik!
Showcase Photography 2–4 *and* The
Art Directors' Index to
Photographers 20.
*In 1995 Kodak sponsored Jim to
lecture throughout the United States.
Topics include digital photography for
which he has won four national awards
including a Kodak Gallery award. He
was also invited to lecture at the World
Council of Professional Photography and
Imaging in Ireland in October 1995.*

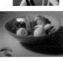

Photographer: **DAVID DRAY**
Address: 60 Milton Avenue
Margate
Kent CT9 1TT
England
Telephone: + 44 (0) 1843 22 36 40
Biography: *He is a graphic artist working on the
Isle of Thanet, Kent, England. He
trained at the Canterbury College of
Art, where he first started using
cellulose thinners to produce montages
from gravure printing. Later he applied
the thinners technique to colour
photocopies to achieve results as
illustrated. He uses this technique with
his own photography or (as
appropriate) with other photographers'
work to maintain complete control in
design briefs.*

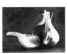

Photographer: **MANUEL FERNANDEZ VILAR**
Studio: Foto Fernandez V
Address: Avda. Constitucion-20
26004 Logroño (La Rioja)
Spain
Telephone: + 34 (941) 23 19 39
Biography: *Professional photographer for the last
35 years, specializing in industrial work
and portraiture. Various exhibitions;
winner of the Goya prize for the best
industrial photograph in 1991.*

Photographer: **MICHÈLE FRANCKEN**
Address: N.V. Francken CPM
Vlaanderensraat 51
9000 Gent
Belgium
Telephone: + 32 (0) 9 225 4308
Fax: + 32 (0) 9 224 2132
Biography: *I work to create a mood with lighting
and composition. I work a lot on
location for a greater feeling of intimacy.
I feel at ease with fashion and
advertising, and strive for a technical
excellence that will move the viewer!*

Photographer: **MIKE GALLETLY**

Address: STUDIO 3
THE PEOPLE'S HALL
OLAF STREET
LONDON W11 4BE
ENGLAND

Telephone: + 44 (01 71) 221 09 25

Fax: + 44 (01 71) 229 11 36

Biography: *Has been working as a still-life advertising photographer since 1976. Based in West London, he produces original photography for advertising brochures and books throughout Europe. He works both directly for clients and through advertising agencies and design groups, with subjects as diverse as cars and cosmetics.*

Photographer: **ROY GENGGAM**

Studio: GENGGAM PHOTOGRAPHY

Address: JL. KH. MUHASYIM VIII NO. 37
CILANDAK-JAKARTA
INDONESIA

Telephone: + 62 (21) 76 93 697

Fax: + 62 (21) 75 09 636

Biography: *Photographer with cinematography education, specializing in advertising and architectural photography, and also much work in fine art photography.*

Photographer: **TIM HAWKINS**

Address: 35 NANSEN ROAD
BATTERSEA
LONDON SW11 5NS
ENGLAND

Telephone: + 44 (01 71) 223 9094

Fax: + 44 (08 36) 586 999

Biography: Ante Photography: *digger driver, Fleet Air Arm helicopter pilot, J. Walter Thompson and more.* First photographic commission: *lady holding cup of tea, Uxbridge 1981, fee £22.50 including materials.* Worst moment: *arriving on location with no lens for 4x5 inch camera.* Training: *"Uncle" Colin (Glanfield), Plough Studios, London.* Good at: *orange segments to Landscape Arch and Interiors.* Work/work: *Glaxo, Philips, Observer, TSB, Royal Navy, Independent, Lancome, Price Waterhouse, Trafalgar House, P&O).* Work/play: *books – Photographers' Britain Dorset, (1991), WWII American Uniforms, (1993).* Best purchase: *Linhof Technikardan.* Favourite camera: *Leica M2 + 21mm.* Photographers that come to mind: *Strand, Coburn, Brandt, Brassai, George Rogers, Capa, Larry Burrows, Tim Page.* Outlook: *CC20R+CC05M.*

Photographer: **ROGER HICKS**

Address: ROGER & FRANCES
5 ALFRED ROAD
BIRCHINGTON
KENT CT7 9ND
ENGLAND

Telephone: + 44 (0) 1843 848 664

Fax: + 44 (0) 1843 848 665

Biography: *Wordsmith and photographer, both self-taught. Author of over 50 books, including this one; regular contributor to The British Journal of Photography, Shutterbug, Darkroom User and other photographic magazines. Has illustrated 'How-To' books, historical/travel books, and of course photography books. Works with his American-born wife, Frances E. Schultz, to provide words, pictures, or packages of words and pictures suitable for an international market.*

Photographer: **K HURST**

Studio: K

Address: 9 HAMPTON ROAD
GREAT LEVER
BOLTON
LANCASHIRE BL3 2DX
ENGLAND

Telephone: + 44 (01 204) 366 072

Biography: *K's work is concerned with the positive representations of women: women seen as assertive without being viewed as aggressive, women seen as natural without being viewed as uncultured, women seen as feminine without being viewed as passive. Her images have been exhibited in a number of leading galleries and have received major awards as well as being published as a range of very personal greetings cards. K specializes in people, black and white and hand colouring and her work is applicable to editorial, advertising and fashion as well as being bought as fine art.*

Photographer: **ANGELOU IOANNIS**

Address: AI – PHOTOGRAPHER
20 XATZILAZAROU STREET 546.43
THESSALONIUI
GREECE (STUDIO)
PO BOX 50797 – 54014
THESSALONIUI
GREECE (MAIL)

Telephone: + 30 (0) 31 813 772 (STUDIO)

Pager: + 30 (0) 31 237 400

Fax: + 30 (0) 31 238 854

Biography: *Commercial still life photographer, with clients throughout Greece. Teacher of photography and (recently) writer as well. Interested in alternative lighting techniques and/or combinations of different light sources. Involved in digital imaging. He likes to broaden his vision constantly.*

Photographer: **COSKUN IPEK**
Studio: SP QUANTUM
Address: FULYA CAD. 29/3-41
80290 MECIDIYEKÖY
ISTANBUL
TURKEY
OR
NATO YOLU
YENI SOKAK
ASAS APT. NO: 3/6
81220 CENGELKÖY
ISTANBUL
TURKEY
Telephone: + 90 (212) 211 44 97
OR 211 47 86 OR 212 37 00
Fax: + 90 (212) 21 21 393
Biography: *Born in Istanbul in 1965, he graduated from the Department of Photography in the Faculty of Arts at the Istanbul Mimar Sinan University in 1988. After eighteen months' experience at one of the most important Turkish advertising agencies, he established his own studio with two partners in 1992. He specializes in food, still life, fashion, interior and architectural photography.*

Photographer: **MARC JOYE**
Studio: PHOTOGRAPHY JOYE BVBA
Address: BRUSSELBAAN 262
1790 AFFLIGEM
BELGIUM
Telephone: + 32 (53) 66 29 45
Fax: + 32 (53) 66 29 52
Agents: (JAPAN) MITSUO NAGAMITSU
(3) 32 95 14 90
(FRANCE) MARYLINE KÖPKO
(1) 44 89 64 64
Biography: *After studying film and TV techniques he turned over to advertising photography, where he found he had a great advantage in being able to organize the shoots. Now, he always prepares his shoots like a movie, with story boards to get the sales story into the picture.. Photographing on Sinar 4x5 and 8x10 inch, he likes to do arranged set-ups both in the studio and on location. He finds creating effects directly on the transparencies the most exciting work.*

Photographer: **KAZUO KAWAI**
Address: 5–7–1 OOI
SHINAGAWA-KU
TOKYO 140
JAPAN
Telephone: + 81 (0) 3 3777–7273
Fax: + 81 (0) 3 3777 7354

Photographer: **AIK KHOO**
Studio: STUDIO PASHE SDN. BHD.
Address: 165 JALAN AMINUDDIN BAKI
TAMAN TUN DR. ISMAIL
60000 KUALA LUMPUR
MALAYSIA
Telephone: + 60 (3) 718 8831
Fax: + 60 (3) 717 3736

Photographer: **RAY KIRBY**
Address: SPRINGHAM OAST
GROVE HILL
HELLINGLY
HAILSHAM
E. SUSSEX BN27 4HE
ENGLAND
Telephone: + 44 (14 53) 812 148
Biography: *Began by working as a photographer in the R.A.F., and then in studios in London. He worked in advertising and magazines, and in the record industry. He wrote a book called* Photographing Glamour, *and is now based in Sussex where he runs a picture library and designs and manufactures large format cameras.*

Photographer: **BEN LAGUNAS AND ALEX KURI**
Address: BLAK PRODUCTIONS PHOTOGRAPHERS
MONTES HIMALAYA 801
VALLE DON CAMILI
TOLUCA
MEXICO CP 50140
Telephone/Fax: + 52 (0) 72 17 06 57
Biography: *Ben and Alex studied in the USA, and are now based in Mexico. Their photographic company, BLAK Productions, also provides full production services such as casting, scouting, etc. They are master photography instructors for Kodak; their editorial work has appeared in international and national magazines, and they also work in fine art, with exhibitions and work in galleries. their work can also be seen in* The Golden Guide, *the Art Directors' Index, and other publications. They work all around the world for a client base which includes advertising agencies, record companies, direct clients and magazines.*

Photographer: **PETER LAQUA**
Address: MARBACHERSTRASSE 29
78048 VILLINGEN
GERMANY
Telephone: + 49 (0) 7721 305 01
Fax: + 49 (0) 7721 303 55
Biography: *born in 1960, Peter Laqua studied portraiture and industrial photography for three years. Since 1990 he has had his own studio. A prizewinner in the 1994 Minolta Art Project, he has also had exhibitions on the theme of Pol-Art (fine art photography) and on the theme of 'Zwieback' in Stuttgart in 1992.*

Photographer: **MATTHEW LEIGHTON**
Address: CALLE 61 #17–37,
BOGOTA
COLOMBIA
Telephone: 249 3771 AND 249 0275
Fax: 218 9648
Biography: *Matthew was born in England in 1959. He worked in different studios in London for five years and moved to Columbia in 1981. He now has his own advertising studio and laboratory in Bogota and specializes in food, still life, fashion and special effects for agencies and direct clients such as General Foods, JCB, Johnson & Johnson, Kellogs, Mastercard, Nabisco, Pepsi Cola, Plumrose, Proctor and Gamble, Unilever, and many local companies. He has also produced photographs for a series of 15 cookery books. He won five awards in 1993 for "best photographer for the Andean countries" and the Golden Condor with Leo Burnett. He is married with two children.*

Photographer: **RON McMILLAN**
Address: THE OLD BARN
BLACK ROBINS FARM
GRANTS LANE
EDENBRIDGE
KENT TN8 6QP
ENGLAND
Telephone: + 44 (0) 732 866111
Fax: + 44 (0) 732 867223
Biography: *Ron McMillan has been an advertising photographer for over twenty years. He recently custom built a new studio, converting a 200 year old barn on a farm site, on the Surrey/Kent borders. This rare opportunity to design his new drive-in studio from scratch has allowed Ron to put all his experience to use in its layout and provision of facilities including a luxury fitted kitchen. Ron's work covers food, still life, people, and travel, and has taken him to numerous locations in Europe, the Middle East and the USA.*

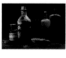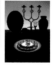

Photographer: **EROS MAURONER**
Address: ARICI & MAURONER FOTOGRAFI
VIA B. MAGGI 51/B
25124 BRESCIA
ITALY
Telephone: + 39 (0) 30 22 55 88 AND
24 24 212
Fax: + 39 (0) 30 22 55 88
Biography: *After years of experience in still-life photography, in design and architecture, he is now engaged with pictures of people, artists, singers. He doesn't like to specialize: versatility enables him to bring real excitement to whatever he undertakes. Part of him studies the project intellectually, while another part is just getting the feeling of it; somehow he can separate the two. Suddenly the solution appears, as if it were something he had never thought about. This helps him to infuse freshness into the final result. He is more attracted by ideas than by virtuosity, even if virtuosity subsequently becomes essential to realize the idea.*
There's also something else of paramount importance in his professional life – having fun!

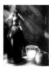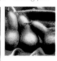

Photographer: **FABIO MEAZZI**
Studio: WANTED
Address: VIA PEROSI 5
20146 MILANO
ITALY
Telephone: + 39 (02) 48 95 26 50
Fax: + 39 (02) 42 34 898
Biography: Fabio is 38 years old and has been a photographer for over 15 years. he is a member Wanted, producing both digital and traditional photography.

Photographer: **RUDI MÜHLBAUER**
Address: KREILERSTRASSE 13A
81673 MÜNCHEN
GERMANY
Telephone: + 49 (0) 89 432 969
Biography: Born in 1965, Rudi has been taking photographs since early childhood. Is familiar with a wide variety of photographic equipment. Specialities include advertsing, still life, landscapes, and photo-journalism. Currently working performing digital imaging and retouching for a number of clients.

Photographer: **JAY MYRDAL**
Studio: JAM STUDIOS
Address: 11 LONDON MEWS
LONDON W2 1HY
ENGLAND
Telephone: + 44 (01 71) 262 7441
Fax: + 44 (01 71) 262 7476
Biography: *An American living and working in London since the middle '60s, Jay has worked in many areas of photography from editorial through rock and roll to advertising.*
His work remains wide-ranging, but he is best known for special effects and complicated shots; he works on a single image for many days if necessary. An extensive knowledge of practical electronics, computers, software and mathematics is brought into the service of photography when required, and he has a good working relationship with top-quality model makers and postproduction houses as well as working closely with third party suppliers. He has recently purchased a powerful electronic retouching system and expects to work more in this medium in the future.

Photographer: **MAURIZIO POLVERELLI**

Address: VIA ENNIO 75
47044 IGEA MARINA (RN)
ITALY

Telephone: + 39 (05 41) 33 08 81

Fax: + 39 (05 41) 33 08 81

Biography: *Born in Rimini 30 years ago. He wanted to be a photographer even as a child, and so studied photography in Milan at the European Institute of Design followed by working as an assistant to Adriano Brusaferri, who specializes in food. In 1990 he opened his own studio in Rimini. Since then he has had some important advertising clients such as the Mario Formica calendar. Some of the images from this were exhibited in the Modern Art Gallery in Bergamo and in London. At present he works mainly in Rimini; in Milan he is represented by Overseas Agency.*

Photographer: **MASSIMO ROBECCHI**

Studio: PHOTO PRODUCTIONS

Address: 44 BOULEVARD D'ITALIE
MC 98000 MONACO
MONTECARLO

Telephone: + 33 93 50 18 27

Representative: BETTINA MÜLLER,
NEULERCHENFELDERSTRAβE 50
1160 WIEN
AUSTRIA
PHONE + 43 (1) 403 29 79

Biography: *A 35-year-old photographer, he has worked in Italy and other European countries for 15 years. He is equally at home in Advertising and Fashion (campaigns and editorial) and organizes many professional workshops and stages for young photographers. He also has his own substantial stock library with more than a million images on file. He is looking for a good English agent!!*

Photographer: **TERRY RYAN**

Address: TERRY RYAN PHOTOGRAPHY
193 CHARLES STREET
LEICESTER LE1 1LA
ENGLAND

Telephone: + 44 (0) 116 254 46 61

Fax: + 44 (0) 116 247 0933

Biography: *Terry Ryan is one of those photographers whose work is constantly seen by a discerning public without receiving the credit it deserves. Terry's clients include The Boots Company Ltd., British Midlands Airways, Britvic, Grattans, Pedigree Petfoods, the Regent Belt Company, Volkswagen and Weetabix to name but a few.*

The dominating factors in his work are an imaginative and original approach. His style has no bounds and he can turn his hand equally to indoor and outdoor settings. He is meticulous in composition, differential focus and precise cropping, but equally, he uses space generously where the layout permits a pictorial composition. His work shows the cohesion one would expect from a versatile artist: he is never a jack of all trades, and his pictures are always exciting.

Photographer: **GÉRARD DE ST MAXENT**

Address: 14 BD EXELMANS
75016 PARIS
FRANCE

Telephone: + 33 (0) 1 42 24 43 33

Biography: *Has worked in advertising and publicity since 1970. Specializes in black and white but is also fully at home in colour.*

Photographer: **FRANCES SCHULTZ**

Address: ROGER & FRANCES
5 ALFRED ROAD
BIRCHINGTON
KENT CT7 9ND
ENGLAND

Telephone: + 44 (0) 1843 848 664

Fax: + 44 (0) 1843 848 665

Mobile: + 44 (589) 367 845

Biography: *American-born, British-based photographer and writer. Specialist in black and white, particularly travel, and in hand colouring. Experienced printer. Regular contributor to Shutterbug and Darkroom User; work also appears in other magazines in Europe and the United States. Author (with Roger Hicks) of numerous books, mostly on photography.*

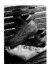

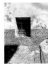

Photographer: **STRUAN**

Address: 60 HERBERT AVENUE
TORONTO
ONTARIO M4L 3P9
CANADA

Telephone: + 1 (0) 416 698 6768

Fax: + 1 (0) 416 698 3338

Biography: *"Intuition, simplicity and passion – these are the ingredients I use to create the images that keep me on the edge." The early part of Struan's life was spent mostly in Europe: London, Paris and Geneva. After a year at Toronto's Ryerson University in 1969, he opened his own studio in Toronto in 1970, but in 1989 he gave up his large studio and full time staff, the better to operate on an international level.*

He has constantly been in the forefront of beauty and fashion photography, both advertising and editorial, and since 1982 he has also been directing television commercials. He has won numerous awards: Clios for advertising in the US, Studio Magazine awards, National Hasselblad awards, awards in the National Capic Awards Shows. His work has appeared in magazines in Japan, the United States, Germany, and Britain as well as Canada.

Photographer: **YOSHIHARU TAKAHASHI**
Studio: SHAKTI CO.
Address: 7-4-7 HIGASHI-NAKAHAMA
JOTU-KU
OSAKA
JAPAN
Telephone: + 81 (06) 967 5211
Fax: + 81 (06) 963 3172
Biography: *Claims not to remember how many photos he has taken, but goes by the maxim that as long as there is light and shadow, he will continue shooting ...*

Photographer: **RAYMOND TAN**
Address: EFFECT STUDIO
4 LENG KEE ROAD
THYE HONG CENTRE
SINGAPORE 0315
Telephone: + 65 (0) 479 41 73
Fax: + 65 (0) 479 47 64
Biography: *He started from scratch as an assistant. It's been around ten years now, and he prefers shooting products to fashion. He strongly believes that photography is a never-ending process of learning: no-one can ever truly say that he is an expert and has nothing more to learn.*

Photographer: **ROBERT VAN TONGEREN**
Studio: FOTOSTUDIO TOBERT VAN TONGEREN
Address: JULIANAPLEIN 105
POSTBUS 50
NL 6640 AB BEUNINGEN
THE NETHERLANDS
Telephone: + 31 (088 97) 732 91
Fax: + 31 (088 97) 748 18
Biography: *Robert Van Tongeren is an all-round photographer and is always searching for perfection in the science of photographic lighting. He uses almost exclusively large formats (4x5 inch or 8x10 inch) in order to get the highest quality possible. His clients are very varied, with big names alongside small firms, but he still manages to find time for personal and research work to improve his scope and skills still more.*

Photographer: **WANTED**
Address: VIA PEROSI 5
20146 MILANO
ITALY
Telephone: + 39 (02) 48 95 26 50
Fax: + 39 (02) 42 34 898
Biography: *Wanted is a company created by Francesco Bellesia, Mario Di Benedetto and fabio Meazzi. It specialises in both digital and traditional photography, as well as post-production, in the fields of still life, industry, food and special effects photography.*

Photographer: **MATTHEW WARD**
Address: STUDIO SIX
9 PARK HILL
CLAPHAM
LONDON SW4 9NS
ENGLAND
Telephone: + 44 (0) 171 622 5223
Fax: + 44 (0) 171 720 1533
Biography: *Matthew Ward began his career as a photographer having assisted several advertising photographers and learning the craft of studio management. Coming to photography from a science and engineering background has enabled him to solve most of the technical problems that he has come across; particularly with respect to lighting. The diversity of the work he undertakes – everything except fashion – enables him to look at each challenge afresh and this varied experience has equipped him with a variety of techniques from which to draw when creating images. He is very keen to keep abreast of current developments and is exploring digital imaging. Current projects include a book on gardening and a book on American Cars whilst continuing to work for his corporate and advertising clients.*

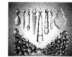

Photographer: **DAVID N. WATTS A.B.I.P.P.**
Studio: THOMAS NEILE PHOTOGRAPHERS
Address: JOSEPH WILSON INDUSTRIAL ESTATE
WHITSTABLE
KENT CT5 3EB
ENGLAND
Telephone: + 44 (01 227) 272 650
Fax: + 44 (01 227) 770 233
Biography: *David Watts studied photography at the London Polytechnic and after three years started his own business in 1966, specializing in industrial and commercial photography. The business now runs two large studios and is backed by its own in-house colour laboratory. Work ranges from cars to computer chips, while the laboratory also processes outside work from larger industrial companies and other specialist photographers.*

Photographer: **MARK WILLIAMS**
Address: ARK STUDIO
9 PARK HILL
LONDON SW4 9NS
ENGLAND
Telephone: + 44 (0) 171 622 2283
Fax: + 44 (0) 171 498 9497
Biography: *Mark Williams is an advertising photographer shooting still life and 'lifestyle' photographs for clients including Nokia, Shell and Max Factor. For several years before specializing, he spent most of his time travelling throughout Europe, South East Asia and North America for book publishers and for magazines such as World of Interiors; many of his images of people, places, art and architecture are now syndicated world wide by Tony Stone Images. Mark is now based in London at Ark Studio which he set up in 1994 in partnership with another photographer and his girlfriend Siri, who is an advertising stylist.*

Photographer: **NICK WRIGHT**

Address: STUDIO SIX
9 PARK HILL
CLAPHAM
LONDON SW4 9NS
ENGLAND

Telephone: + 44 (0) 171 622 5223

Fax: + 44 (0) 171 720 1533

Biography: *After twenty years in photography, he can turn his hand to most subjects though he is probably best known for his pictures of people and for still lifes. He has photographed many celebrities, and clients have included* Which? *magazine, W.H. Smith, Nestlé and E.M.I. Like any self employed photographer, he is always looking for new and challenging commissions, especially in landscape: he has illustrated several books, wholly or in part, most notably Daphne du Maurier's* Enchanted Cornwall.

Photographer: **STEFANO ZAPPALLÀ**

Studio: GREEN & EVER GREEN S.A.S.

Address: VIA CARLO MADERNO 2
20136 MILANO
ITALY

Telephone: + 39 (02) 58 10 69 50

Fax: + 39 (02) 58 11 43 88

Biography: *A commercial still life and food photographer based in Milan. He specializes in complex lighting situations and painterly sets. Clients include Motta, Banila, Firestone and Fratelli Rossetti.*

ACKNOWLEDGMENTS

First and foremost, we must thank all the photographers who gave so generously of pictures, information and time. We hope we have stayed faithful to your intentions, and we hope you like the book, despite the inevitable errors which have crept in. It would be invidious to single out individuals, but it is an intriguing footnote that the best photographers were often the most relaxed, helpful and indeed enthusiastic about the Pro-Lighting series.

We must also thank Christopher Bouladon and his colleagues in Switzerland, and of course Brian Morris who invented the whole idea for the series: and in Britain, we owe a particular debt to Colin Glanfield, who was the proverbial "ever present help in time of trouble".

The manufacturers and distributors who made equipment available for the lighting pictures at the beginning of the book deserve our thanks too: Photon Beard, Strobex and Linhof and Professional Sales (UK importers of Hensel flash). And finally, we would like to thank Chris Summers, whose willingness to make reference to prints at odd hours made it much easier for us to keep track of the large numbers of pictures which crossed our desks.